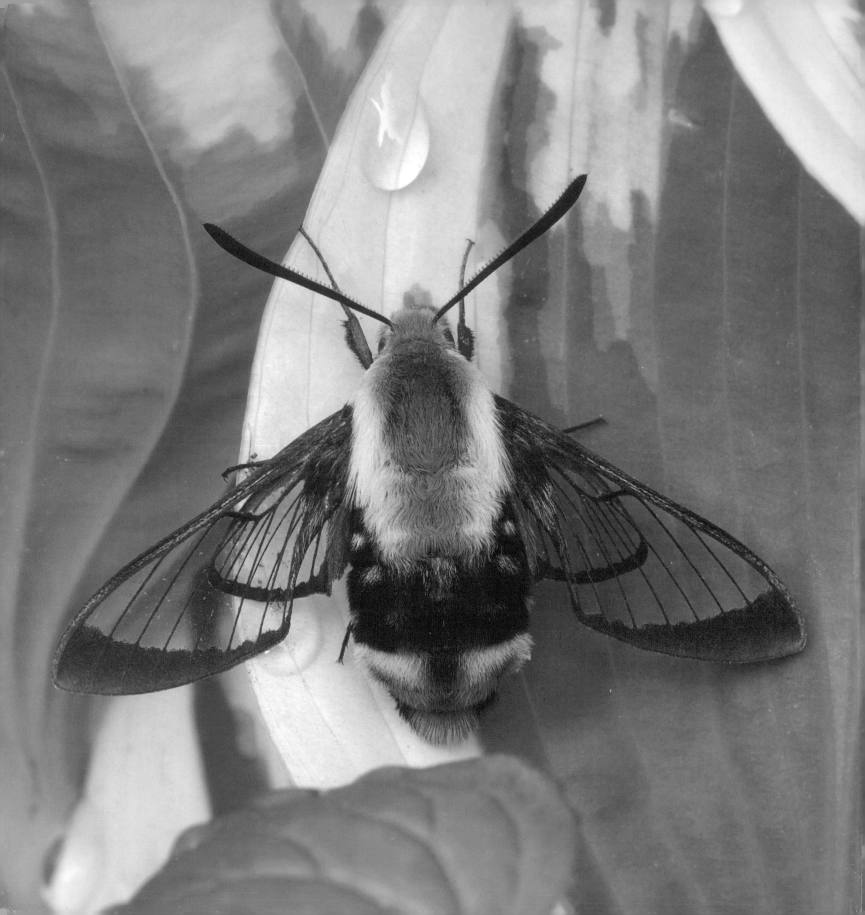

MACRO PHOTOGRAPHY

for Gardeners and Nature Lovers

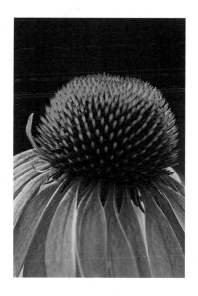

The Essential Guide To Digital Techniques

ALAN L. DETRICK

TIMBER PRESS
PORTLAND • LONDON

Design by Jane Jeszeck/Jigsaw,
www.jigsawseattle com

Published in 2008 by
Timber Press, Inc.

The Haseltine Building
133 S.W. Second Avenue, Suite 450
Portland, Oregon 97204-3527
www.timberpress.com

2 The Quadrant
135 Salusbury Road
London NW6 6RJ
www.timberpress.co.uk

Printed in China

Library of Congress Cataloging-in-Publication Data

Detrick, Alan L.
Macro photography for gardeners and nature lovers
: the essential guide to digital techniques / Alan L.
Detrick.
 p. cm.
Includes bibliographical references and index.
ISBN-13: 978-0-88192-890-7
1. Macrophotography--Handbooks, manuals, etc.
2. Nature photography--Handbooks, manuals, etc.
3. Photography--Digital techniques--Handbooks,
manuals, etc. I. Title.
TR684.D48 2008
778.3'24--dc22
 2008010682

A catalog record for this book is also
available from the British Library.

HALF TITLE PAGE *A white hibiscus
from behind in morning sunlight.*

FRONTISPIECE *Bumblebee moth resting
on a hosta leaf in the early morning.*

TITLE PAGE *Backlighting on the
golden brown disks of coneflower.*

RIGHT *Close-up of Camassia blossoms.*

*To Linda, my partner,
who made it all possible*

Contents

Acknowledgments 7

About This Book 9

1. The Macro World Introduced 11

 What Is Macro Photography? 13

 Development of Macro Photography 15

 Macro Awareness 19

2. Equipment 25

 The Camera 27

 Lenses and Lens Accessories 29

 Tripods 40

 Light Modifiers 44

3. Looking at Images 55

 Exposure 57

 Depth of Field 66

 Focus 70

 Lighting 77

 Composition 82

 Background 84

 Movement 87

4. Realistic or Artistic? 93

5. Flora, Fauna, and Beyond 101

 Flora 103

 Fauna 120

 Beyond 127

6. Digital File Basics 139

 Resolution 144

 Color 146

 File Mode 151

 File Format 151

 Guidelines for File Choices 153

7. Digital Workflow 155

 Capture 156

 Download Files 160

 Do Initial Edit 160

 Make Global Adjustments 160

 Back Up Raw 162

 Optimize 163

 Store 165

My Gear 169

Resources 170

Glossary 173

Index 175

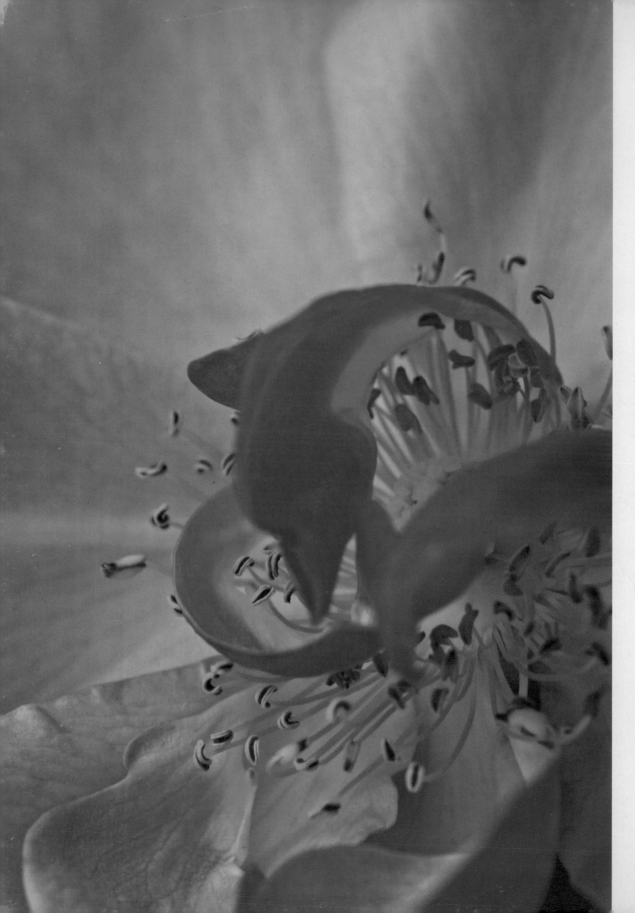

The soft sunlight on the center of this shrub rose presented a "What could it be?" feeling when in this close. Even if I set the aperture at f22, parts of the image would be out of focus. I elected to use a medium aperture and focus on the anthers.

Canon 1Ds Mark II with 180mm f3.5 L macro lens, 1/40 second at f11

Acknowledgments

I AM FREQUENTLY ASKED how and why I became a photographer. The "why" is a combination of family history, the desire to create, and a love of nature.

My grandfather, Christian Detrick, was a freelance photojournalist before newspapers had staff photographers. In 1934, he decided to go to Lakewood, New Jersey, to shoot the arrival of the *Hindenburg*. His assistant could not go so he enlisted the help of my uncle, Leonard Detrick. The one-day shoot became a three-day outing when the dirigible burst into flames and crashed at the landing site. Immediately upon returning to his regular job, Leonard was fired. However, his boss kindly told him he thought he would make "a fine photographer." Leonard ultimately became one of the lead photographers for the New York City *Daily News*.

While I always knew *that* part of the family history, it was not until a conversation with my mother a few years before her death that I discovered her great-grandfather owned and ran a large nursery in Germany in the 1800s that remained in the family until recently. At that point, it seemed obvious that I was destined not only to be a photographer but also to be drawn to photograph horticultural subjects and gardens.

The "how" I became a professional photographer is somewhat different. When our daughter graduated from college, my wife, Linda, suggested we try to turn my love of photography into a business. I would do the photography and Linda would handle the marketing and contracts. The combination of a business background, lots of research, long days of predawn-until-dusk shoots, and a lot of luck produced results. In a few short years, we noticed that the major portion of our business involved gardening, and that became where we focused.

Over the years, I continually took photography workshops with exceptional photographers including John Paul Caponigro, Dick Frank, Arthur Meyerson, Seth Resnick, John Shaw, and Larry West.

Each one of them in their own way exerted a positive influence on my photography. To this day, I try to learn from photographers who offer a different way of looking at or thinking about a subject.

Fellow garden photographers also influence my work. My good friend Roger Foley generously and unselfishly shares his expertise on working with light in a garden. Ian Adams, author of *The Art of Garden Photography* and techno-expert, encouraged me to write this book and consistently keeps me updated on the latest and greatest. Friend and successful garden writer Ellen Spector Platt continually provides sage and meaningful advice on the process of writing a book. The transatlantic couple judiwhite and Graham Rice have been treasured friends and valuable sounding boards for many years.

Thanks also to Peter Kaplan for allowing me to tell the story of "Liberté mon Amour," and to Canon, Nikon, and Sigma for graciously providing macro equipment for the photographs.

I would like to say a special thank you to all the students who attended my workshops. Their participation allowed me to better understand not only the problem areas in macro photography but the goals as well. I hope this book addresses most if not all of their concerns.

I would be remiss if I didn't mention my editor, Lorraine Anderson. Her patience, understanding, and eye for details, along with the encouragement of Tom Fischer and the rest of the Timber staff, made this project a reality.

In the end, credit for any level of success goes to my loving wife, Linda. Her unseen hand is the reason for the viability of my photography, our business, and this book. Being a photographer, let alone writing a book, would not be possible for me without her help, support, guidance, and, most of all, patience. If there are any mistakes, they are mine. All the credit really belongs to my best friend, Linda.

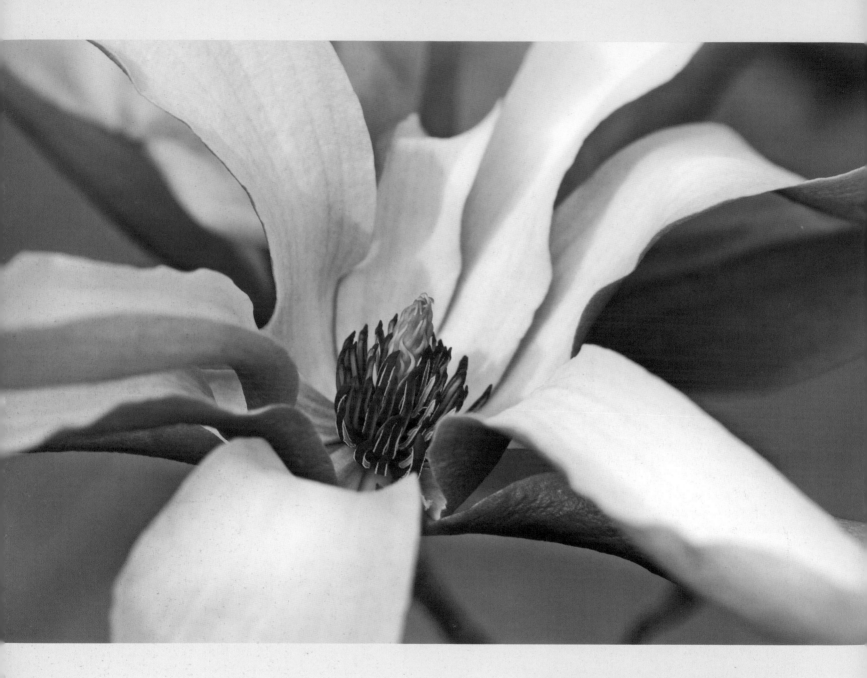

All roads lead to Rome, only in this case it's the petals of this magnolia blossom pulling us to the center. Focus on the center and let everything else go soft. Blossom was placed slightly off center in the frame.

Canon 1Ds Mark II with 180mm f3.5 L macro lens, 1/80 second at f8 +1/3 stop exposure

About This Book

FOR ANYONE WHO LOVES nature, whether admiring the flowers in a garden, watching a butterfly, or examining nature's patterns, the desire to capture these images is as natural as taking the next breath. Macro photography is the visual portal to a world most people walk by without a glance. Plants, animals, and parts of plants and animals never before imagined enter the camera's viewfinder. Best of all, close-up photography does not require trips to Alaska, Africa, or any other exotic locale to capture visually compelling natural images. A walk in the backyard garden or a neighborhood park can provide a wealth of material to photograph close up.

While it may be exciting to think about capturing the image of one petal of a flower or a single dewdrop, or filling the frame with a butterfly sipping nectar, macro photography is intimidating to many photographers. The technical considerations can seem overwhelming. Fortunately, the equipment available today makes macro photography much easier than it was years ago. It's still more dependent upon good technique than normal shooting, but with some work and experience, the photographer of flora and fauna will find that the macro world offers incredible new opportunities.

This book is designed to help macro beginners as well as more advanced photographers develop a practical approach to capturing professional-quality macro images with a minimum of fuss and a maximum of fun. For the beginner, this book will help to establish a solid foundation in the language of macro photography and provide an introduction to the technical considerations. The more advanced photographer will gain a better understanding of how to approach an image under difficult conditions. While some point-and-shoot cameras can capture macro images, the techniques and advice in this book are aimed at users of digital single-lens reflex (DSLR) cameras.

Some macro books go into great technical detail with formulas, charts, and elaborate field setups. While those books are a great source of information, this book presents a less technical and more user-friendly approach to macro photography. It covers macro basics, equipment considerations, field techniques, and digital photography. In each chapter, sidebars provide a more detailed explanation of some technical consideration or point out where or why digital photography requires a different approach from film. Different photographic styles and how they are achieved are explored. Common mistakes that photographers make when first attempting to do close-up work are also mentioned.

In class, students are always interested in the thought process behind different images. They want to know what attracted me to the image, why I chose a particular angle, what I left out, and what f-stop I used and why. For this reason, I have included five case studies that reveal my thought process.

While digital photography certainly involves the computer, this book does not go into great detail on computers and software. The intent is to give you an understanding of macro photography that will endure regardless of advances in computer and software technology.

Above all, I hope reading this book enables you to have fun capturing your very own macro images—not the images or style of any other photographer, professional or amateur, but images that represent your vision, images that put a smile on your face each time you view them.

The Macro World Introduced

IN 2001 I WAS FORTUNATE TO BE PART OF A press tour to Holland to photograph the spring bulb displays. It was a group of sixteen professional photographers specializing in the fields of gardening and horticulture. The two questions group members asked most often were "How early can we get into the gardens?" and "How late can we stay in the gardens?" For photographers, this "Let's get going!" And "Just a few more minutes!" attitude is not unusual.

The light glowing through this morning glory was captivating. The shadow from the pistil and anthers became critical. Medium aperture kept the blossom before it flared sharp. I raised the ISO to 320 to compensate for a breeze and overexposed slightly. Several images similar to this were taken where I varied the background. This one with a dark background is the most dramatic.

Canon 1Ds Mark II with 180mm f3.5 L macro lens, 1/200 second at f11 +2/3 stop exposure

This macro image of a dahlia is appealing in a number of ways. The diffused lighting is a perfect match for the soft pink coloration. The limited sharpness front to back also helps support the overall feeling I wanted in this image. I framed the subject tightly to let the viewer know it was my intention that some of the blossom be excluded. Allowing just a touch of green at the bottom added interest.

Canon 1Ds with 180mm f3.5 L macro lens, 1/2 second at f22 +2/3 stop exposure

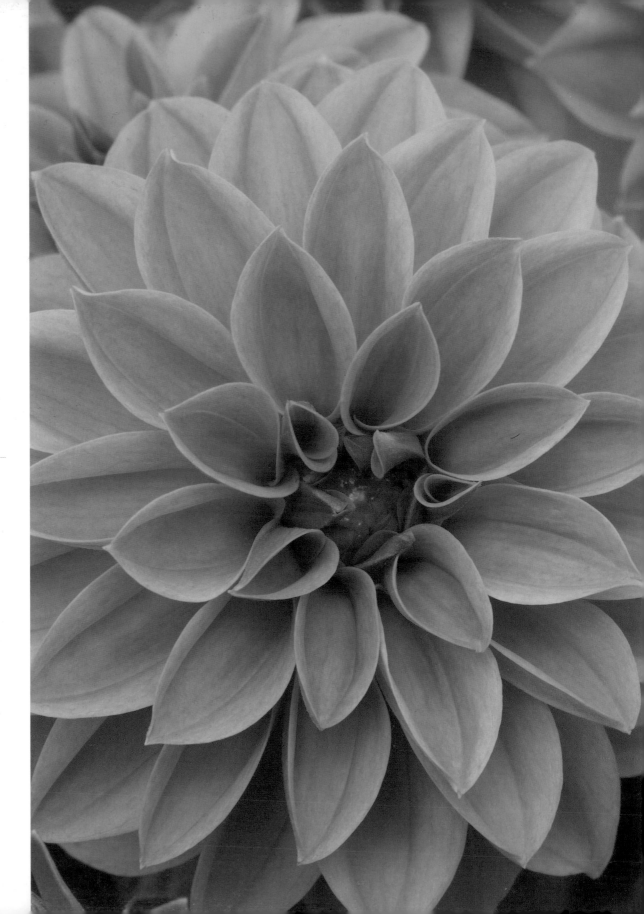

This attitude sometimes translates into an eagerness to be told first thing which pieces of equipment are needed when trying new areas of photography. While this equipment-first approach may work for normal images, it seems like putting the cart before the horse for a more technically demanding type of photography. How can a photographer know which pieces of equipment are needed without knowing why the equipment is needed? Before getting down to equipment talk, it's essential to have a broader understanding of the world of macro photography.

This chapter is an introduction to the macro world. It looks at what constitutes macro photography, gives some historic perspective, and discusses how macro differs from normal shooting. Besides the technical considerations, macro has its own language, so this chapter also demystifies some of the language of macro photography.

This image is a close-up of a variety of plants in a container. The total area of the picture is the starting point for macro images. The color harmony of the combination of blue, pink, and wine blooms initially caught my interest. The light brushing across the blossoms from right to left highlights the blue and a few of the pinks. While the lighting is diffused, there are still highlights and shadows to give depth and feeling to the image.

Canon 1Ds with 180mm f3.5 L macro lens, 1/8 second at f22 –1/3 stop exposure

What Is Macro Photography?

Not too long ago, 35mm cameras were sold with a 50mm lens. It was a very versatile lens but it was limited in how close it could be to a subject and still focus. It lost focusing ability when an area of about 10 by 15 inches filled the camera viewfinder. Different equipment was needed to photograph subjects or areas smaller than this. This need became the starting

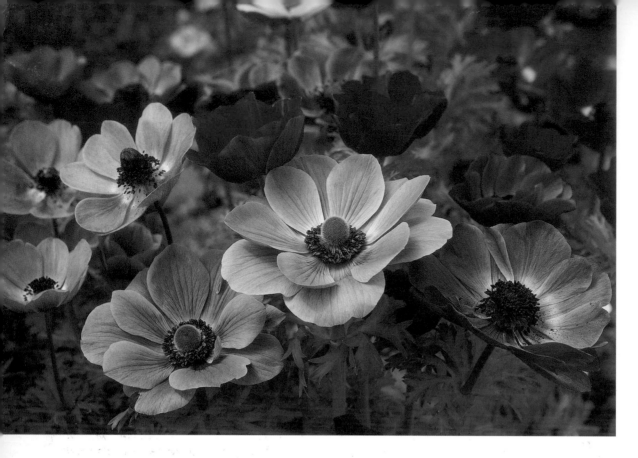

The Language of Magnification

While digital sensors have replaced film as the light-recording medium in our cameras, the terms common in macro photography haven't changed. The terms *magnification* (or *reproduction*) *ratio* and *image scale* still refer to expressions of the relationship of the actual size of the object photographed to that object's image size on the digital sensor. For instance, an image scale of 1✛, a magnification ratio of 1:1, and the term *life size* all mean that the actual size of the object being photographed is equal to the size of the object's image on the sensor. At this scale, a one-inch-long beetle has an image that measures one inch in length on the camera's digital sensor.

Manufacturers of specialized macro equipment use this terminology to describe the capabilities of their products. You'll see a maximum magnification listed among the features of a macro lens. Having an understanding of the language associated with macro prevents unpleasant surprises when you purchase such equipment.

The strong mix of colors of these spring anemone really draws attention. This was a large bed of plants so I had the luxury of looking for a composition that would be something more than a straight-on head shot. The trio of blossoms forming an arc was perfect. To help prevent the image from being static, I placed the trio so there would be more room on the left side of the picture than the right side. I wanted the three main blossoms to be sharp but the background to go soft.

Canon 1Ds with 24-70mm f2.8 L zoom lens, 1/125 second at f11 +1/3 stop exposure

point for the photography called close-up or macro photography.

To be accurate, the terms close-up and macro are not synonymous but describe two different magnification ratios. The difference is in how the size of the actual subject relates to the size of the image on film or microchip. Technically, close-up photography is capturing an image on film or digital sensor that's one-tenth the size of the actual subject or larger, up to the same size as the actual subject (life size or 1:1), while macro photography is defined as capturing an image that's at least the same size on film or digital sensor as the actual subject and up to ten times the size of the actual subject (10:1). Thus, macro photography makes the small world even larger than close-up photography. Most of the lenses sold under the macro (or in the case of Nikon, *micro*) designation are limited to close-up capability by definition. This causes some blurring of the distinction between the terms.

Regardless of how the lens is labeled, the topic of this book is shooting subjects or areas that range in size from 10 by 15 inches to 1 by 1-1/2 inches, which includes a whole world of flora and fauna. Whether you want to call that close-up or macro is up to you. In practical terms, what's important is understanding that to capture an image of something smaller than 10 by 15 inches, different equipment and photographic technique are needed.

Development of Macro Photography

Traditionally, the most common solution for overcoming the focusing problem in close-up situations was to increase the distance between the camera and the lens. Fifty years ago this was accomplished by attaching extension tubes of various lengths between camera and lens. It was also common practice to add extension by attaching a bellows to the camera lens mount with a special lens called a short mount lens on the front of the bellows. The extension tube or bellows attachment increased the distance between the lens and the camera body to allow the photographer to focus closer to the subject than normal. Unfortunately, increasing the distance from the lens to the camera had the negative effect of decreasing the amount of light reaching the film. This meant the exposure also changed. If the extension tube or bellows was connected to the camera's metering system, the change in exposure was handled auto-

I had taken a few images of these violets when I noticed how the backlighting really made this blossom glow. Because it was the only blossom that was fully backlit, I decided to go in very tight with just sections of other blossoms and some foliage included. Making the plane of the blossom match the plane of my camera enabled me to keep the subject sharp and the background soft.

Canon 1Ds with 180mm f3.5 L macro lens, 1/8 second at f22 –1/3 stop exposure

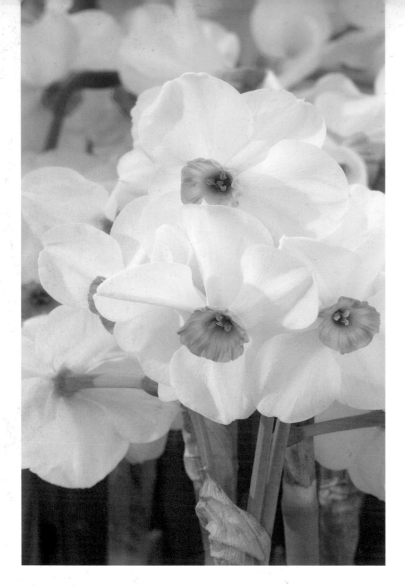

Daffodils and springtime go hand in hand. This group with their orange cups and clean white petals were at their peak when I photographed them. The late-day sun added extra life to the frontmost blossoms. The amount of white in the image necessitated some exposure compensation on the plus side.

Canon 1Ds with 180mm f3.5 L macro lens, 1/10 second at f22 +2/3 stop exposure

matically. However, not all bellows or extension tubes were automatic. In these cases, the photographer had to perform exposure calculations involving the length of the extension tube or how far the bellows were extended.

Additional calculations had to be made anytime flash was used. The relationship between the speed of the film, the flash's power, and the distance from the flash to the subject had to be considered. Photographers made measurements in the field and consulted exposure tables to get the correct exposure.

Early macro lenses were usually 50–55mm and originally designed for copy work inside a studio. These early designs had built-in extension that allowed focusing to half life size. To get to life-size images, additional extension was needed. The working distance from the front of the lens to the subject was very limited. The lenses had good-quality optics but were not suited for use in the field.

Thankfully, the camera and lens manufacturers responded to the void in the marketplace. In the 1980s Canon, Nikon, and a number of other manufacturers introduced dedicated macro lenses in 100mm and then 200mm sizes. Macro lenses of 100mm focused up to life size without adding any extension. They were easy to use and reasonably priced. When long macro lenses up to 200mm became available, many of them had a tripod collar (an adjustable ring surrounding the lens with a platform that attaches to the tripod head), making it quick and easy to change from a horizontal to a vertical image. Focusing was done manually, either by rotating the focusing ring on the lens or by attaching the camera and lens to a focusing rail that moved the camera and lens in and out relative to the subject.

Improvements kept coming. The camera and lens manufacturers appealed to a large potential market by adding more automatic features to the cameras—autofocus, autoflash, autoexposure, and the like. Today, digital single-lens reflex (DSLR) cameras handle difficult exposure problems automatically with ease. The camera and flash talk to each other, eliminating more exposure guesswork. Numerous lenses and lens accessories that make it easier to capture quality images consistently are now more readily available. Macro capability is now included on many zoom lenses. There are even point-and-shoot cameras with macro capability. But despite all the current advancements, the normal 35mm digital camera system is still limited in its ability to consistently take a full range of quality macro shots. For the photographer interested in macro photography on a more-than-casual basis, the reality is that additional equipment, including some of the old remedies, is needed to effectively capture good close-up images.

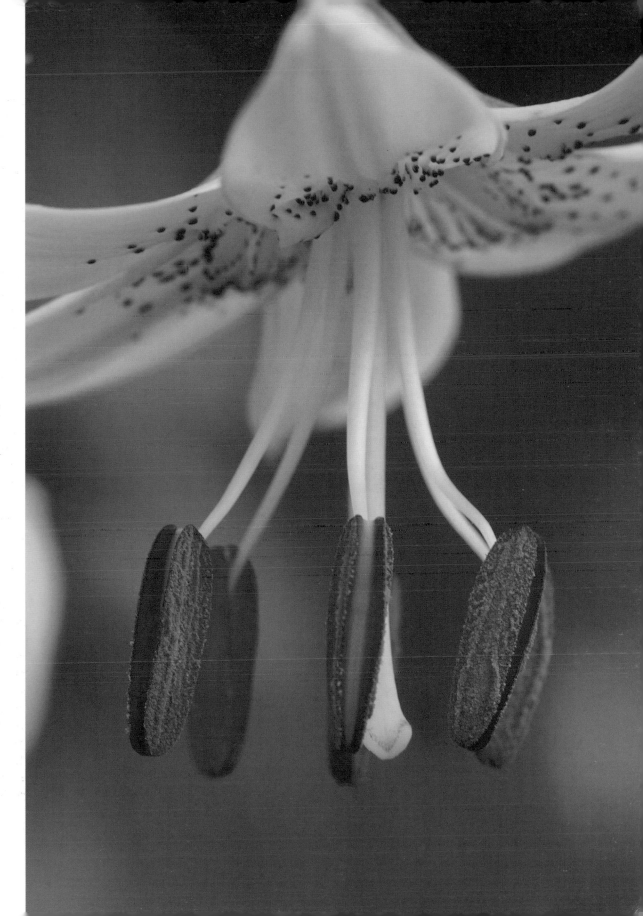

The typical Lilium photo shows the pendant behavior of the blossoms. I wanted to see if there was an image to be captured as I looked up at the flower. It was impossible to get a tight shot with front-to-back sharpness. I elected to try to get the anther and some of the filament sharp. This plane of focus would also include some portion of the petals. Going in very tight on the blossom eliminated distracting background elements.

Canon 1Ds with 180mm f3.5 L macro lens, 1/20 second at f11

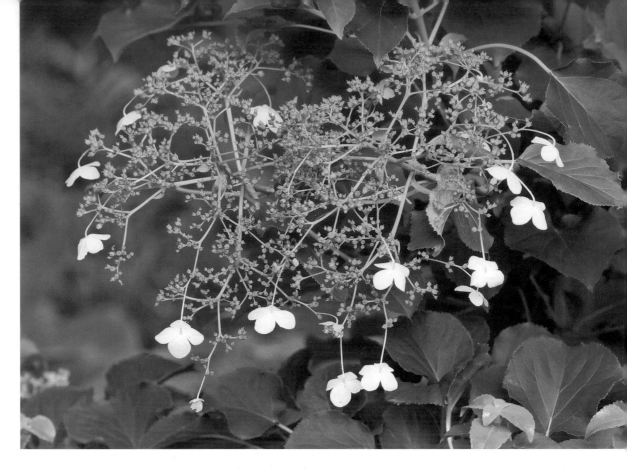

These images represent the concept of pictures within pictures. The image of the entire blossom cluster of climbing hydrangea is not that interesting. I noticed, however, that the single floret in the upper part of the cluster made a nice gesture. Having the floret completely sharp would diminish the overall feel that originally caught my eye, so I wanted a fairly shallow depth of field. I concentrated on getting the curve of the stem and just a bit of the floret sharp. Positioning the floret in the center of a hosta leaf in the background blocked out any distractions.

Canon 1Ds Mark II with 180mm f3.5 L macro lens, blossom cluster 0.6 second at f8 +1/3 stop exposure, floret 1/2 second at f11 +1/3 stop exposure

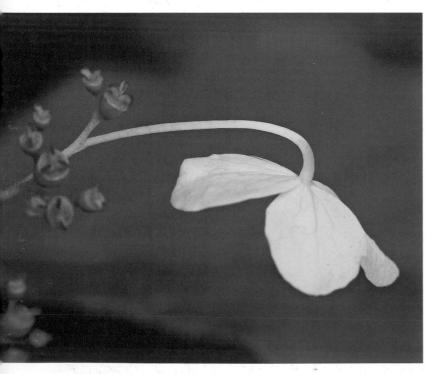

Macro Seeing

Because macro images differ from larger-scale ones, being able to see potential shots will take a bit of training and practice. It won't happen overnight. To understand "macro seeing," walk around and look at everything through a magnifying glass. Better yet, cut a small opening of approximately 4 by 6 inches in a large piece of cardboard and walk around your yard looking only through this opening. Whether you use the magnifying glass or the cardboard frame, your vision becomes more concentrated. The background and distracting areas are reduced, and the subject is narrowed to a small area. With more experience, you will start to look at objects as if you had the magnifying glass or the cardboard frame in hand and be able to judge fairly quickly which blossoms, leaves, insects, and the like are the best subjects.

Cropping and Enlarging Versus Macro

Instead of employing good macro technique and equipment, you may be tempted to shoot a normal-size image and then crop and enlarge the image file on your computer. When you crop an image, you keep the pixels in the cropped portion and throw the rest away. The resulting digital file thus contains fewer pixels, which limits what you can do with it. If the file is too small for its intended use, the computer can increase the total number of pixels by a process called interpolation. This produces a digital file made up of some of the pixels from the original capture and some from the software program used in the computer interpolation. An image created in such a manner may exhibit uneven or blotchy color instead of gradual tones. Thus, although you can get macro images by cropping and enlarging, it's no substitute for good macro photography.

Macro Awareness

In addition to equipment with the ability to focus in tight, you need a different visual sense when you do macro work. Landscape photographers are used to taking it all in. When they walk through a garden, they tend to see design elements, plants, combinations, color, and foliage as part of the whole. But seeing the big picture can cause you to miss the small details. When you are doing macro photography, those small details become the subjects of attention.

In addition to being able to see the shot and having the right equipment, you need to be aware of a few other considerations in macro photography. As you move in closer, the magnification of the subject increases in the viewfinder and on the sensor. *Everything* about the subject gets magnified. It's this magnification that allows you to enter a different world and makes macro so exciting. The magnification, however, applies

These photos are another example of seeing macro images in the garden. In walking through the garden in the early morning, I noticed an out-of-place bright spot on the ornamental grass. On closer inspection I found a resting green stink bug. The bug was still immobile from the cool night temperatures and the dew, giving me time to get the image. Look for and be aware of shapes that seem out of place.

Canon 1Ds Mark II with 180mm f3.5 L macro lens, 1/4 second at f22

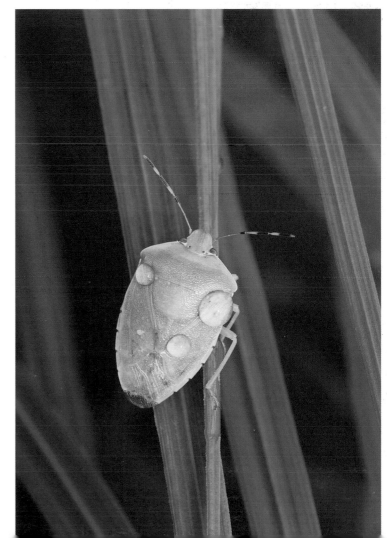

This cluster of tuberous begonia 'Pin-up Rose' with each blossom at peak really caught my attention. For composition, I normally try to place the subject off center in the frame to keep the image interesting. Moving this cluster to the right or left in the frame brought distracting elements into the picture. The variation in lighting, however, with the blossoms on the left being the brightest, solved the composition problem by keeping the image from being static. The directional light also brought out all the attractive texture of the blossoms.

Canon 1Ds with 180mm f3.5 L macro lens, 1/20 second at f16 +2/3 stop exposure

to the bad features as well as the good. Tiny faults in the subject, hardly noticeable before, now jump out. The slight brown spot on a blossom hidden among other blossoms becomes very evident.

While missed problems like a leaf tear or a brown spot can be corrected in the computer, adopting the "I'll fix it in Photoshop" attitude for every problem leads to more computer and less camera time. The better approach is to eliminate as many possible problems as you can in the beginning, by examining your subjects more carefully for flaws and faults. Looking through the camera viewfinder or at the LCD for flaws won't do it. Both the viewfinder, because it's so small, and the camera LCD, because of its inaccuracies, are less than reliable for good image evaluation. Get in the practice of moving in to visually examine the subject close up before setting up your camera and tripod.

Like every small flaw in the subject, any camera movement or movement of the subject is also magnified. Photographers used to walking with camera in hand through a garden and pausing for a shot will have a hard time getting good close-up captures. The smaller apertures common in macro photography mean slower shutter speeds. As a result, the tiny camera shake from hand holding the camera produces a blurry image. Using a tripod becomes essential.

Digital cameras give you some help with reducing motion. In the analog world, the film speed on which exposures depend is the same for every frame in the roll. With the new digital wonders, the ISO rating (film speed) can be changed for each shot. While this might seem like the perfect solution to any movement or low-light situations, there's a drawback to changing the setting. When you change the ISO setting to a higher value, the camera increases the electrical charge to the sensor, and this in turn increases any artifacts or digital noise, especially in the shadows or areas of extreme contrast, which can result in a poor-quality digital file. Depending on the camera, digital noise can rapidly increase above an ISO setting of 400. Try not to get into the habit of raising the ISO setting every time you want greater shutter speed. Keep the camera at its optimum setting and raise the ISO only when all other avenues to get the shot are closed. If you do change the ISO, remember to return it to the optimal setting after you capture the shot.

Perhaps the most daunting technical challenge in macro photography is working with the depth of field of an image. The field, or the area that appears sharp, gets more limited as magnification increases. The greater the magnification, the more depth of field you give up. A wide-angle shot, with its uniform sharpness, might have a depth of field measured in yards. In macro photography, the depth of field is measured in inches or fractions of an inch. Because of this, it's essential to pay careful attention to focusing.

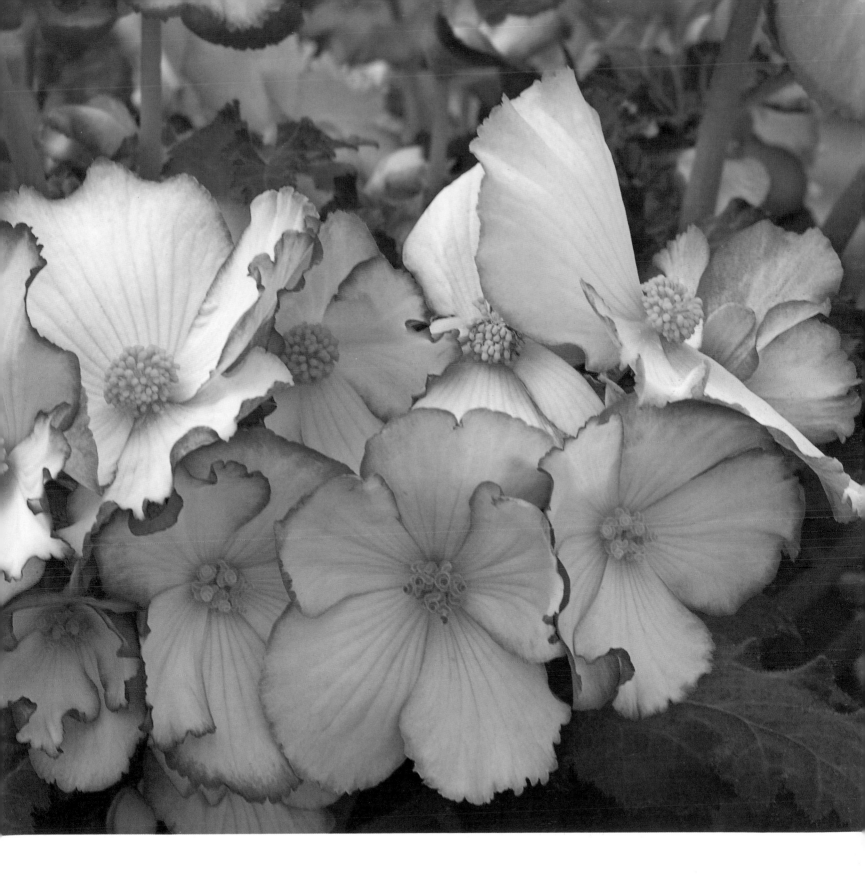

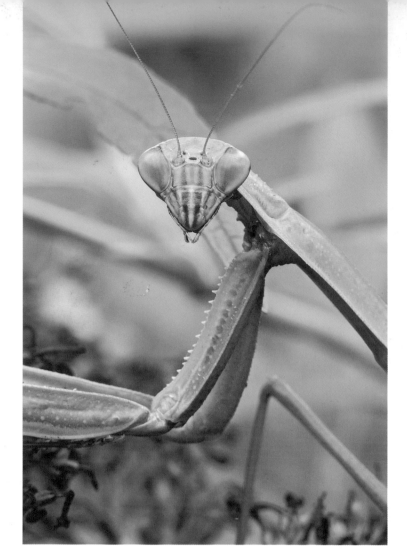

RIGHT **Oenothera speciosa**
in changing light.

Canon 1Ds Mark II with 180mm
f3.5 L macro lens, first image 1/30
second at f11, second image 1/50
second at f11, +2/3 stop exposure
on both images

I had set up the camera and tripod in the middle of a few butterfly bushes to photograph monarch butterflies when I noticed this praying mantis looking at me. I tried a number of horizontal images but the numerous branches made the image far too busy. I rotated the tripod collar to the vertical position and moved in to capture just a head-and-shoulder portrait. At this point, the mantis started to get nervous about my near presence. Her attitude of "don't come any closer" made the image.

Canon 1Ds Mark II with 180mm f3.5
L macro lens, 1/3 second at f22

Digital or Color Noise

Digital cameras are most efficient at capturing information in the bright areas of an image. Conversely, they have the most difficulty capturing information from shadowed areas. This results in blotches of color (called artifacts or noise) showing up in dark areas of the image when the camera is having trouble sensing and recording information. When you increase the ISO setting, the frequency and visibility of color noise also increases. To see if there's any noise in your image, increase the magnification of the image on your computer monitor until you are viewing it at 100 percent. Then scroll around the image to locate any areas with noise. Software programs to reduce or eliminate noise in digital files are available.

Producing a macro image can be very simple or very complex, depending on the shooting conditions and the vision of the photographer. Digital photography allows the possibility of endlessly adjusting or manipulating an image on your computer. Nevertheless, you should resist this temptation. Digital photography is about capturing the largest amount of information you can while shooting and then making adjustments in the computer to produce the best image. Good camera technique means less time spent in front of a computer screen. Understanding the process from beginning to end is just as important as selecting the right equipment. Like everything worthwhile, macro photography takes practice. Enjoy the journey.

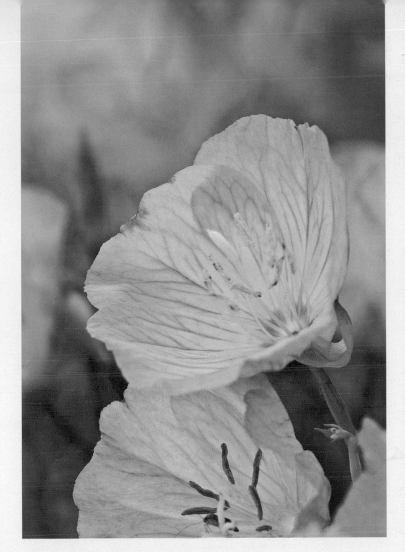

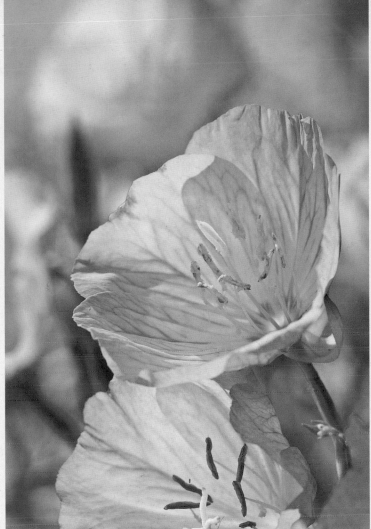

Photographing in Changing Light

Two images of pink evening primrose (*Oenothera speciosa*) represent an exercise in photographing a subject in changing light. In early spring these plants spread out and form a carpet of light pink. If they like the area where they are planted, they become almost invasive. Rather than take a wide-angle shot of the pink carpet of flowers, I decided on a close-up of one or two blossoms in order to highlight their semi-translucent quality. The next step was to locate a blossom positioned in such a way that the blossom could be sharp with a soft background to give depth to the image. I was concerned that in the strong sunlight, the light coming through the blossom might be too harsh. I positioned the camera to take advantage of the shadow cast by a nearby large oak tree.

The initial exposures were done as the trunk of the large tree shaded the blossom and surrounding area. This worked to keep texture in the flower and still show some translucence. As the sun moved, so did the shadow. The lighting on the blossom and area changed. In ten minutes, the shadow had moved completely and the sun filled the frame. The character and feel of the image had changed, as evidenced by the next exposures. My earlier concern regarding the harshness of the sunlight proved unfounded. In fact, I think the sunlit image has more of a spring feel than the other. The lesson is that if you have a good subject in your frame in changing light conditions, stay put. The camera is all ready to go, and the different lighting may give extra opportunities for additional quality images.

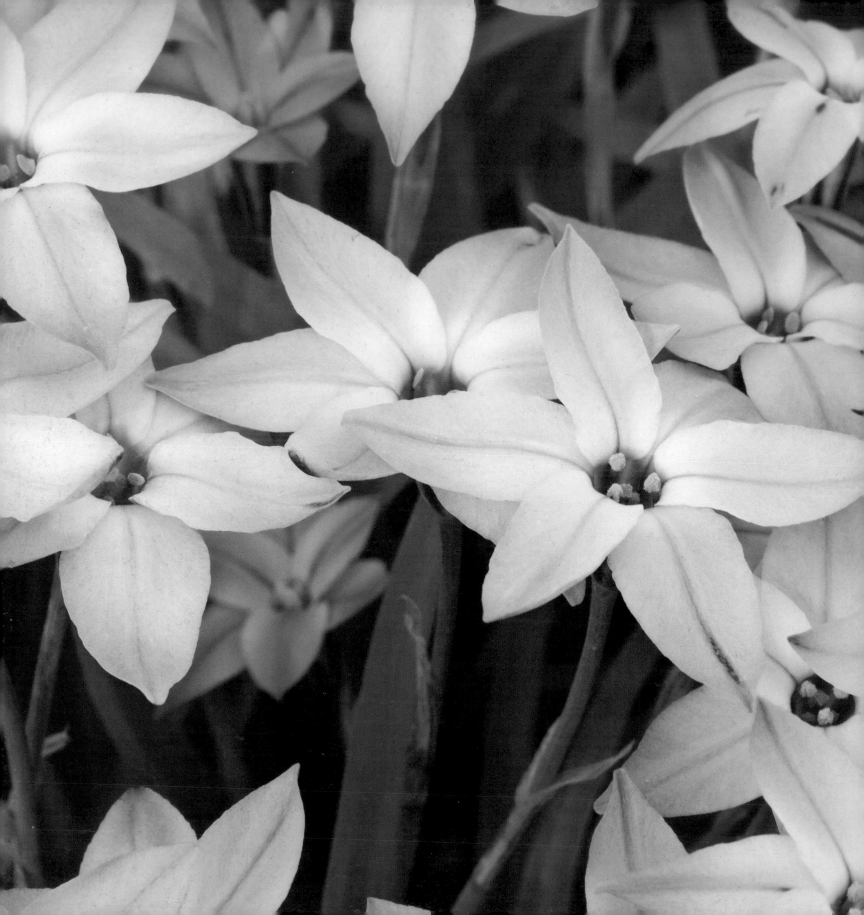

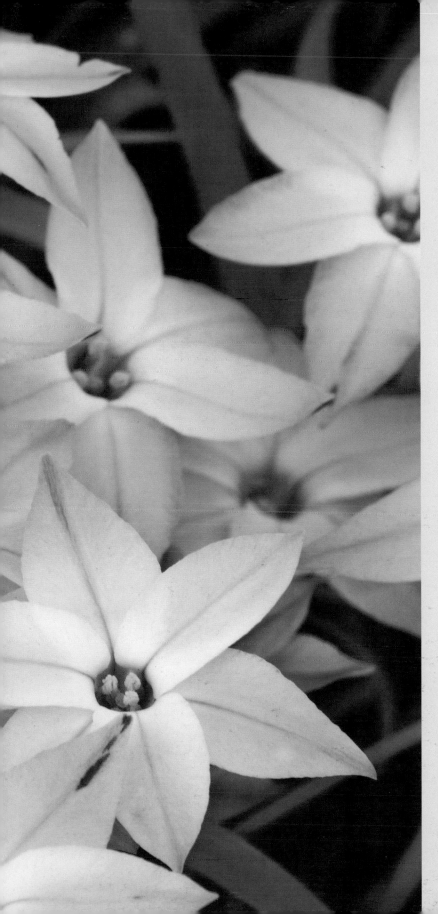

2
Equipment

GET A GROUP OF PHOTOGRAPHERS TOGETHER and pretty soon they're talking about equipment—the newest lenses being offered, the latest camera body, carbon tripods, computers, hard drives, and software. But trying to keep up with the latest products can be overwhelming for someone just starting out, and it's not really necessary. In the beginning, it's better to keep everything as simple as possible until you have a sound foundation in the basic principles.

The softness of the light blue color in these Ipherion blossoms is difficult to capture. The setting sun brushing across a few of the blossoms was the solution I needed. I positioned the brightest blossoms to the right and let the shadow go off to the upper left. I bracketed the exposure to the plus side to keep the light blossoms from going grey.

Canon 1Ds Mark II with 180mm f3.5 L macro lens, 1/4 second at f22 +2/3 stop exposure

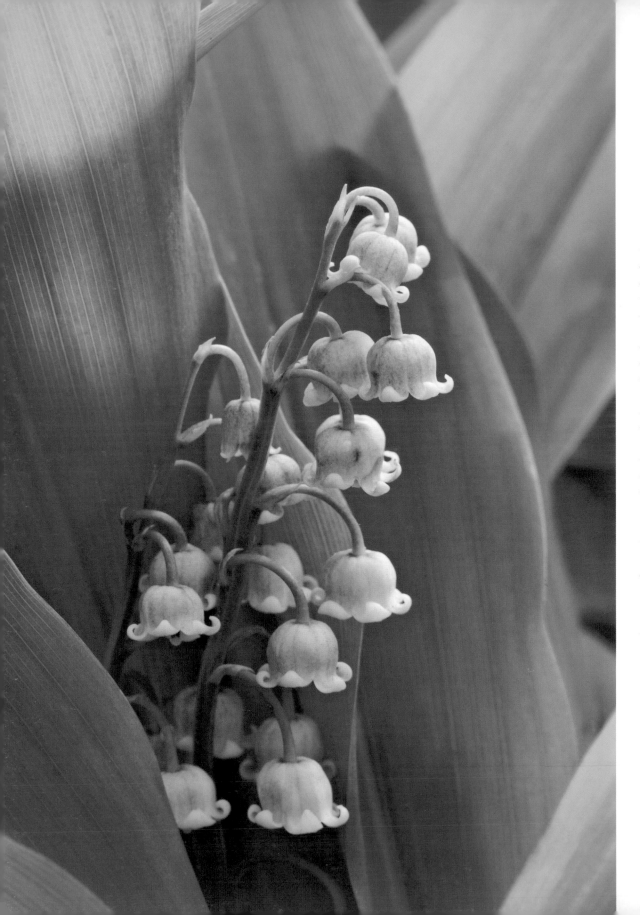

Groups of lily-of-the-valley are always a welcome sight in the spring. Getting a good close-up of the tiny bell-shaped blossoms, however, is a challenge. Many times the blossoms are hidden among the leaves or the plants are so close to one another that a clear shot is impossible. Sometimes a good plant is right in the middle of the group and getting a tripod into position low to the ground is difficult. After searching along the edges of a large group in my backyard, I found this plant in a position where I could set up the tripod and camera. I went in tight to eliminate the busy background but left enough room so that the image didn't appear cramped. I placed the blossoms so that a dark leaf gave them separation. Late-afternoon diffused back-lighting completed the image.

Canon 1Ds Mark II with 180mm f3.5 L macro lens, 1/4 second at f16

Selecting one or two good pieces of equipment and learning how to use these effectively is better than having a loaded camera bag and not knowing how anything works. You can add equipment as you gain experience. For now, let's take a look at the different tools available and how they fit into the macro world.

The Camera

Years ago, the camera body was simply a mechanical device that held film and moved it from frame to frame while metering the light. Not so anymore. Whether made by Canon, Nikon, Fuji, or any other major manufacturer, every digital camera is a minicomputer with more bells and whistles than anyone can use. But don't let all the features confuse you. Take them one at a time to find out how they work and whether you need them.

There are digital single-lens reflex (DSLR) cameras to fit every budget. If you are thinking of purchasing a new camera, take time to research the marketplace. Some cameras seem to have the controls in all the wrong places, while others fit like a glove. Your camera should fit comfortably in your hands and be relatively easy to use.

Whether working with a new camera or one you already own, read the camera manual at least once. Find out which functions are controlled by which button or dial. The last thing anyone wants is to be out in the field thumbing through the camera manual to find out what the blinking light means or how to change settings. Be sure to carry the manual in the camera bag. The only thing worse than being in the field and consulting the manual for basic information is being in the field with the camera doing strange things while the manual is safe and warm at home.

So many new cameras are introduced every year that it's impossible to list all the available models and their features. Instead, I'll describe those features that are valuable in macro photography.

Cable release connection

Make sure your camera accepts a cable release. This is a wire that attaches to the camera and enables you to release the shutter from a distance so you don't have to manually press the shutter-release button. Using a finger to press the button may cause the camera to move slightly, which is undesirable because this movement shows up as a blurred image at shutter speeds between 1/30 and 1 second. Besides eliminating camera

This violet was hanging over the side of a container in a greenhouse. I found the soft sunlight brushing across the blossom very attractive. It was late in the afternoon, so even though the sunlight was on the blossom, it wasn't very strong. I chose a medium aperture to help soften the background and still give enough shutter speed to offset the slight air movement from the greenhouse fans. I shot the blossom on an angle to include the spur hanging down. The depth of field runs through the center plane of the blossom.

Canon 1Ds Mark II with 180mm f3.5 L macro lens, 1/13 second at f11 +2/3 stop exposure

shake, the cable release lets you move out from behind the camera to concentrate on the subject.

Autofocus

Today's cameras all focus automatically, but this isn't always a welcome feature. Many photographers, in fact, choose to turn off autofocus when taking macro images. I use the autofocus feature when I can and turn it off when the image is better handled by focusing manually.

In autofocus mode, the area where the camera focuses, called the active focus area, is indicated by a rectangle, an ellipse, or a cross pattern visible in the viewfinder. To give the photographer control over the focus, most digital single-lens reflex cameras allow the user to tell the camera where to focus by designating which point to use within the active focus area. Check the camera manual under "autofocus point selection" for instructions on how to do this. The ability to direct where you want the lens to focus is a helpful feature to learn and use in macro work.

Choosing and Using a Cable Release

The cable release is a small but important piece of equipment, enabling you to activate the shutter release remotely. Look for a cable release 18 inches or more in length for the greatest flexibility when working in the field. A cable release can be either mechanical or electronic. The current electronic releases are more expensive but are well designed and easy to operate. If you use a mechanical release, you will need an adapter to connect it to the newer cameras.

Whichever cable release you decide to use, don't let it hang from the camera so that all its weight is tugging at the connector. Over time, this will cause a kink in the cable and it will break. Use a clip or an elastic band to carry the weight of the cable, as illustrated in the photo of my tripod later in this chapter.

Mirror lockup

Mirror lockup is a feature that prevents any vibration or camera shake from affecting the sharpness of an image. Sometimes an image taken without using this feature looks fairly sharp to the naked eye but when viewed at high magnification looks soft around the edges. What happens is that the movement of the mirror in the camera causes a slight vibration when you use slower shutter speeds, between 1/30 and 1 second. The mirror lockup feature prevents this from occurring.

Depth-of-field preview

What you see when you look in the camera's viewfinder is the image as if shot at the lens's largest opening. In practice, most images are shot at smaller f-stops and more of the image appears sharp than at maximum aperture. The depth-of-field preview feature allows you to view the image and check for sharpness at the actual f-stop used. Without this feature, it's difficult to judge what will be sharp in the final image.

The preview feature has one drawback. The stopping down (going to a smaller f-stop) of the aperture means less light enters the viewfinder, making it difficult to see all the details of the scene. When you first use the preview function, examining an image for sharpness in the darker-than-normal viewfinder is difficult. Stay with it, though—it will get easier. The result is well worth the time and effort it takes to learn this technique.

Automatic sharpening

Digital cameras have built-in automatic sharpening to offset the inherent softening of digital capture. If you are taking close-ups of flowers to send over the Internet to friends and family, this is fine. If, however, you are going to be shooting raw (that is, in a file format for unprocessed captured data, sometimes written RAW), want as much control of the digital image file as possible, and plan to work on the files in the computer, turn off the camera's digital sharpening feature. Sharpening can be handled effectively when the file is downloaded onto the computer, during the editing process, and during output to a printer.

A mechanical (top) and an electronic (bottom) cable release.

Lenses and Lens Accessories

Every photographer has a favorite lens. Wide-angle lenses are selected for shooting the large vistas of landscape images. For animal and bird photography, the telephoto is the lens of choice. Macro is no different. In fact, more than any other type of photography, macro is dependent on the right lenses and lens accessories. This does not mean that you need a large number of lenses and accessories in order to make close-up

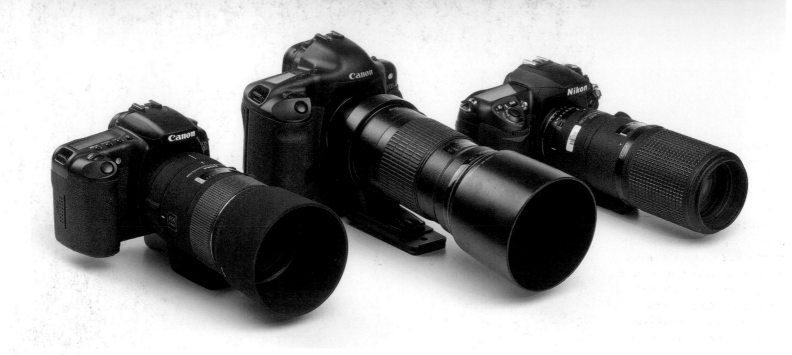

Three long macro lens examples. From left to right, Canon 20D with a Sigma APO Macro 150mm f2.8 lens, Canon 1Ds Mark II with a Canon EF 180mm f3.5 L macro lens, Nikon D200 with a 200mm f4D AF Micro-Nikkor. All of these lenses have tripod collars.

images. Many photographers, including me, handle most of their macro shooting with just one or two pieces of equipment.

You can set your camera up for macro photography with several different types of lens and lens accessory equipment. You can use a diopter to magnify the image before it reaches the lens. You can increase the distance from the lens to the camera by attaching an extension tube, which allows closer focusing. Or you can add an extender to magnify the image after it passes through the lens. While none of these accessories enable you to do a full range of close-up work, any one of them is an avenue into macro photography. But the best solution is to use a dedicated macro lens specifically designed for close-up photography. Each of these approaches has its advantages, problems, and costs.

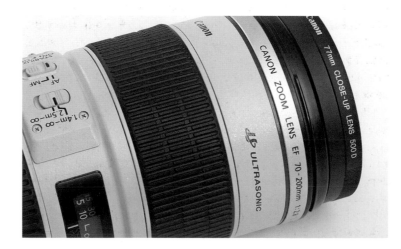

Canon two-element 500D diopter attached to a 70–200mm f2.8 L zoom lens. The lens shade is not attached, in order to make the diopter visible.

I was in the garden looking for a few winter interest scenes when the dried remnants of astilbe blossoms bowed by the snow caught my eye. I was shooting with a zoom but had the Canon 500D diopter in my pocket. Rather than going inside and changing lenses, I attached the diopter to the zoom lens to capture this photograph. I decided that the arch of the stems was of prime importance. Shooting from a backlight position captured the arch of the stems as semi-silhouettes and added the sparkle of the freshly fallen snow to the image. The low camera position allowed me to include a small portion of blue sky to offset all the white in the image.

Canon 1Ds Mark II with Canon 70-200mm f2.8 L zoom lens with 500D diopter, 1/100 second at f11 +1 stop exposure

Diopters

The least expensive piece of close-up equipment is a diopter, a filter that is screwed onto the front of the lens. The diopter acts like a magnifying glass that enlarges the image in the same manner that reading glasses enlarge text in a book. Just like reading glasses, diopters come in different strengths, termed +1, +2, +3, and +4. They are small and lightweight, and fit easily in the camera bag. A diopter doesn't affect exposure or the lens's maximum aperture but has a very narrow focus range and will not focus at infinity. If the diopter you have on your camera doesn't allow you to focus and compose for the desired image size, you have to take it off and screw a different one on the front of the lens, which makes the regular use of diopters in the field unwieldy. Still, if you want to travel light, if you take only an occasional macro image, or if you want a relatively inexpensive way to find out if you like macro work, diopters are a viable option.

If you decide to purchase diopters, keep in mind that they are relatively inexpensive optical elements that are placed in front of an expensive lens. Even if you are just trying to decide if you like macro photography, don't buy the bargain store diopter. Purchase high-quality single-element models from B+W, Heliopan, or Singh-Ray rather than getting the cheapest model available.

For photographers demanding the best results in an image when using a diopter, two-element diopters from manufacturers such as Canon

and Nikon are also available. Canon offers its 250D and 500D diopters optimized for 50–135mm and 70–300mm lenses respectively. Nikon produces its 3T and 4T for the 85–200mm lens and its 5T and 6T for the 70–210mm lens. Check the manufacturer's specifications to make sure that the diopter or diopters you buy will fit your lens.

Extension tubes

Extension tubes, a macro solution more than fifty years ago, are still very useful today. These lens accessories are hollow tubes with no optical elements (glass lenses) that are attached between the lens and the camera body. By moving the lens farther away from the camera, the extension tube decreases the normal minimum focusing distance of the lens. For example, if you can normally focus no closer than 8 feet from the subject, an extension tube can allow you to focus from only 6 feet away.

Extension tubes can be used with any lens, from wide-angle to tele-photo. They are available in different lengths from camera manufac-turers such as Canon and Nikon as well as from independent lens and equipment suppliers. Sets of different-size tubes are also available. Using the different-size tubes on different-size lenses provides a wide range of magnification possibilities. The magnification ratio of any tube-lens combination is calculated by dividing the tube size by the length of the lens. For example, a 50mm extension tube used with a 100mm lens allows focusing up to 1/2 life size.

Extension tubes have a greater focusing range than diopters, are less expensive than a true macro lens, and because they have no optical element in them, don't affect the quality of the image. Their disadvan-

Canon 12mm extension tube used with a 28–80mm zoom lens.

tage is a loss of light reaching the sensor. The greater the length of extension used, the greater the loss of light. Adding 100mm of extension to a 100mm regular telephoto lens allows focusing to life size but results in a loss of light equivalent to two f-stops or using a shutter speed two times slower. For example, if the exposure setting without the extender is a shutter speed of 1/125 second with an aperture of f8, adding 100mm of extension will change the exposure to 1/30 second at f8. The loss of light is also evident in a darker viewfinder, which makes it more difficult to examine your subject for composition and sharpness.

All factors considered, extension tubes are a valuable addition for any photographer whose budget does not permit buying a dedicated macro lens.

Extenders

Extenders, sometimes called teleconverters or multipliers, are tubes with optical elements in them that magnify the subject after the image passes through the lens. Like extension tubes, extenders are attached between the camera and the lens. With an extender, focusing at infinity and the minimum focusing distance of the lens stay the same but the resulting image is magnified. The drawback to extenders is a loss of light of one or two f-stops, depending on which extender is used, as well as a slight loss of image quality.

The two most common extenders are the 1.4+ and the 2+. The 1.4+ extender magnifies the image 1.4 times, with a loss of light of one f-stop. Using a 1.4+ extender on a 200mm f4 lens is the equivalent of using a 280mm f5.6 lens. A 2+ extender gives greater magnification but results in a loss of light equivalent to two f-stops. Using a 2+ extender on the

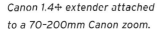
Canon 1.4+ extender attached to a 70-200mm Canon zoom.

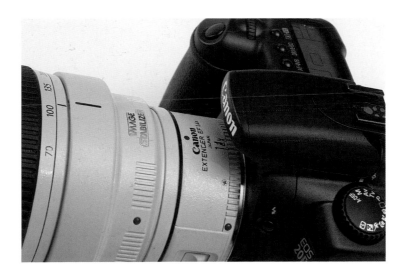

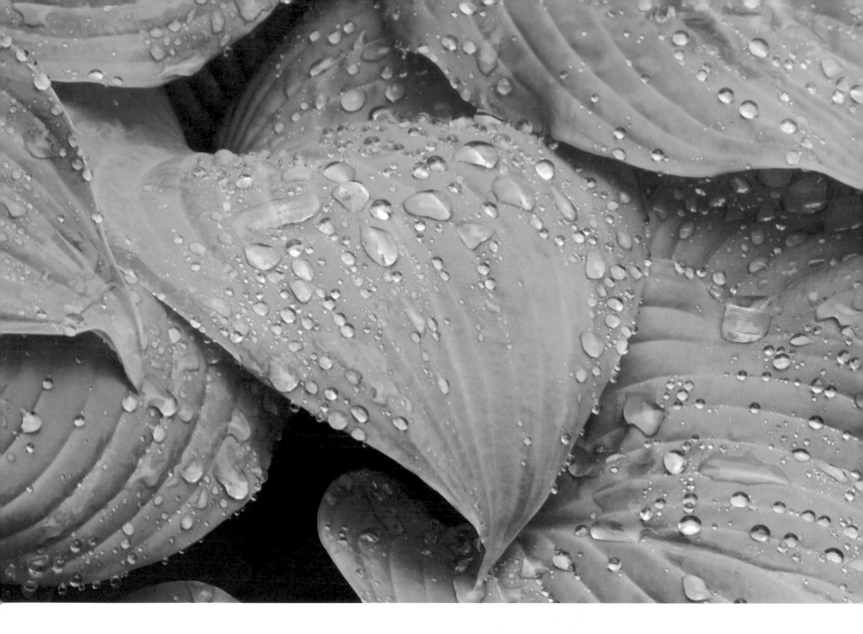

same 200mm f4 lens is equal to using a 400mm f8 lens. In low-light situations, using the 2+ extender means slower shutter speeds and greater difficulty focusing due to a dark viewfinder.

Many photographers use extenders in combination with a telephoto lens to photograph small insects. For example, using a 1.4+ extender on a 300mm telephoto lens is a popular choice for photographing butterflies. This combination allows the photographer to stay a good distance from the subject and still capture a close-up image.

If you decide to add an extender to your camera bag, purchase the best quality you can. Extenders have optical elements in them and you don't want to degrade the image more than necessary with a lesser-quality piece of equipment.

Dedicated macro lenses

The best and most versatile of all the macro equipment possibilities is the dedicated macro lens. While I have most of the lens accessories for macro work, I always reach for my main 180mm macro lens when I set up for macro images.

Dedicated macro lenses are designed to allow focusing in many cases from infinity to life size. They can focus up close without distorting the image as well as handle any shooting at infinity. This is the lens to consider if you're serious about good-quality macro photography. The only drawback is that these lenses, with all of the added versatility and quality, have a higher price tag attached.

Macro lenses come in a variety of different sizes. The most common are in the 50-60mm, 90-100mm, and 180-200mm size ranges. There are two practical differences, other than price, to consider when deciding whether to use a 50mm, 100mm, or 200mm macro lens. First is the different working distances (the distance between the front of the lens and the subject) and second is the different perspective or field of view of each size.

The 50mm macro lens is small, light, and reasonably priced. It has a working distance at 1/2 life size of 3.75 inches. This means that when you look through the viewfinder, you're looking at an area covering 2 by 3 inches and the front of the lens is less than 4 inches away from the subject. At life size the front of the lens is 2.75 inches from the subject when looking at an area of 1 by 1-1/2 inches. Being so close to any subject

Dedicated macro lenses. Left to right, Sigma 105mm f2.8 EX DG macro lens, Canon 100mm f2.8 macro lens, Nikon 105mm f2.8 ED-IF AFS VR Micro-Nikkor lens, Sigma APO Macro 150mm f2.8 ES DG lens, Canon EF 180mm f3.5 L macro lens, Nikon 200mm f4D ED-IF AF Micro-Nikkor lens.

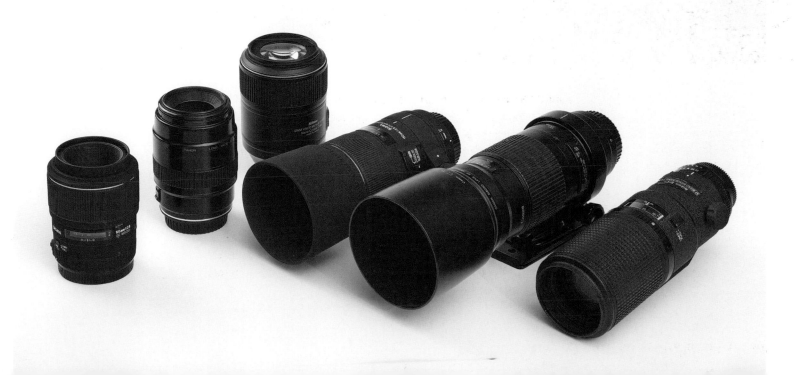

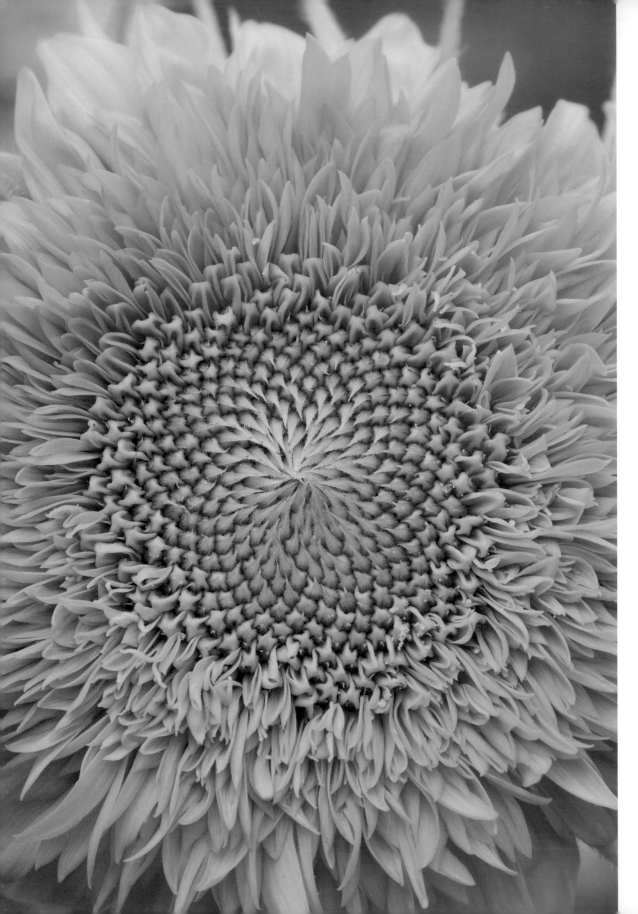

Although this is simply a straight-on head photo of a sunflower, it is still an effective image. The geometric pattern of the center disk is emphasized by going in close and not showing the full flower. Because the camera is straight on to the blossom, a medium aperture will give all the depth of field needed while softening the background.

Canon 1Ds Mark II with 100mm f2.8 macro lens, 1/8 second at f11

greatly hampers your ability to reflect or add light. It also means that you might be casting a shadow into the frame. When the subjects are insects, the nearness of the camera and the photographer keeps most insects on the move trying to hide. The 50mm lens has a wide perspective. It includes more background than the longer lenses, allowing distracting objects in the distance to be in the picture. While its size, weight, and attractive price seem to make this a good choice, the lack of working distance and the wide perspective outweigh the advantages. The 50mm macro is not the best choice for photographing in the field.

For general macro fieldwork, the 100mm and 200mm dedicated macro lenses are the best choices to consider. The 100mm macro lens is relatively small, light, and easy to handle. In addition to having macro capability, it can be used as a short telephoto lens for normal photography. It has a greater working distance when in close and a narrower field of view than the 50mm lens. If you hand hold the camera in order to capture images of constantly moving subjects like insects, the 100mm lens is a good choice. If you are serious about macro photography, the 100mm macro lens is a good addition to the camera bag. Canon, Nikon, Sigma, and Tokina offer lenses in this size range.

The long dedicated macro lenses in the 180-200mm size range are the largest and most expensive of the macro lenses. If I had to choose only one piece of macro equipment, it would be a long telephoto macro lens like the 180mm Canon macro. In fact, this lens accounts for the majority of my close-up work.

These lenses have a number of important advantages. Compared to the 100mm or the 50mm, they have the greatest amount of working distance. A 200mm macro lens is about 18 inches from the subject when you're photographing life size, compared to the less-than-3-inch working distance for the 50mm lens. This allows plenty of room between the front of the lens and the subject to modify the light as well as giving insects a greater sense of security. The narrow field of view or perspective of the long macro lenses lets you eliminate unwanted background elements with minor changes in the position of the camera.

Most of the better lenses in this size come with a tripod collar, a ring around the lens that allows you to rotate the camera and lens without moving the tripod. This valuable feature adds balance to the camera and lens, but more important, the tripod collar lets the camera rotate from a horizontal shot to a vertical shot while maintaining the same composition.

No matter which size lens you use, make sure it has a switch to turn the autofocus on and off. Many times the autofocus has trouble locking onto the intended subject. The photographer envisions a tiny portion of a spider web, but the camera picks up something in the background on which to focus. Check your camera's LCD to make sure that the focus has

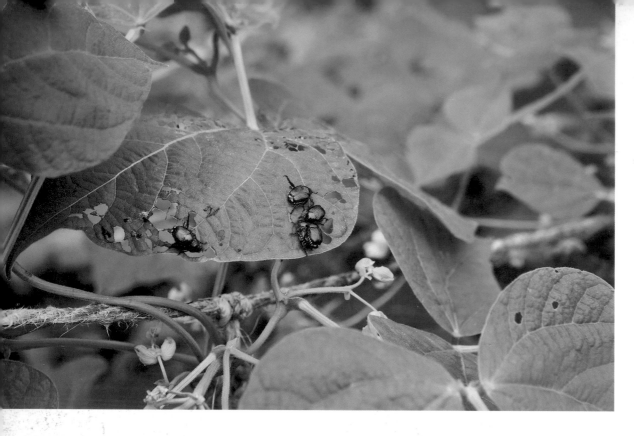

Image Stabilizers and Anti-Shake Systems

This image was made possible by the macro capability of my zoom lens. I was traveling by bus and had narrowed my equipment to one camera with a 24-70mm f2.8 zoom lens, a tripod, a cable release, a polarizing filter, and two compact flash cards. I had been shooting mostly wide-angle images when I spotted these Japanese beetles on a bean vine. While not an attractive "wow!" image, it does tell a story. I used the polarizing filter to cut the glare of the shiny bronze wing covers of the beetles. A slight breeze meant a middle f-stop and higher shutter speed. The macro capability of the zoom wasn't great, but it was enough to get the image.

Canon 1Ds Mark II with 24-70mm f2.8 L zoom lens, 1/60 second at f8, polarizing filter, -1/3 stop exposure

remained on the desired subject and not the plant in the background. If focusing problems are evident, turn off autofocus after the focus is set to assure the focus will not change when you take the picture.

Many of today's zoom lenses also include some macro capability. Sometimes when you're shooting a variety of scenes, a macro opportunity comes along. Rather than going to the camera bag and adding a diopter, an extension tube, or an extender, or changing lenses, you might be able to capture the image with the macro setting of the zoom lens. Keep in mind that the macro capability of these lenses is limited. The typical macro capability with a zoom lens such as a 24-70mm zoom is about 1/4 life size. In effect, it can focus from infinity down to an area measuring 4 by 6 inches. Also, because the macro feature on a zoom is not one of its primary functions, the image quality might not be the best. Even with these qualifications, the macro capability on a zoom lens can enable you to get a shot you might otherwise miss.

Lens shades

No discussion of lenses is complete without mentioning lens shades. More than any other piece of equipment, the lens shade is the one tool every photographer has but often forgets to use. Some photographers believe they need the lens shade only when shooting into the light, while others think that the quality lenses offered today with their modern anti-reflective coatings take care of any glare concerns. There are times, however,

To help combat camera/lens movement, manufacturers offer lenses and cameras with image stabilization, vibration reduction, or built in anti-shake features. Each manufacturer has a different term for it and may approach the problem differently but all the systems work to reduce or eliminate the effects of camera movement. In practical terms, these technological features allow the photographer to shoot at shutter speeds one to two or even three times slower. On the other hand, image stabilizer features cost extra and use more battery power. They also do not replace a good tripod.

LEFT *After I captured a number of big images of the Camassia from different angles, I tried to capture a close-up without changing lenses or adding accessories. I focused the lens at its closest focusing distance and looked for a few blossoms that stood out from the rest. This group of blossoms was just slightly higher than its surrounding neighbors.*

Canon 1Ds Mark II with 70–200mm f2.8 L zoom lens at the 200mm setting and its closest focusing distance, 1/30 second at f8

This is my main macro setup—a 180mm Canon f3.5 L macro lens with tripod collar, a Kirk BH1 tripod head, and a Gitzo 1348 carbon tripod. Note the rubber band around the tripod head to keep the weight of the cable release off the point of connection.

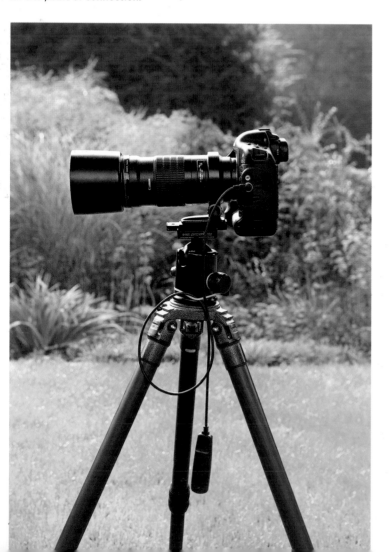

when unnoticed glare from the sun or another source hits the front of the lens. To be safe, get in the practice of always using the lens shade. The reward will be better images.

When you are shooting a backlit scene, even with a lens shade, check the front of the lens to make sure no sunlight is hitting the glass element. Even if your lens is a model with a built-in shade, it's important to avoid having light hit the front of the lens.

Tripods

Besides camera and lens, perhaps the most vital but most often over-looked piece of additional equipment any garden or nature photographer needs is a tripod. Professional horticultural and landscape photographers, even those who do little macro work, agree that using a tripod dramatically improves their images.

Of the many reasons to use a tripod, the most important is to steady the camera. This is mandatory in macro photography. Any camera movement, no matter how slight, at slow shutter speeds increases the chance the image will be blurred. No matter how good you are at hand holding the camera, your hand won't be steady enough for most macro work.

A tripod also slows down the process and enables the photographer to consider the composition of the entire scene. This alone will help prevent taking "snapshots." Because the camera does not move, the image in the viewfinder remains the same within the frame top to bottom and right border to left border. When a camera is handheld, the scene

and its composition change each and every time the camera is raised and lowered. For the advanced photographer who takes multiple exposures to later combine in the computer, a tripod is necessary to assure the perfect registration of the different exposures. In addition, repeat captures using a tripod are exactly the same no matter how many exposures are made, while repeat exposures when hand holding a camera are never the same.

Although current air travel weight restrictions and the desire to carry less bulky equipment might tempt you to buy the shortest and lightest tripod you can find, this is one area where less is not more. Look at the tripods professionals use: the largest tripods they can handle. Resist the temptation to go as short and lightweight as possible. A larger tripod will steady a camera and lens far better than a small, light one.

There are two parts to a tripod setup: the tripod (legs) and the

This Gerbera *'Giant Spinner'* *blossom screams color. The plant was in a greenhouse, and including the entire flower would also have included some distracting pipes and support structure. By going in very tight, I eliminated the surrounding environment. The soft sidelighting brought out the blossom's texture.*

Canon 1Ds with 180mm f3.5 L macro lens, 1/20 second at f16 +1/3 stop exposure

Traveling with Photography Equipment

Airline restrictions on both size and weight have changed which equipment I take and which I leave at home. For the greatest macro capability, I travel with the following equipment: a Canon 550D diopter, the 70–200mm zoom lens I use it with, a 12mm extension tube, a 1.4+ extender that I use with a 300mm telephoto lens, and a Canon 180mm macro lens. Without fail, I reach first for the 180mm lens when doing macro photography. I include the diopter, extension tube, and extender when traveling because they give me some extra possibilities without having to change lenses. They're small and light and so don't add much weight or take up much space. My travel bag also has a 24–70mm zoom lens with some macro capability. My tripod, a Gitzo 1348 with a Kirk ballhead, is wrapped in bubble wrap, put into a tripod bag, and checked through with the other luggage. Travel restrictions are always changing. Check with the airlines to make sure your camera bag and its contents comply with their latest size and weight requirements.

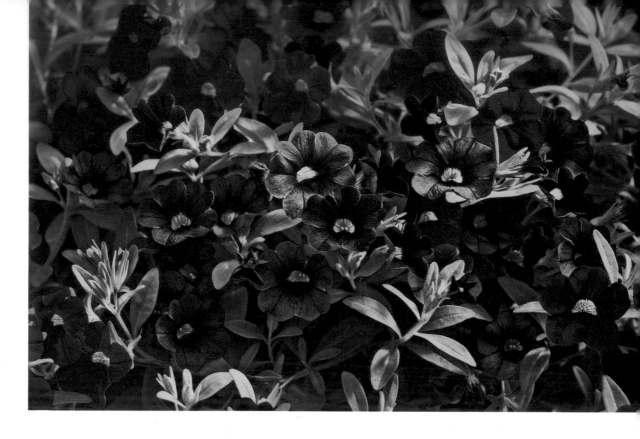

tripod head. Whether you buy them separately or as a package, there are different options to consider. Check to see how low the tripod can get. Many flowers grow close to the ground, so if that's your joy, look for a tripod with legs that will spread out so the camera is as low as possible. Stay away from the tripods with a long center column and resist the salesperson's advice to use the center column for ground-level images. It's next to impossible to attach a camera to the center column upside down and comfortably take a picture. Using a tripod with a center column to add height to a short tripod is not the way to save weight. As the center column is raised, the tripod turns into a three-legged monopod. Speaking of legs, a tripod with legs that work independently is a better choice than one where all three connected legs move together. As far as size is concerned, the best approach is to get a tripod as tall as or taller than you that still goes as low to the ground as needed without relying on a center column.

Tripods are made from a variety of materials. Carbon tripods, while more expensive, lighten the load without any sacrifice in steadiness. Aluminum models are priced more reasonably but are heavier to carry. Tripod manufacturers Gitzo and Manfrotto offer a wide selection in different materials. Ask other photographers their opinions. Try using different models in the store to make sure they operate easily before making a decision. If one tripod does not feel right, try another one.

The tripod head holds the camera and lens on the tripod. It should

This is a tight image of Calibrachoa 'Cabaret Red' and 'Cabaret Purple' growing in a container. The strong colors of these plants can almost be overwhelming. The soft lighting from the side created subtle bright spots and shadow areas that toned down the color without diminishing its vitality. The light and a medium f-stop added a feeling of depth to the image.

Canon 1Ds Mark II with 180mm f3.5 L macro lens, 1/15 second at f8 –1/3 stop exposure

tilt up and down, move left and right, change camera angle, and even rotate. Two tripod head designs meet these criteria. The first, called a pan-and-tilt, uses separate handles to lock and unlock each direction or axis. This is cumbersome to use in the garden for macro work.

The second type of tripod head is called a ballhead. This has been my choice for the last thirty years. A ballhead has a ball set in a holder with controls that lock or unlock the ball and allow it to move freely in all directions (up and down, left and right, and tilt right or left) simultaneously. Making any camera position changes while having movement in all directions at the same time seems challenging, especially when you're trying to make minor adjustments in only one direction. It takes a little time to get used to working with a ballhead, but the result is increased speed and ease of use in the field.

Ballheads come in a wide range of sizes. The larger heads, while more expensive, hold the camera and lens more securely. Top-quality ballheads are available from Kirk Photo, Really Right Stuff, and Arca-Swiss.

My Gitzo 1348 / Kirk BH1 tripod with legs fully open to show how low the camera can be positioned. A tripod with a center post of any length would position the camera much higher.

Ornamental kale has become very popular for adding fall color to a garden. This one, Brassica oleracea 'Nagoya Red', is especially attractive. I wanted the image to show the texture as well as highlight the contrast of the soft pink and green colors of the leaves. I framed the pink color of the center leaves surrounded by green. The light coming from the right brought out the texture of the leaf edge as well as adding depth and sparkle to the image.

Canon 1Ds with 180mm f3.5 L macro lens, 1/5 second at f22

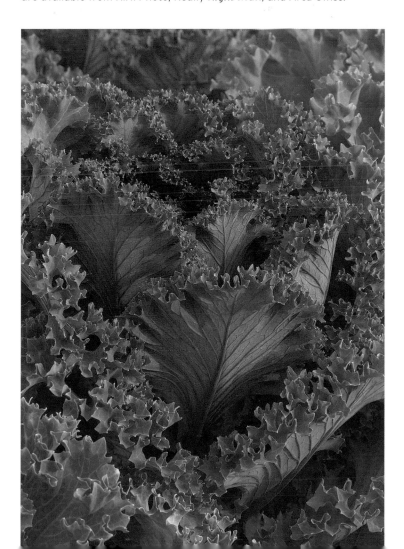

Light Modifiers

One of the great advantages of macro photography is the ability to add, subtract, or diffuse the light on a subject. If the subject is very dark, you can add light by using a reflector. If the reflector doesn't add enough light, you can use flash to add more (a technique known as fill flash). When the light is too bright, it can be diffused. If the image is still too bright, light can be blocked from all or part of the subject. You can modify the light reaching selected parts of an image or the entire image. It's even possible to add, diffuse, and subtract light all in one shot with a combination of different equipment.

Good photography depends upon good lighting, and the ability to adjust the lighting in macro photography is a major bonus. For photographers just starting close-up work, it's important to learn how to use reflectors and diffusers in a variety of lighting conditions as a foundation for more advanced techniques such as using flash.

Reflectors

Reflectors are flat panels with surfaces that reflect light. They come in all sizes and shapes, from small round shapes to large rectangles. They range from simple homemade aluminum foil squares to very large commercially produced items that collapse into small, easy-to-carry sizes with their own cases. While homemade foil reflectors work at times, the commercial product with its low cost, quality design, and ease of use makes it a better choice for any photographer.

For macro fieldwork, round or rectangular reflectors in the 20-to-

RIGHT This image of Narcissus 'Romance' is a good example of using a reflector to add directional lighting. This group of daffodils was completely in the shade and the lighting was flat and uninteresting. I positioned a reflector behind and to the left of the blossoms to cast light onto their back edges and provide the extra punch the photograph needed. The composition of this image is also worth noting. The single blossom in focus is almost dead center. The group of blossoms bunched to the left and facing diagonally to the right keeps the image from being static.

Canon 1Ds Mark II with 180mm f3.5 L macro lens, 1/30 second at f11 +1/3 stop exposure

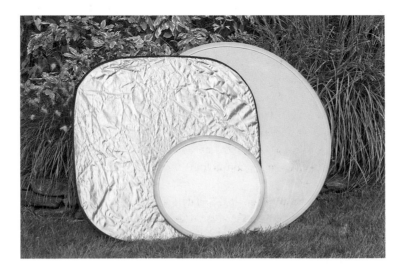

Three different reflectors. The square soft-gold reflector is made by Westcott. The two round soft-white reflectors are from Photek. The small round one has yellowed with age.

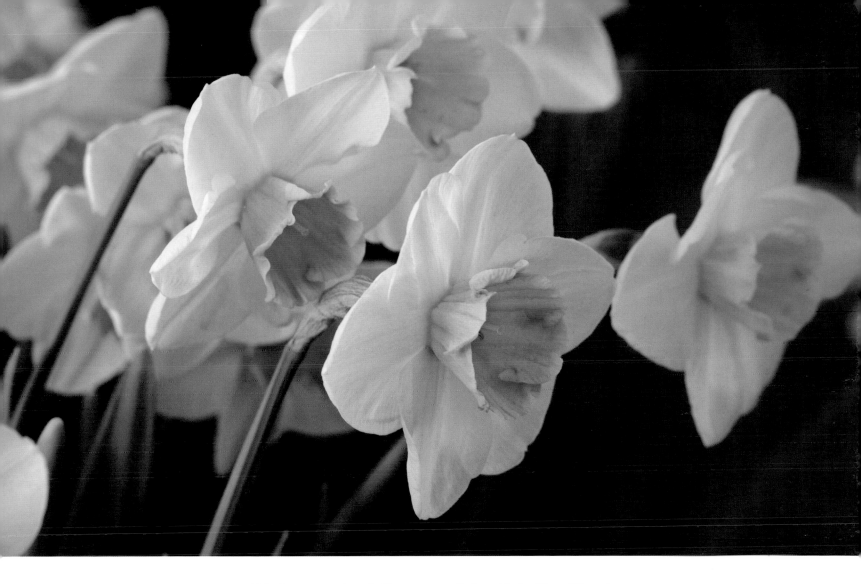

40-inch range work well. They are usually two-sided, with a different reflection color or pattern on each side. Be careful of using a reflector with a shiny gold side. Initially you might believe that because this side reflects the greatest and most intense light, it's the best choice. This brightness and intensity, however, often results in an image with an arti-ficial colorcast. Also, because this reflector is like a mirror, it will reflect very bright points of light into the picture that may be evident to the viewer. The same concerns are true of the silver side of reflectors. The best choice for adding light in the garden is a reflector with a soft white material on one side and a soft gold or other warm-colored material on the opposite side.

Using a reflector to add light to a dark area is very easy. Position the reflector to bounce light into the area where additional light is needed. By moving the reflector nearer to or farther from the subject and changing the angle of the reflector, you can adjust both the amount of light and

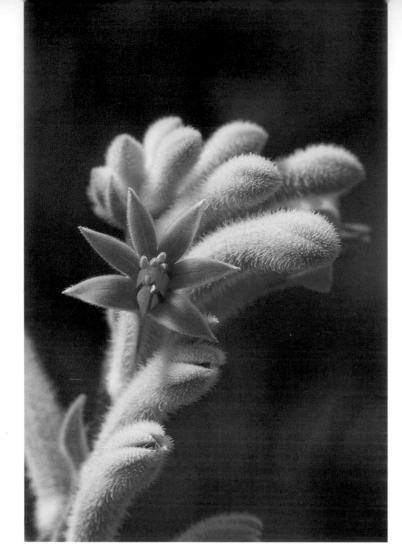
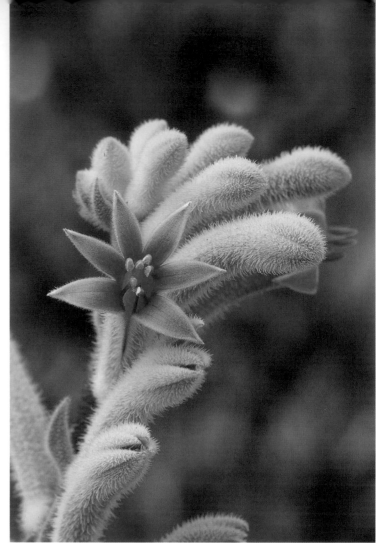

Getting a good image of this kangaroo paw was a challenge. The very strong yellow and green blossom structure was positioned in front of a bright and busy background. My first inclination was to block the light from the background to tone it down. I decided to use a medium f-stop to insure some separation between the flower and the background.

Canon 1Ds with 180mm f3.5 L macro lens, 1/30 second at f11

the direction of light added to the shadows. If the shadow area under a blossom requires some light, place the reflector on the ground and reflect light up. Look at the subject while changing the reflector's position to see the actual changes to the lighting on the subject. Be careful not to reflect too much light, as it is possible to make the scene appear unnatural. The aim is to add just enough light to improve the image without any manipulation being obvious to the viewer.

If you don't have a reflector handy, use any white or light surface, such as a newspaper or the palm of your hand. Make sure, however, that the color of whatever you use is not reflected onto the subject.

Reflectors are also used to completely block light from a subject. Even bright light evident in the background or in other areas can be blocked. Blocking sunlight does not make the image go black. There's still plenty of light to keep the shadows open.

I didn't know if blocking the background light was the only way to capture a good image. To make sure I came home with at least one good image, I varied my approach by using a diffuser to soften the light over the entire image. I changed my aperture to a smaller f-stop for greater depth of field. The first approach of blocking light is better. The bright background of the diffused image is very distracting.

Canon 1Ds with 180mm f3.5 L macro lens, 1/15 second at f16

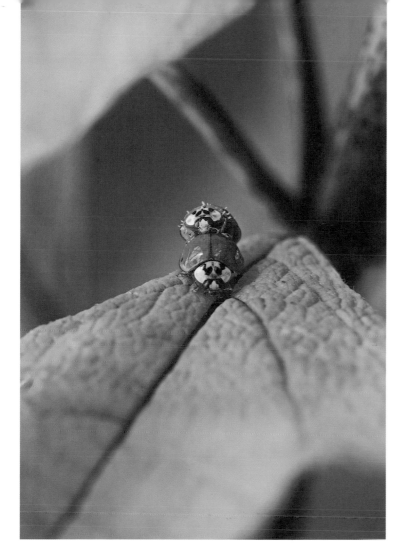
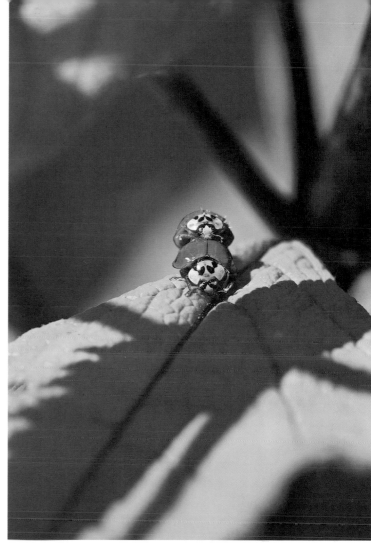

Diffusers

Diffusers are flat panels made of semi-opaque or semi-transparent material. Like reflectors, these tools are easily and effectively used in the field for light modification. Changing the position and angle of the diffuser changes the intensity and quality of the light on the subject. Harsh sunlight, the enemy of flower photography, is scattered or diffused by positioning the diffuser between the bright light (sun) and the subject. The result is a nice soft light more favorable to many flowers and plants. Diffusers are also used to soften any bright spots of light that appear anywhere in the picture.

Diffusers come in the same sizes and shapes as reflectors. Some manufacturers offer combination sets that include one frame with different reflector and diffuser fabrics that can be slipped on and off the frame. Reflectors and diffusers are available from many manufacturers, including Westcott, Photoflex, and Lastolite.

This pair of ladybugs was almost hidden among the leaves. It was midmorning and the light was made up of strong shadows and bright streaks of sun. I moved the camera and tripod into position and focused on the closest ladybug. I selected a medium f-stop to keep all the leaves and branches soft and out of focus, and I used a diffuser to even the shadows and highlights. I took the second photograph without using the diffuser to demonstrate how much less attractive the image would be if the dark shadows and bright sunlight remained unaltered.

Canon 1Ds Mark II with 180mm f3.5 L macro lens, diffused-light image 1/20 second at f11, sunlit image 1/60 second at f11

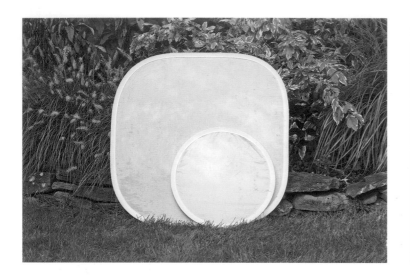

Diffusers from Westcott and Photek.

The small 22-inch Photek diffuser positioned between the sun and the subject. I normally prefer a larger diffuser but used the small one for demonstration purposes.

Flash

With my digital camera, I use less flash for supplemental light than I did with my film camera. To be honest, it's easier to control, correct, and adjust light with computer software. Still, small portable flash units are effective supplemental lighting tools.

For most garden photography, using flash to completely light the subject is not recommended, especially when photographing flowers. Its hard, harsh light robs flowers of color vitality and texture. Completely lighting a subject with flash sometimes results in unnatural-looking black backgrounds. If there are no other alternatives and you must use flash to light a subject, bounce the flash off a reflector or shoot the flash through a diffuser to soften the effect.

For more natural-looking plant images, flash is better suited to add light to the shadows. Depending upon the camera or flash, there are different ways to do this. The camera can be set to control the flash or the flash can operate independently. Whichever approach you attempt, the goal is to add just enough light to the dark area to bring out some detail without overexposing the bright area. This is easy to do by setting either the camera or the flash to underexpose the flash by two f-stops. Use these settings as a starting point and try a few test shots to determine the best settings. Refer to your camera and flash manual for instructions.

Flash can be used to stop motion when shooting insects. In this case, the flash is the main source of light. Don't be surprised if the image background goes black when there's any distance between the subject and the background. The intensity of flash lighting falls off quickly in these applications.

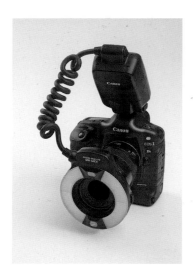

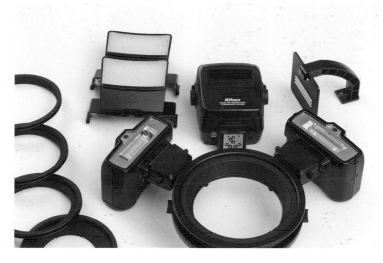

The Nikon R1C1 Wireless Close-up Speedlight Kit is a two-flash-unit system designed for macro work.

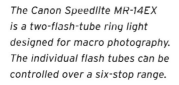

The Canon Speedlite MR-14EX is a two-flash-tube ring light designed for macro photography. The individual flash tubes can be controlled over a six-stop range.

Flash for Insect Photography

Using small portable shoe-mount flash units as the main source of light to photograph insects is a useful technique but it takes some testing and experience. First, be aware that the camera's digital sensor reads the flash's sudden burst of light differently from how a film camera would read it. Digital is more sensitive to flash and therefore the digital flash doesn't need to be as strong or powerful in order to accomplish the same effect as it would when using film. Look for an inexpensive low-power flash to fill your macro needs. If your budget is unlimited, consider flash units specifically designed for close-up photography. After you have the flash, experiment and practice with your camera and bracket exposures and flash settings to find the best combinations.

When using a flash, be careful not to place it too close to the subject. Normal flash units used for shooting family pictures are very strong and can overpower the subject with more light than needed in a macro image. Also, except in the case of insect photography, don't use the flash directly attached to the camera hot shoe but instead position it off axis so that the light adds interest to the image. Try different angles and heights. Even try using the flash to backlight the subject. Once again, try some test shots with the flash before using it in the field.

A number of companies offer flash units with single flash, multiple flash, and ring flashes designed for close-up photography. The multiple flash units allow you to position the individual units as well as to control the different power output settings.sidebar

Filters

In addition to reflectors, diffusers, and flash units, filters that screw onto the front of the lens are another way to change or modify the light. The one "must have" filter is the polarizer. This filter is comprised of two separate pieces of special glass together in one filter holder. The front piece of glass can be rotated while the other piece stays stationary in the filter mount. Rotating the front glass reduces or eliminates glare and reflections. A polarizer is especially effective when you are working with reflections in water, plants that have waxy surfaces, or other images with distracting glare. Be careful when using a polarizer if the sky is included in the image frame. The sky can turn from blue to dark purple if the filter is rotated to its maximum effectiveness. This is a sure signal to the viewer that a polarizing filter was used.

For the polarizer to work best, the direction of the light should be

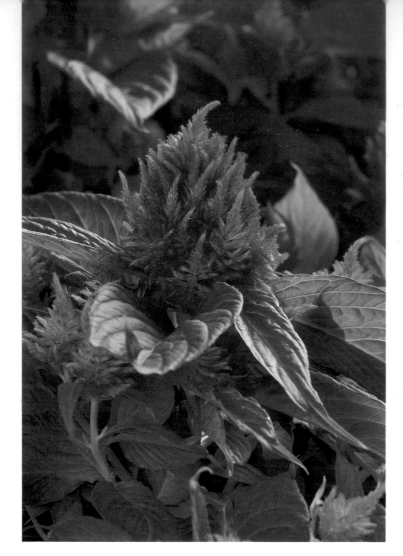

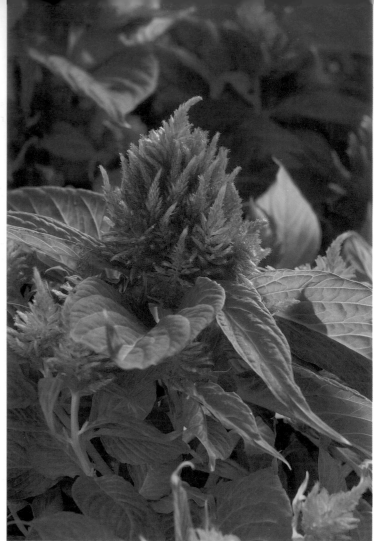

perpendicular to the camera. A simple way to remember this is to stretch out your arms from your body and look to the right or the left. If the sun or source of light is off either the left or right arm, the filter will work. It also works to reduce glare and reflection in backlit situations. But if the light comes from behind the camera's position and head on to the subject, the polarizer loses its effectiveness.

There are two main types of polarizer filters, linear and circular. The linear polarizers are used for the older film cameras. If you don't own one, look for quality circular polarizers for your digital needs from manufacturers such as B+W and Heliopan. Make sure to get the right size to fit your lens.

Computer software

It may seem strange, but computer software is now an important piece of photography equipment. Teamed with digital photography, the computer

These two images of Celosia *demonstrate the effect of a polarizing filter. The glare on the leaves in the first image is distracting and unattractive. The second image was taken with a polarizing filter attached. Even though the glare is eliminated in this example, there's still some light mottling on the leaves.*

Canon 1Ds with 180mm f3.5 L macro lens, without polarizing filter 1/40 second at f11, with polarizing filter 1/8 second at f11

provides additional light modification capability. Color balance, exposure, and contrast are just a few of the factors that can be adjusted with software programs today. Photoshop, Photoshop Elements, Lightroom, Aperture, and many other image-editing and digital workflow programs have more adjustments available than can be learned in a lifetime. When you set up to photograph an image, you can consider the added capability and solutions offered by computer software along with the light modification tools used in the field. The possibilities and combinations of possibilities are endless. But the new computer capability doesn't mean adjustments in the field are any less important. You can get the best of both worlds if you pay attention to light modification before capture and then use computer software to make precise adjustments afterward.

Equipment is very personal to each photographer. Take time to decide what subjects interest you the most, look over your current equipment, and if you are missing tools, make informed decisions carefully before you buy. A camera, a macro lens, a tripod and tripod head, a cable release, reflectors, diffusers, and a computer are all you need to capture a world of exciting macro images.

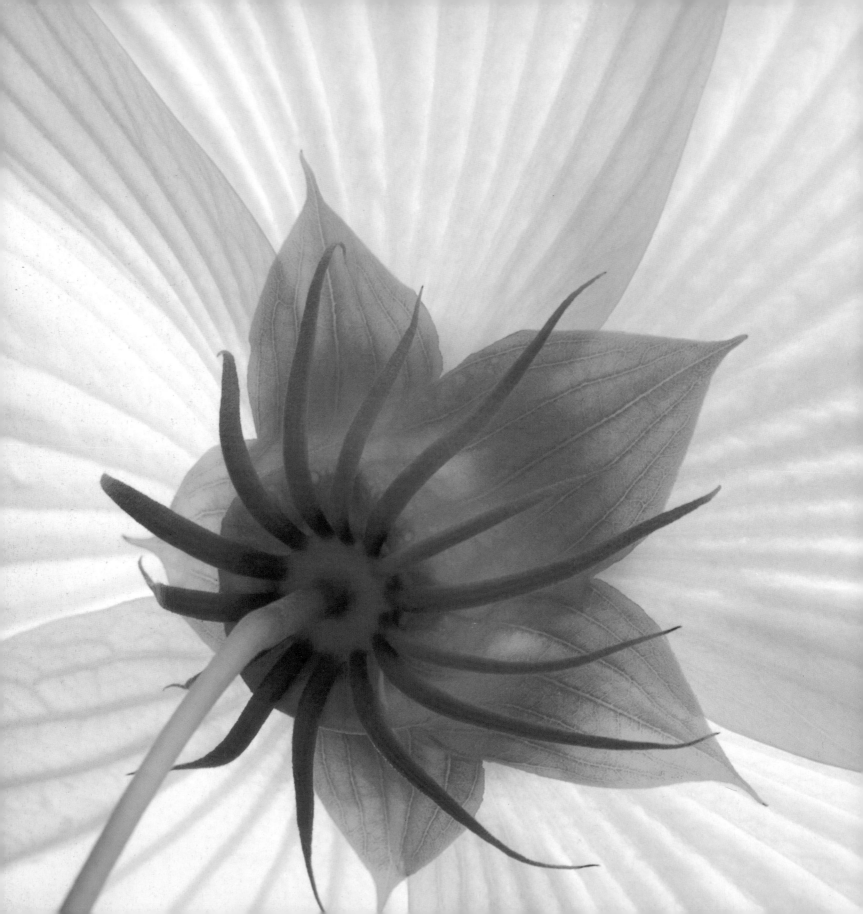

Jockeying for Position

Sometimes the best shot of the day presents itself just as you are getting ready to pack up the equipment. I had been in the garden photographing for an hour or so. As the sun climbed, I kept moving locations and did most of my morning's work photographing at the edge of or in the shade. In walking back to the house, I happened to glance around the garden, and the white hibiscus caught my eye. It was in full sun and my angle of view presented me with sparkling backlit blossoms. With the low morning sunlight hitting the front of the bush, the back of the semi-translucent blossoms seemed to glow. If I could set up an edge-to-edge image of a single blossom, the image might work.

My first attempts were verticals. I thought an image with the white flower dramatically flowing upward would be the one. The first ones were OK but none of the verticals captured the excitement I felt when the scene first caught my eye. The switch to a horizontal format was my next choice. I decided to include more of the blossom, as much as possible without including any background. The only blossom I could get in close to was one facing from my left to my right. The very structure of the blossom made getting the composition of the lower-left corner for the base of the flower and everything else difficult. I made tiny adjustments to the camera position to get the base in the same plane as the petals. I wanted the base with its edges against the petals to be sharp. The petals, with their rounded edges and texture, would appear naturally soft. I thought this would give me an image with tremendous feeling.

The rotating collar on the lens made it possible to rotate the camera slightly so that the line of a petal edge at the bottom of the frame was nearly horizontal. To make sure I got one capture with the white of the petals bright but still showing the ribs' and petals' separation plus the texture, I made exposures of normal, +1/3, +2/3, and all the way up to +2 stops. I didn't do any light modification at the time of capture because this changed the magic of the light coming through the blossom. I did lighten the green base area slightly on the computer to get the image to represent what I saw that morning.

A white hibiscus from behind in morning sunlight.

Canon 1Ds with 180mm f3.5 L macro lens, 1/10 second at f22 +1 stop exposure

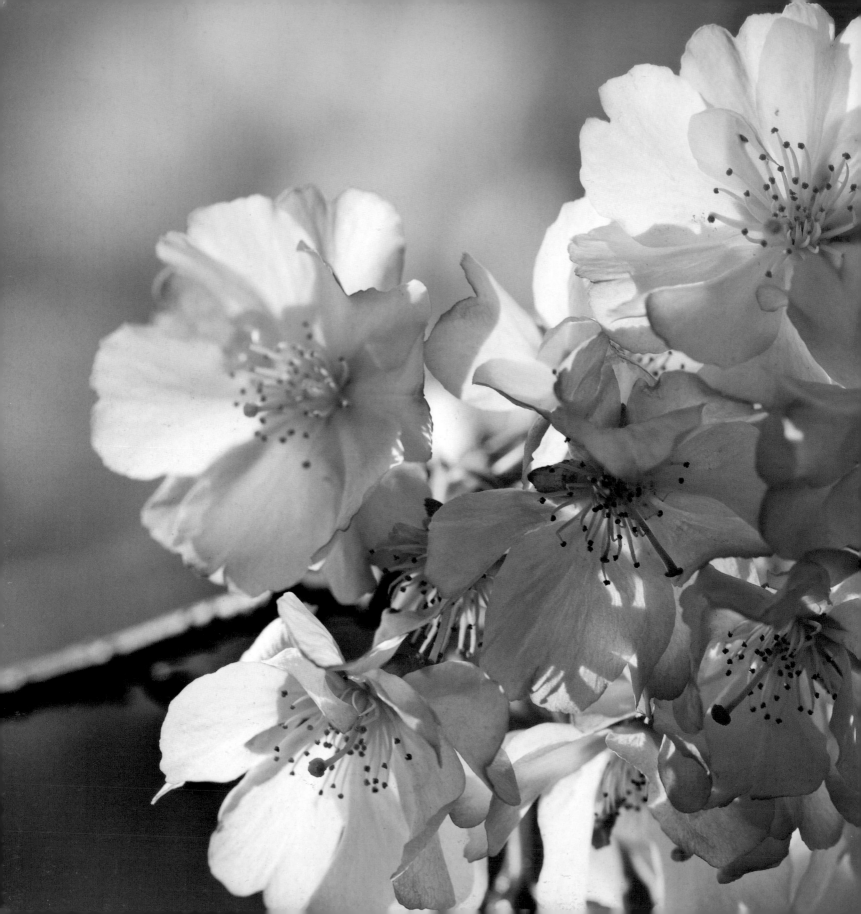

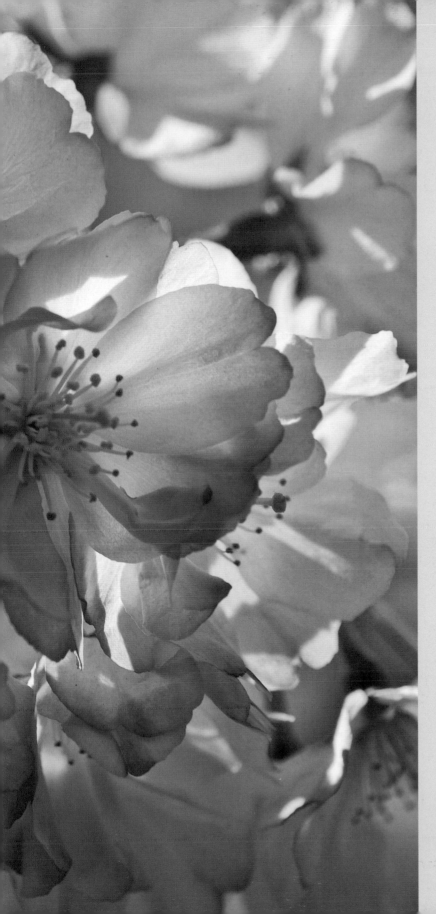

3
Looking at Images

PHOTOGRAPHY IS A NEVER-ENDING JOURNEY. New tools, technologies, and techniques constantly provide exciting possibilities and challenges. A good practice is to look back over your images and notice how they have changed from year to year. Even though the subject matter, the technique, and your technical ability may evolve over time, certain aspects of your images always remain constant. This is your eye, your photographic style.

The opportunity to capture sunlight coming through these translucent cherry blossoms couldn't be passed up. A shallow depth of field kept the background from becoming too busy and still showed a repeat of the circular forms of the blossoms. I overexposed to keep the light pastel feeling and prevent any silhouette of the blossoms.

Canon 1Ds Mark II with 180mm f3.5 L macro lens, 1/200 second at f8 +1 stop exposure

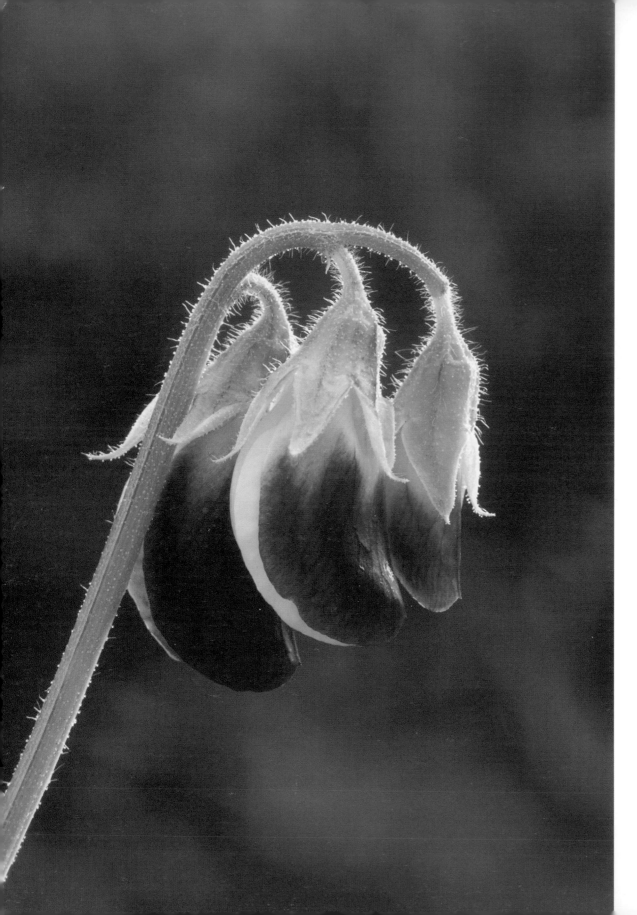

I have a soft spot for sweet pea buds. Their grace and beauty make them almost as attractive as the blossom. The backlighting on this caught my attention. The background with the same color palette as the bud was an added bonus. I positioned the stem on an angle and overexposed slightly to keep the image from becoming a silhouette. I wanted to make sure that the rim lighting on the stem highlighted every stem hair, so I used a small aperture.

Canon 1Ds with 180mm f3.5 L macro lens, 1/3 second at f22 +1/3 stop exposure

The images made by renowned photographers Ansel Adams, Brett Weston, and Eliot Porter, for example, all have a distinctive feel to them. Regardless of the subject matter, the style of each photograph is a result of how the maker blends exposure, depth of field, focus, composition, and lighting to produce an image that represents his or her vision. The degree of control the photographer has over each of these components differs. Some, like exposure and depth of field, depend upon conditions in the field, which may limit the options available to the photographer. Composition and focus, more subjective, are totally within the photographer's control.

While these are individual elements, they need to be thought of as parts of a whole, with each component interacting directly or indirectly with the others. Making a change in one can and will affect the others. For example, as the light changes, the exposure settings may have to change. As the exposure changes, the depth of field changes. As the depth of field changes, the focus point may have to change. In all cases it's important to be aware of how these elements combine to affect the final image.

These components are more sensitive to one another in macro than in regular photography. Subtle changes in one can result in major changes in another. While you may understand the basic makeup of an image, it's worthwhile to revisit each component to see where and why macro is technically more demanding.

Exposure

Exposure, the total amount of light reaching the digital sensor, is determined by the combination of the size of the opening in the lens (f-stop) and how long it stays open (shutter speed). It seems very simple. Yet every photographer shoots images that are either darker or lighter than what was intended. It may be an image of a beach scene where the sand comes out more gray than white or it may be a night scene that's more daylight than dark. Somehow the exposure was incorrect for these images. The answer to why certain images are consistently either too light or too dark lies in understanding how the camera looks at and measures (meters) the light in a scene.

When the camera's metering system measures the amount of light in a scene, it's measuring only the brightness (luminance). It does not know what colors are in the scene, how much contrast is in the picture, or what the photographer intends. It calculates the amount of light from the

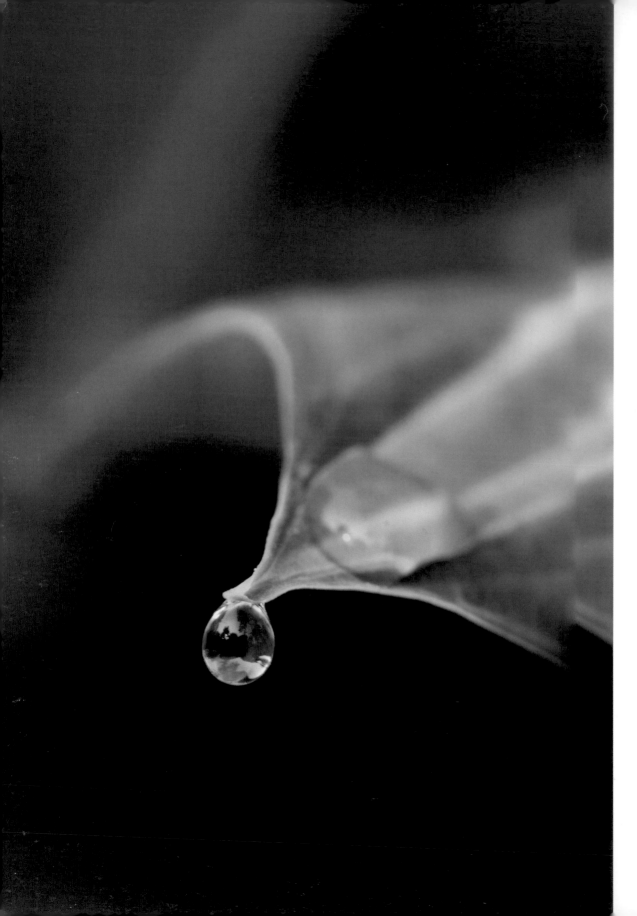

This image depicts a combination of a dewdrop and a droplet of water formed by guttation, a process whereby root pressure forces water to be exuded on leaf margins. The focus is on the droplet hanging on the very tip of the hosta leaf rather than on the dewdrop on top of the leaf. I positioned the camera so that the hanging drop had a dark background to make it stand out. A very shallow depth of field allowed the curves of the leaf to act as leading lines in the image composition without creating a distracting or busy background. I bracketed the exposure toward underexposure to compensate for the dark background.

Canon 1Ds Mark II with 180mm f3.5 L macro lens, 1/10 second at f8 -2/3 stop exposure

Apertures and F-Stops

The aperture of a camera, the lens opening that allows light to reach the digital sensor, is similar to the iris of a human eye. By adjusting the size of the opening, the iris controls the amount of light reaching the retina. In a dark room, the iris enlarges or opens up to its widest circle to let in the greatest amount of light. If we go outside into bright sunlight, the iris contracts or closes down to a much smaller opening, thereby reducing the amount of light reaching the retina. The camera lens has a diaphragm that acts similar to the eye's iris in controlling the size of the opening.

The f-stop settings designate the different possible sizes of the aperture. F2.8, f4, f5.6, f8, f11, f16, f22, and f32 are typical full f-stop settings on macro lenses. The smaller the f-stop number, the larger the lens opening. Conversely, the larger the f-stop number, the smaller the lens opening. A change from f2.8 to f4—or from any full f-stop setting upward to the next full f-stop—reduces the size of the aperture by half. Changing the setting downward by a full f-stop—going from f4 to f2.8, for example—doubles the size of the lens opening. There are many intermediate settings as well.

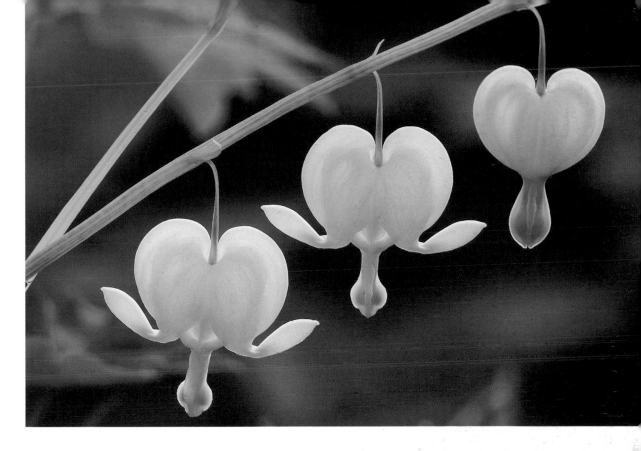

darkest area to the lightest area, averages the readings, and compares that to a reference standard of middle-tone gray. In practice, the camera believes everything it looks at and measures is a gray scene. The problem in getting an accurate exposure for every image is that not all scenes are middle gray. To get an accurate exposure for any image that's either lighter or darker than gray, the photographer has to make adjustments to the camera's metering. This is called exposure compensation. Some cameras allow the photographer to make meter adjustments in thirds of a stop while others allow adjustments only in half stops. Check your camera manual for the correct procedure. If you don't make any exposure compensation, you will capture gray beach scenes and nights that look like daylight.

The camera's automatic exposure settings are more prone to error in macro than regular photography. If you are photographing a white flower, for example, and go in close enough so the flower fills the entire frame, every meter reading will be identical. The camera will think it's looking at a gray flower and will give an appropriate f-stop and shutter speed combination. If you make no exposure adjustments, the image of this white flower will be gray. To get the white flower to appear white instead of gray, you have to set the camera to overexpose by adjusting the exposure to the plus (+) side. This results in more light reaching the sensor. There's no exact rule as to how much adjustment to make. The

The unusual shape of these bleeding hearts, Dicentra spectabilis 'Alba', makes them a photographer's dream. Most of the time, however, the individual blossoms are turned toward one another, making it difficult to get an image of more than one blossom facing the camera. This group of three was an exception, with each one in the same plane as the others. I placed the group against a darker background for separation and overexposed to compensate for the backlighting and to show some of the blossoms' translucence.

Canon 1Ds with 180mm f3.5 L macro lens, 1/8 second at f16 +2/3 stop exposure

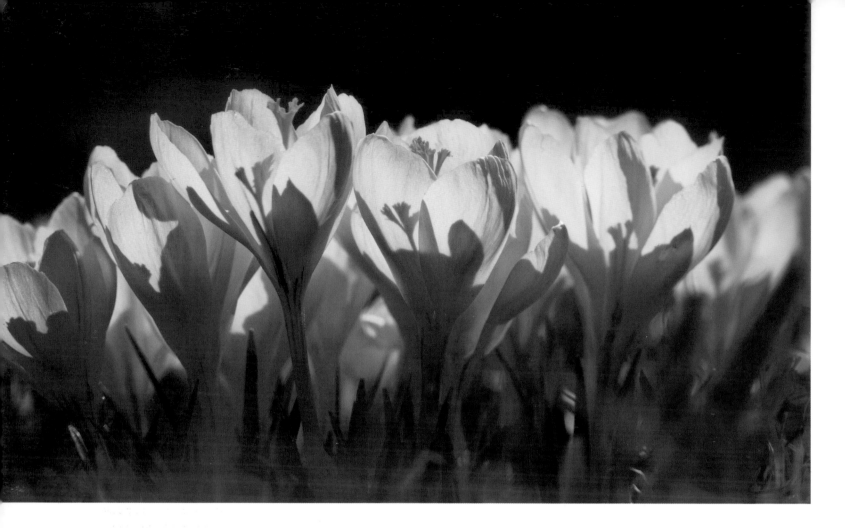

The bright orange stigmas of Crocus 'Jeanne d'Arc' casting their shadows on the white petals make for a dramatic image. A low camera position was necessary to show the stigmas, the stigma shadows, and the petals at the same time. A medium aperture assured that the grass in the foreground didn't come into focus and kept the background blurred. Adjusting the exposure to the plus side kept the white petals white and also slightly lightened the foreground.

Canon 1Ds Mark II with 180mm f3.5 L macro lens, 1/100 second at f11 +1 stop exposure

greater the amount of light area in the frame, the more overexposure or additional light will be needed. Examine the technical information accompanying each image in this book to see the wide range of exposure compensation (+1/3 stop, +2/3 stop, and so forth) used.

One of the great aids to getting good exposure in a digital image is the histogram displayed on your camera's LCD when you press the shutter-release button. The histogram is a graphical representation of the light values, brightness, or luminance in an image. The graph's horizontal axis represents the range of light values from pure black or 0 on the left to pure white or 255 on the right. The vertical axis indicates the concentration of information (the number of pixels) at a particular value. If a histogram shows a large number of pixels against the left border of the graph, this indicates that some areas in the scene have no detail in the shadows—in other words, the areas are underexposed. If the pixels peak against the right border, the scene has overexposed highlights or loss of detail in the bright areas. A scene with detail in both the shadows and the highlights will have a histogram with pixels shown over the full range from pure black to pure white.

While the camera's histogram is not as accurate as the histogram in computer software, a quick check of the camera's histogram after pressing the shutter-release button will indicate whether the exposure is close for any particular scene. If you shoot the same image a number of times at different exposures (a practice known as bracketing), you can use the more accurate histogram on your computer to select the best image file.

In addition to exposure compensation, many cameras have the ability to change the metering pattern. Cameras leave the factory with a default setting to take multiple meter readings at various points in a scene and average them. Canon calls this evaluative metering, while Nikon's term is matrix metering. More advanced cameras allow the photographer to change to partial metering, which means the light metering is both center-weighted (giving emphasis to the center area) and limited to a smaller section of the image. Some cameras can be changed to spot metering, where only a very small circular area is measured. In the beginning, get used to using the default setting on your camera. Once you understand how the camera meters light and can get consistently well-exposed captures, try the different metering options.

The object in digital photography is to gather the maximum amount of information in an image file. The better the exposure, the more information you have. A good exposure has enough light so that detail in both the dark and light areas can be seen. Too little light and the detail in the shadows is lost. Too much light and the detail in the bright areas will be lost.

Histogram indicating under-exposure, with detail lost in the shadows.

Histogram indicating over-exposure, with detail lost in the highlights.

Histogram indicating detail in both highlights and shadows. This is sometimes described as "gap right and gap left."

Experiment with Exposure

If exposure seems way too complicated or if you are not convinced that it makes a difference, try this experiment. Get two pieces of paper, one black and one white. Set your camera on a tripod and fill the frame with the white paper—in other words, only white paper should be visible in the viewfinder. Note the camera's exposure setting. Without changing the lighting in any way, follow the same procedure with the piece of black paper. You will see two different exposure settings—too little exposure for the white paper and too much for the black paper. If you were to take the pictures of both the white and black papers at the normal setting without adjusting the exposure, both captures would look like a gray piece of paper.

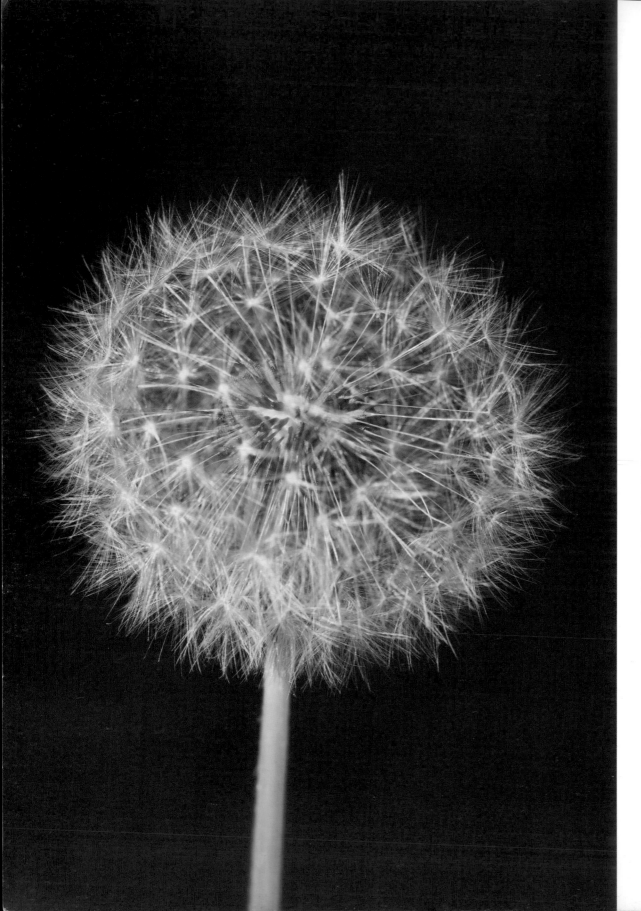

There's no one way to shoot a subject. This dandelion sitting in a patch of sunlight is a perfect example. I usually focus on the perimeter of a round object when getting the subject sharp front to back is doubtful. This time, however, I decided to try to make the individual stems inside the seed-head ball stand out. I focused on a point about halfway from the front to the center. The lighting coming from the left made everything almost glisten. I overexposed to make sure the seed head would be white against the dark background.

Canon 1Ds Mark II with 180mm f3.5 L macro lens, 1/25 second at f11 +2/3 stop exposure

When just starting to work in digital, some photographers choose to expose the digital capture exactly the same as if the camera were loaded with film. With transparency film, it was common to set the camera to underexpose in order to get greater color saturation and prevent any overexposure of the highlights. Beginning digital shooters continued this practice by routinely underexposing their digital captures by a stop and then correcting that underexposure in the computer. But digital is not film and routinely underexposing is not a good practice.

Every scene has varying amounts of light that range from the shadows to the highlights. For illustration purposes, let's say that digital cameras can record detail within a range of about seven f-stops of

Not all macro opportunities are outdoors. This asparagus fern, Asparagus densiflorus, *was on my porch. The backlighting and the gentle curve of the frond made an interesting composition. The texture of the frond was important so I used a small aperture and a long shutter speed.*

Canon 1Ds with 180mm f3.5 L macro lens, 2-1/2 seconds at f16

F-Stops and Shutter Speeds

Many combinations of f-stop and shutter speed let in the identical amount of light. If you take one shot and then double the size of the aperture and cut the shutter speed in half, the same amount of light will reach the sensor. For example, start with an aperture of f8 at a shutter speed of 1/250 second. Changing from f8 to f5.6, which doubles the aperture, lets in twice the amount of light. In order to have the same total amount of light, you need to decrease the shutter speed from 1/250 to 1/500 of a second. (In other words, f8 at 1/250 is the same amount of light as f5.6 at 1/500.) The point isn't that you need to calculate all the combinations, but that you understand this relationship between aperture and shutter speed.

light from the darkest point in the image to the brightest point in the image. Within the seven-stop range, more information is available in the brightest section of a scene. In fact, in a scene with a full seven stops of light, half of the information is available at the brightest stop. If the normal procedure is to underexpose by one f-stop and make the appropriate adjustment in the computer, only half of the information in a scene is captured. Remember that digital photography is about gathering or capturing the maximum amount of information. Adjusting the one-stop underexposure in the computer does not add back all the information you failed to capture; it only spreads the captured information out.

DSLR cameras offer the option of a number of different exposure or shooting modes, each designed with different conditions in mind. Common automatic modes, where the camera adjusts both aperture and shutter speed, include the close-up, landscape, and sport modes. Each of the automatic modes is based upon a mathematical formula written by an engineer to tell the camera which aperture and shutter setting to use for a given amount of light. As smart as the programming engineers are, they cannot know the picture the photographer is trying to capture, let alone the interpretation of that image. Do they know there's a slight breeze and therefore a faster shutter speed is needed? Can they see that it's dead calm and a smaller aperture will work for greater depth of field? Making good images, not snapshots, requires input from the photographer. Relying upon fully automatic modes will not produce consistently good images.

There are also semi-automatic modes, where the photographer has control over either the aperture setting or the shutter speed and the camera determines the other. If you want images of children playing soccer, you need a shutter speed that's fast enough to freeze the motion of the children running. In this case, you want control over the shutter speed. Setting the camera to the semi-automatic shutter priority mode and selecting a shutter speed of 1/500 or maybe 1/250 of a second and letting the camera determine the matching aperture setting would be a good starting point.

On the other hand, for garden photography and even more so for macro photography, control over how much of the area of an image will appear sharp is important. Rather than controlling the shutter speed by setting the camera to shutter priority, as with the children, you need to control the depth of field by setting the camera to aperture priority. In this mode, you select the aperture setting (which controls the depth of field) and the camera calculates the corresponding shutter speed.

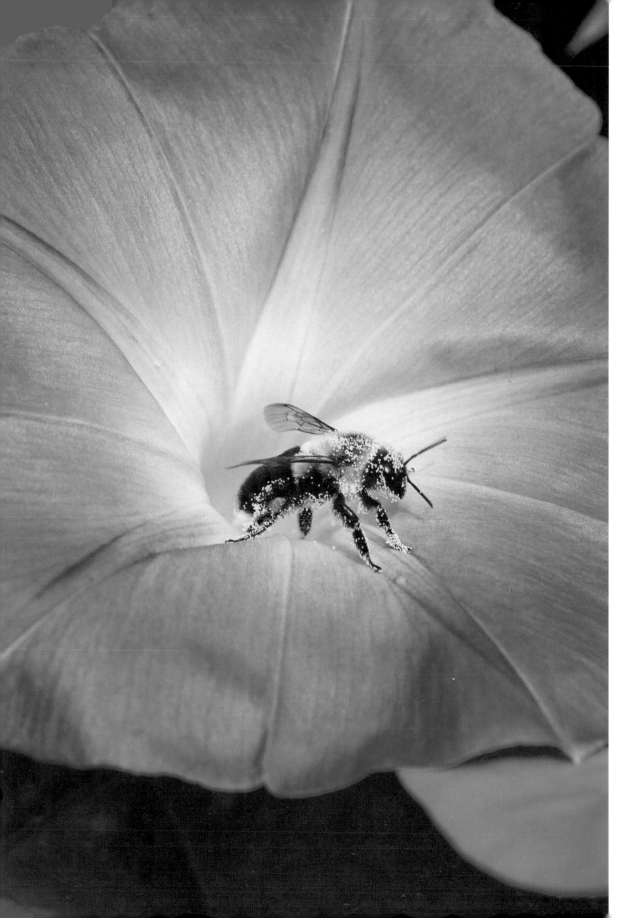

This bee was going from flower to flower. I noticed that it would enter, come out, and then go back into every flower. Each time it entered a flower, I would adjust the height of the tripod and click off a few frames when it entered the second time. This image is one where it paused before taking flight. The tricky part was having an f-stop that would give enough depth of field in combination with a shutter speed fast enough to freeze the constant movement. I increased the ISO to 320 to get the faster shutter speed.

Canon 1Ds Mark II with 180mm f3.5 L macro lens, 1/125 second at f11, ISO 320

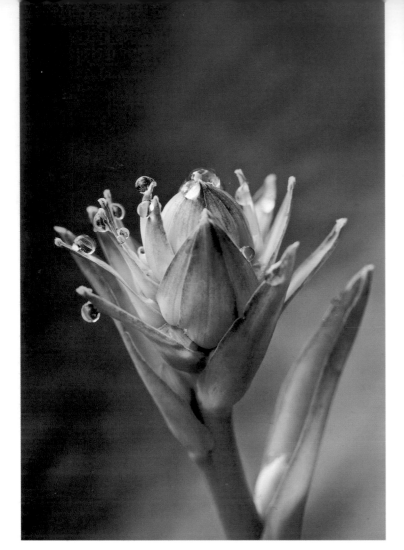

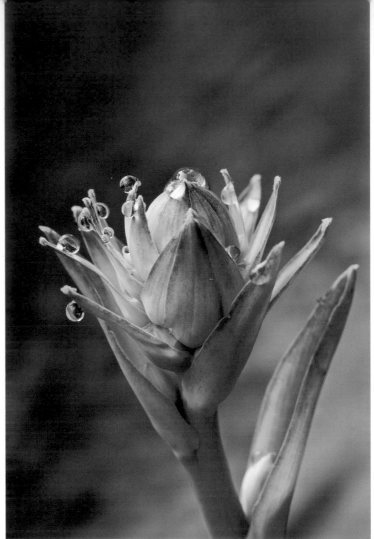

Depth of Field

Depth of field is one of the hardest things to get comfortable with in photography. It would be nice if it were clearly discernible when you are setting up to capture the image, but it's not. Lack of a clear understanding of depth of field is a major stumbling block to producing good close-up images.

Every time you start to press the shutter-release button, the camera focuses the lens. The spot where the lens is focused is called the focus point. In addition to the focus point, there's an area in front of and behind the focus point that appears to be sharp. Depth of field is the distance from the front to the back of this area—the area of an image that appears acceptably sharp to the viewer, both in front of and behind the focus point.

The distribution of the depth of field in an image—how much of the

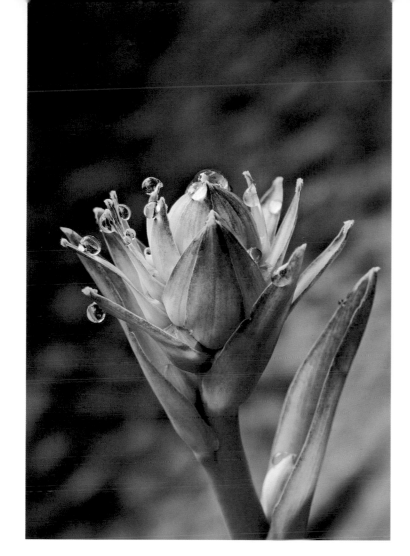
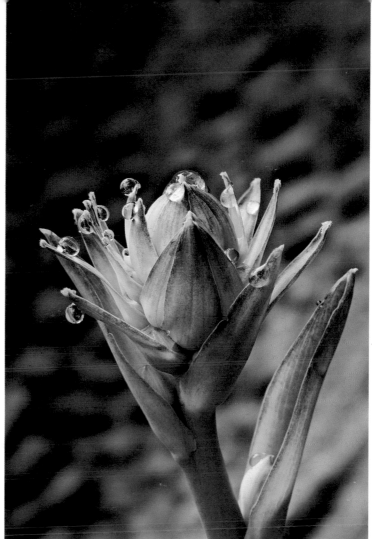

These four images of a hosta bud are an exercise in depth of field. The images were captured at apertures set at f8, f11, f16, and f22, respectively. Examine each one for the sharpness of the bud and the softness of the background. The bud in the first image, with an aperture set at f8, is reasonably sharp with the background very soft. As the aperture gets smaller the depth of field and thus the sharpness of the bud increases but so does the detail of the hosta leaf in the background. At f22, the bud is very sharp but the increased sharpness is more than offset by a distracting background. In situations like this, it's a good practice to bracket the aperture settings so that you are sure to get the image you want.

Canon 1Ds Mark II with 180mm f3.5 L macro lens; left to right, 1/4 second at f8, 1/2 second at f11, 1 second at f16, 2 seconds at f22.

Spiders and their webs make interesting photographic subjects. Because the gossamer webs move with the slightest air current, long exposures don't work. For both the spider and the web to be sharp, the camera must be in the same plane as the web, but this limits composition flexibility. By placing the spider off center and toward the upper right, I was able to get an interesting background of soft green shapes. I adjusted exposure to underexpose in order to keep the background dark. I focused on the spider and turned off the autofocus on the lens. Being careful not to breathe in the direction of the web, I waited until everything was still to press the shutter-release button.

Canon 1Ds Mark II with 180mm f3.5 L macro lens, 1/10 second at f8 –1/3 stop exposure

Depth-of-Field Considerations

Working with depth of field in an image involves three considerations. The first is the actual depth of field or how much of the image will appear sharp. By selecting different apertures, you can increase or decrease the total area of an image that appears to be in focus. The second consideration is where the lens is focused in the image. By changing where the lens is focused, you also change the position of the area in sharp focus. The third consideration is the position of the camera. Placing the back of the camera parallel to the subject allows as much of the entire subject as possible to be included in the sharply focused area.

This snail figurine sitting in a birdbath was an easy call. I wanted some of the moss in front and in back to be sharp. Focusing on the snail positioned it halfway in the depth of field. I included the plant on the left border to offset the symmetry of the image and add depth.

Canon 1Ds Mark II with 70-200mm f2.8 IS L zoom lens, 1 second at f16

sharp area is in front of the focus point and how much is behind it—differs depending upon the type of image. In landscape or scenic shooting, one-third of the area that appears sharp is in front of the focus point and two-thirds is behind it. For example, if the camera is focused on a tree in a garden with an aperture setting that produces a total depth of field of 30 feet, the area of sharpness for this image begins 10 feet in front of the tree and extends 20 feet behind it.

The depth-of-field distribution is different in a macro image. Here, half of the total depth of field is in front of the focus point and half is in back. If you are taking a photo of a flower that fills an area of about 10 by 15 inches and have a total depth of field of 4 inches, the area that appears sharp will start 2 inches in front of the flower and extend 2 inches behind it. Anything in the frame in front of and anything behind the 4-inch area is out of focus. As you go in tighter and tighter on a subject, the depth of field decreases. If you move in closer to photograph a flower that fills an area measuring 2 by 3 inches, the depth of field decreases dramatically to about 1/4 inch–1/8 inch in front of and 1/8 inch behind the flower. What's important isn't the exact size of the area but understanding that as you go in tighter and tighter on the subject and as more of the subject fills the frame, there's less and less depth of field. Think of depth of field as a trade-off. The closer you are to the subject or the greater the magnification of the flower in the frame, the smaller the area that will appear sharp. Simply put, as magnification increases, depth of field decreases.

Many cameras have a depth-of-field preview capability that closes the lens from its maximum opening to the working aperture to help the

photographer see what's sharp and what will appear soft. Looking in the camera's viewfinder and using the preview button allows you to see how the actual image will look. Some references on macro photography insist that such a preview capability is vital. However, be forewarned that because the viewfinder is so small and gets darker when the preview function is used, it's difficult to judge whether the detail in the image is sharp. For example, if the lens has a maximum aperture setting of f4 and the aperture setting for the exposure is f11, the preview lever or button will close the shutter opening from f4 to f11, reducing the total amount of light entering the viewfinder by seven-eighths. In the beginning, it seems nearly impossible to use this feature, let alone make any accurate decision regarding sharpness. If you experience difficulty, instead of looking at everything in the viewfinder frame, look for something in the viewfinder with high contrast that you want to be sharp. Look only at that high-contrast area as the preview button or lever is engaged to get a sense of whether you have sharpness. This is not an exact procedure. With practice, using the preview feature to evaluate sharpness in an image will become automatic and a valuable aid to your focusing routine.

If worrying about all the considerations for depth of field is too much trouble, photographers can always resort to one of the computer programs designed to combine multiple images taken of the same scene but with different focus points. Of course, this involves taking three or more captures with focusing changes for each one and then working on the computer to produce one sharp image. This is a valuable aid for scientific work but can result in images of a more sterile nature. It's better to learn the best technique before relying on a computer program to fix a deficiency in photography craft.

Focus

Focus goes hand in hand with depth of field as a stumbling block when starting out in macro photography. If you are shooting a wide-angle landscape where the image is sharp front to back, you can still get the image you envision even if the focus point is slightly off. However, in macro work, the focus point must be exact. Resorting to changing the aperture to a smaller opening (stopping down) to compensate for diminished depth of field rather than paying attention to the focus does not solve the problem. In fact, it may create additional problems. If there's a slight breeze, the subject is blurred due to a longer exposure. Also, the increase in size of the sharply focused area can change the whole feeling of the image. Stopping down does increase the depth of field, but it's the equivalent of crossing your fingers and hoping it comes out. The correct way to ensure maximum use of available depth of field is not to quickly

This 2-inch blossom of Portulaca 'High Noon Rose' was in prime condition with good sidelighting. The challenge was to have other blossoms in the background without the main blossom merging into them. Using a medium f-stop and placing the main subject's bright petals on the left against a dark area of another blossom accomplished the goal.

Canon 1Ds with 180mm f3.5 L macro lens, 1/20 second at f16

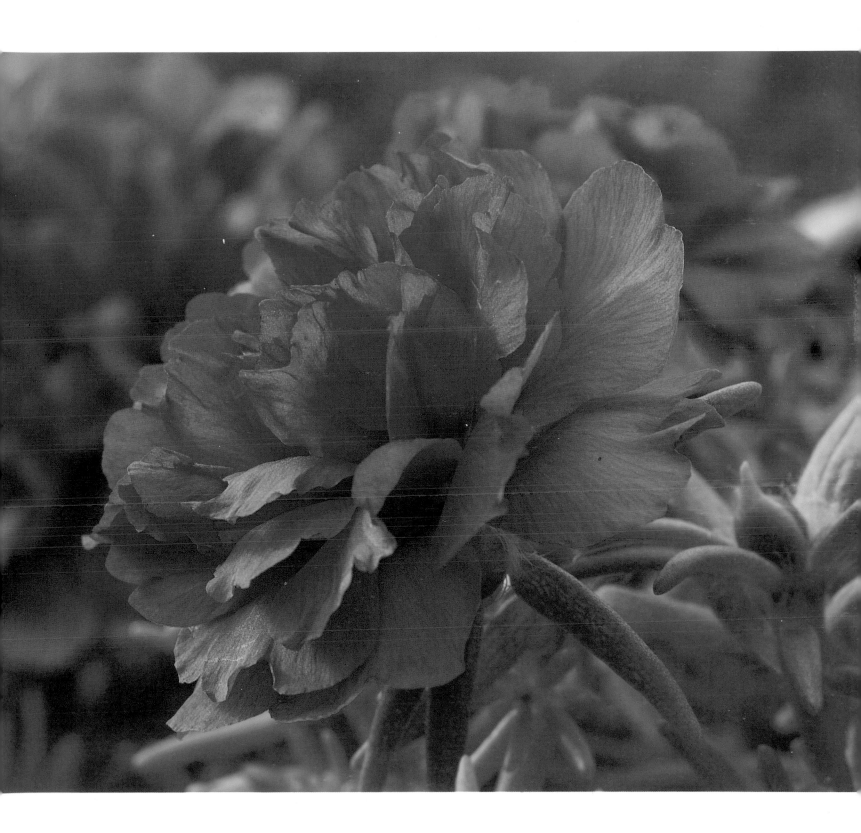

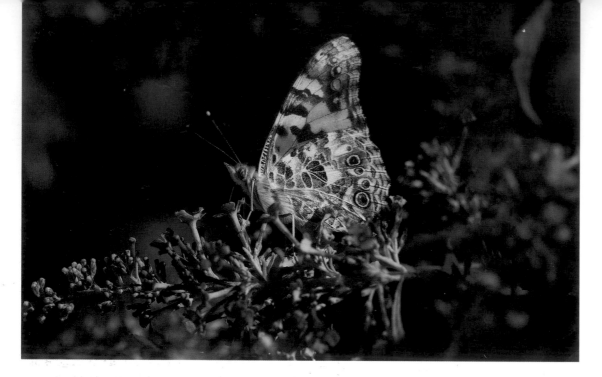

The lighting just brushing this painted lady butterfly as well as its position against a nondistracting background more than made up for its being positioned dead center. With moving subjects, keep shooting and keep the good frames.

Canon 1Ds Mark II with 180mm f3.5 L macro lens, 1/320 second at f8

change the aperture or race to press the shutter-release button but to pay attention and focus carefully.

Today's cameras and lenses are all autofocus. Point the camera, press the shutter-release button, and the camera focuses and captures the image. Depending upon the camera, there are a number of points where it will be able to focus within what is called the active autofocus area. Some cameras have as many as forty-five possible autofocus points (called AF points for short) within the autofocus area but allow you to select fewer.

In autofocus mode, the camera looks for something to latch onto for focus. It may sense the object evident in the foreground or maybe the largest defined area with contrast. In addition to being able to change the number and arrangement of AF points, you can also manually select where to focus as opposed to the camera picking out the closest feature.

Choosing where to focus is easier when there's a noticeable difference in contrast or structure in the image. Choose a feature that's easy to bring into focus. The edge of a stem or leaf works well. Be careful of focusing on very fine features such as a spider web or the fine anther of a flower, because cameras sometimes have trouble recognizing such tiny details. If there are no AF points in the viewfinder that line up where you want the image to be sharp, look for another object the same distance away from the lens as the intended subject and focus on it. Then turn off the autofocus on the lens and move the camera back to the original composition of the image.

Be aware that because there are more focusing-sensitive points in

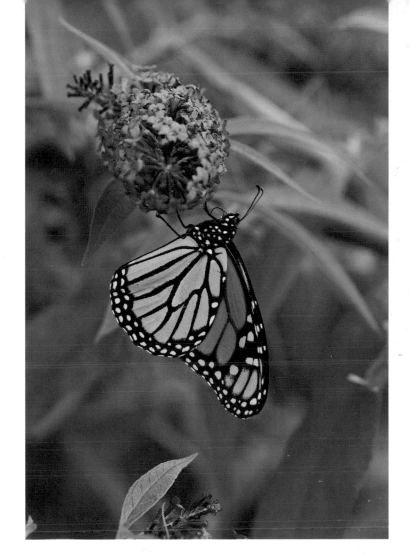

I captured this shot of a monarch butterfly on a cool, cloudy day just before it started to rain. The butterfly was feeding on a butterfly bush but its movements were considerably slower than usual because of the conditions. Even so, the dark day necessitated my changing the ISO from 100 to 400. I managed to get the tripod into position and capture a few images before the monarch moved to another blossom.

Canon 1Ds Mark II with 180mm f3.5 L macro lens, 1/30 second at f8

the camera on the horizontal axis than on the vertical axis, it's more difficult for the camera to focus when you are shooting vertically. If you are using a macro lens with a tripod collar and have trouble focusing on a vertical image, rotate the camera to the horizontal position. After getting the subject in focus horizontally, turn off the autofocus and rotate the camera back to the vertical position.

Check the camera manual for specific information on how to adjust the AF points. Once you are comfortable with focusing and changing the AF points, you will be able to take full advantage of the available depth of field. If you still have problems focusing, turn off the autofocus and focus manually.

Placement of the camera relative to the subject is an important adjunct to focusing and depth of field technique. If you position the back of the camera parallel to the subject being photographed, at any f-stop the area parallel to the back of the camera will be in sharp focus. Let's take an image of a butterfly as an example. If you position the camera

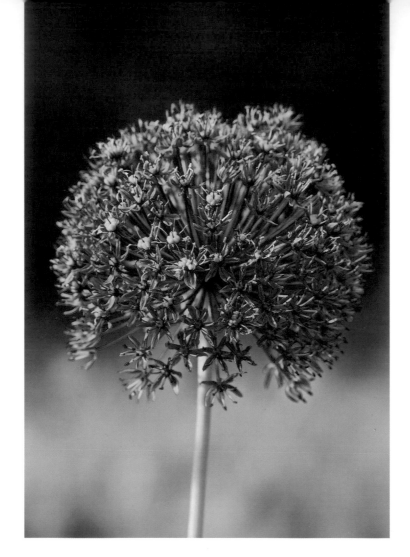

Sometimes having an image sharp from front to back doesn't work. The Allium *blossom in these images is more than 3 inches in diameter. If it were captured with a very small aperture setting of f22 in order to have it appear sharp from front to back, the background would show enough details to be distracting. To keep the background unobtrusive, I used an aperture setting of f8, but this meant that the blossom could no longer be sharp from front to back. Even though the subject isn't totally sharp, there's a way to have the image appear sharp to the viewer. In the first image, the focus is on the center of the blossom; this area is sharp but the perimeter of the blossom is soft. Because of the high contrast, the viewer notices the perimeter first and decides that the image is out of focus. The second image is focused on the perimeter with the center being soft. In this case, the viewer again notices the perimeter first and determines that the image is in focus. If there's a choice of where to focus, select an area of sharp contrast or an edge to make the image appear sharp.*

Canon 1Ds Mark II with 180mm f3.5 L macro lens, both images 1/15 second at f8

back parallel to the butterfly's body and wings, the entire butterfly, eyes to tail, will be sharp even though the depth of field is less than 1/2 inch. However, if you position the camera head-on to the butterfly and focus on the eyes, only the eyes and some of the thorax will be sharp, in an area 1/2 inch deep. Everything else in front of and in back of this area will go soft. Even if you change the aperture setting so you have a 1-inch-deep field, you won't get the entire butterfly in focus.

Checking a camera's position is easy to do when you are shooting stationary objects. With the camera on a tripod, move beside the subject so you can view and compare the positions of the camera back and the subject at the same time. If necessary, adjust the camera back to be parallel to the plane of your subject where you want it to be sharp.

In cases where the subject is moving, like a butterfly, look at the most important area, in this case the eyes. When the eyes appear sharp look at the outside edge of the wings to see if they are sharp. If every-

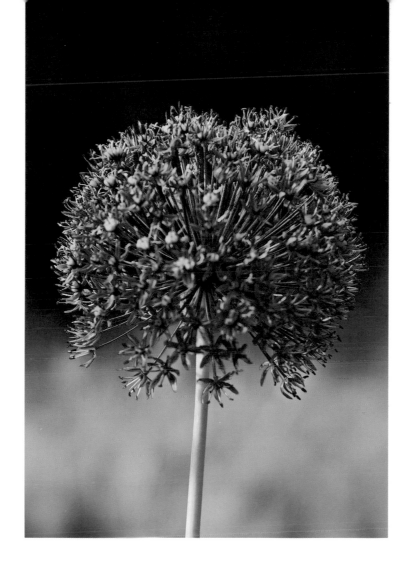

thing appears to be consistently sharp, the camera back is parallel to the subject.

Camera placement is also critical when you want a shallow depth of field for a more artistic image. By moving the camera out of parallel to the subject, you minimize the depth of field and make possible very selective focus. The greater the camera's angle toward the subject, the more limited is the depth of field.

If you change the focus point and have the camera in the best position but still have trouble getting the image as sharp as you would like, another technique might help. The human eye notices whether areas of sharp contrast are in or out of focus before it examines areas of subtle gradations. For instance, we notice if the edges of flowers or leaves are in or out of focus before we perceive whether the inside of the area is sharp. This means if you have a choice, keep in focus the most noticeable features with the sharpest contrast. Look at the two images of the *Allium*

Photographing the light through the back of a large tropical leaf is always a safe bet when the sun is high in the sky. In this image, the leaf midrib and veins caught my interest. By overexposing, I was able to capture the almost iridescent color of the midrib without forcing the leaf to appear too bright.

Canon 1Ds Mark II with 180mm f3.5 L macro lens, 1/3 second at f16 +2/3 stop exposure

blossom. Both images have the same depth of field but one appears sharper than the other. If a perimeter or an area with high contrast appears sharp, the viewer will notice that area first and think the image is sharp. This approach works for any round or oval object where the outside is noticed first. The exception to this is insects and other animals where the eyes are the critical area for focus.

Lighting

There's a maxim that there are three important considerations in any type of photography: lighting, lighting, lighting. The lighting in an image defines the color, structure, texture, space, shape, form, line, and shadow. An image of a less-than-perfect subject that's poorly composed and not quite sharp might still be a "wow!" image when photographed in gorgeous lighting.

In a studio, the photographer has total control of the lighting. He or she can change the direction, quality, or amount of light to suit the image. Out in the field, we depend upon nature for good lighting conditions. In addition, each season, each day, each hour, or even each minute, the lighting outdoors can be different.

This fact is testified to by a story told by Peter B. Kaplan, a great New York City photographer. Peter has taken thousands upon thousands of shots of the Statue of Liberty and has images photographed from the ground, the torch, the sea, and the air. He was hired to photograph the deterioration of this grand national monument for an audiovisual show used to raise money for the massive restoration project. After the audiovisual project was complete, Peter volunteered to photographically document the restoration of the Statue of Liberty for her hundredth anniversary.

One of the images he took the first night he climbed into the torch, photographed by extending a pole with his camera over the railing, became by far the most successful stock photo of all his pole shots. He titled it "Liberté mon Amour." He decided he wanted to recreate this image because the original photograph showed the old torch with pieces of copper missing and lots of dirt on the copper. For a number of years he went to Liberty Island to try to capture more pole shots of a similar nature for his stock library. Try as he might and as often as he did, he was never successful in finding lighting conditions the same as those at that particular moment on that one special day back in 1982 when he took the original. After some three-hundred climbs into the torch, Peter realized that he had many good pole shots but there was only one "Liberté mon Amour."

The key to getting the most out of any lighting condition, besides

This dramatic indoor image is all about color. The orange wall and the black table are the perfect backdrop to the 2-inch-tall container with Isolepis 'Live Wire' seedlings. To make the image really pop, I used a medium aperture so that only the front of the container and some of the plant are in focus. A greater depth of field would have made the image too busy.

Canon 1Ds Mark II with 180mm f3.5 L macro lens, 1/20 second at f11

shooting like crazy when the light is special, is to pay attention to the characteristics of the light.

There's always some direction to light. It comes from the left, the right, the front, the back, above, or below. Think of the path of the sun from dawn to dusk and how the angle of the light changes throughout the day. As you walk around a subject, the light and how it affects the subject also changes. You can have boring front lighting, interesting side-lighting, or dramatic backlighting. The combination of the height or angle of the light and whether it's coming from the front, the side, or behind the subject determine the direction of the light.

In addition to direction, there's also a quality to the light. Light can be soft and diffused as on a foggy morning or hard and harsh as in the noonday sun. Depending upon the subject, one type of lighting can be more favorable than another. Soft lighting works well on a pink rose, but the spines of a cactus jump out with a harder light.

The lighting conditions with the best direction and quality are early

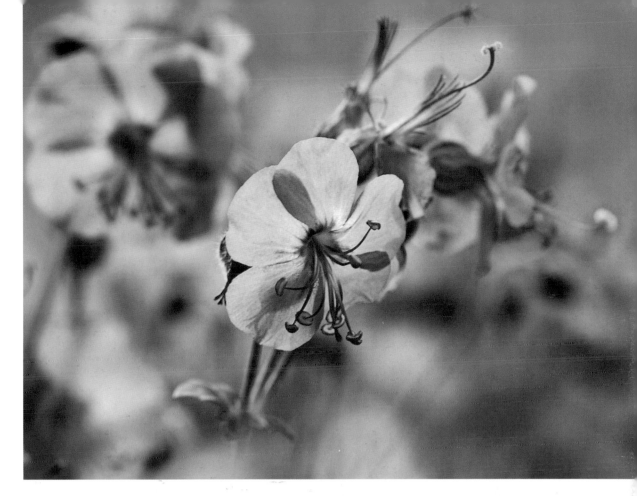

We have a bed of these geraniums in our yard and each spring I find myself photographing them because they are such great subjects. These two images demonstrate lighting direction and how it affects the image. The first image, a very tight shot of a single blossom, is backlit to show the blossom's translucence. If a number of blossoms were captured in this same manner, they would appear as a bunch of bright pink lights. The second image is taken from the opposite side and captures a group of front-lit blossoms. Both images were taken at the same aperture setting, but because the single backlit image is much tighter, there is less depth of field. I bracketed the exposure for both images and selected an overexposed image for the group shot and normal exposure for the single blossom.

Canon 1Ds Mark II with 180mm f3.5 L macro lens, both images f11; the tight image was at 1/10 second while the group shot was 1/6 second with +2/3 stop exposure

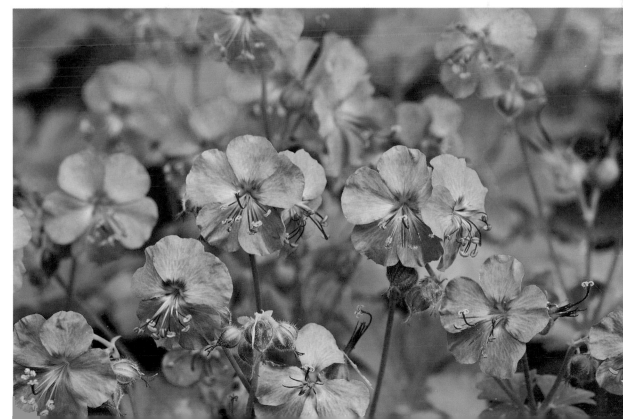

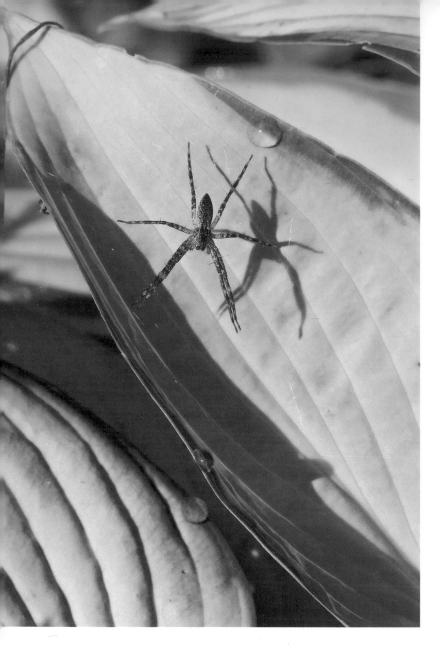

Photography is all about light, but sometimes we forget that light includes shadows. This image of a spider is made by the inclusion of the spider's shadow as it sits on its web. A small f-stop was needed to get both the spider and its shadow sharp.

Canon 1Ds Mark II with 180mm f3.5 L macro lens, 1/10 second at f22 +2/3 stop exposure

and late in the day. While midday lighting gives the photographer more choices of aperture setting or shutter speed, its high contrast makes it the least favorable lighting for photographing in the garden. Morning or evening light, while it affords fewer choices of aperture setting and shutter speed, is the best lighting for garden photography. This lighting is very soft and favors images with saturated color and soft shadows. Don't let the low light and the long shutter speeds under these conditions put you off. Many successful images have been captured at speeds of one or two seconds or even longer.

Like all the other aspects of an image we have covered, the difference lighting makes in an image is magnified in macro photography. Subtle shadows that may go unnoticed in a landscape become very evident in a close-up photo. Bright areas that add sparkle in a landscape become too noticeable in a negative way when you go in tight.

If the lighting conditions in the field are not perfect, you can use reflectors and diffusers to modify the light. Major changes such as blocking large sections of sunlight or adding some directional light are best done at this point. While you can tweak and correct the image files once they are downloaded, making major light modifications before capture results in a better digital file and is a more efficient use of your time.

As you get more comfortable with working in different light conditions, more advanced options will become available to you. For example, if you are working with raw captures, you can take separate exposures for highlights and shadows and then merge them, without major corrections, into one image file in a program such as Photoshop. The result is an image with better highlights and better shadows than was ever possible with film.

As a photographer, my preference is to work with natural light. With film, if the lighting on a flower was not appropriate, I used a reflector or a diffuser. If the reflector or diffuser did not do the job, maybe a flash would help. Since beginning to shoot digital, I'm using less flash or reflector. With Photoshop, Lightroom, Aperture, and other digital editing programs, we have more control and the ability to make any number of delicate lighting adjustments to images. If the shadows are too dark, we can selectively lighten them. Even some highlights that initially appear to be overexposed can be saved. The amount of control available in these programs is incredible. Does this mean that reflectors, diffusers, and fill flash are ancient history? Not at all. Digital technology has simply added more light-modifying tools to our repertoire. I still use reflectors, diffusers, and flash to modify lighting conditions on occasion. When I use any light modifiers, I do so with my computer's abilities in mind. With the added control of digital tools, we now have the best of both worlds.

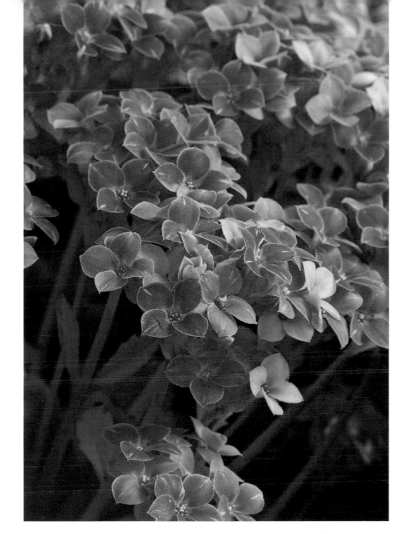

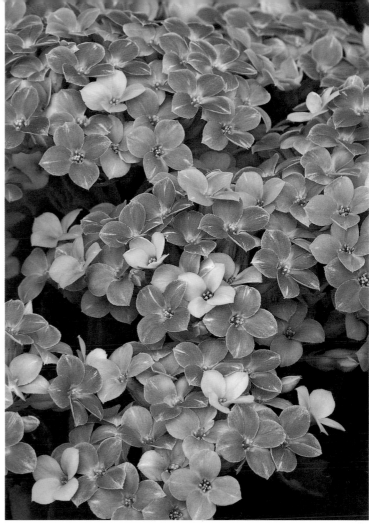

Follow the Shade

If the middle of the day is the only time you can get into a garden to photograph, you will find the best lighting if you follow the shade. Look for subjects close to where the lighting changes from sun to shade. This lighting will be softer than the full sun but will still have some direction.

If you find a good subject, don't settle for just one image. I liked the effect of the sidelighting on the Kalanchoe blossoms in the first image. The dark area under the blossoms made the camera's meter think it needed more exposure than it did, so I had to underexpose. After capturing the first image I moved around to get a closer shot of the blossoms without stems or leaves showing. In this case, the camera's meter was fooled by the lightness of the flowers into thinking less light was needed, so I slightly overexposed this photograph. Both images were taken with a medium aperture to allow some of the back of the image to go soft and add a feeling of depth.

Canon 1Ds with 180mm f3.5 L macro lens, both images 1/3 second at f11; the first image had 1/3 stop underexposure and the second image had 1/3 stop overexposure

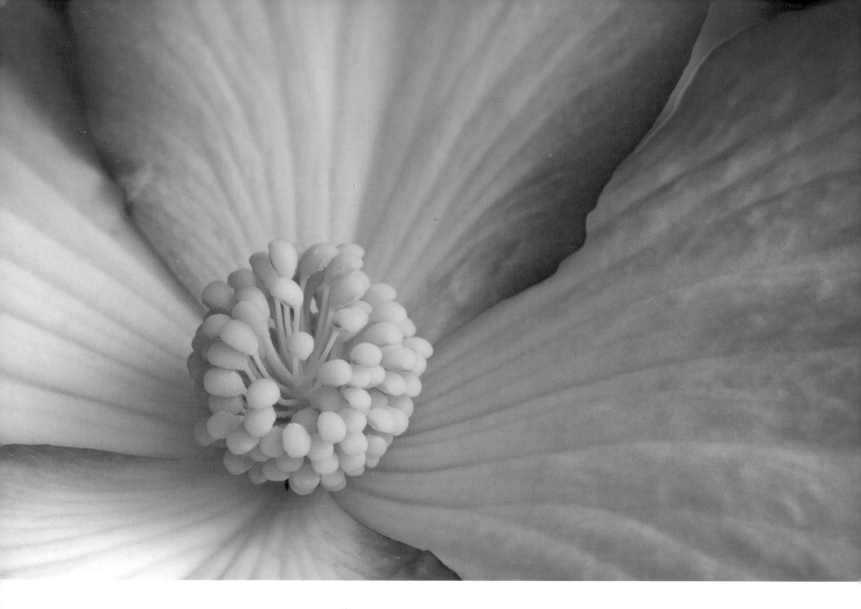

Composition

Composition is the most subjective of all the elements that make up an image. Because in macro you are shooting in tight and the subject is small, there's less flexibility than when shooting landscapes. However, similar decisions such as whether the image should be vertical or horizontal, the angle of the camera, and the placement of the subject in the frame must still be considered in the composition of a macro photograph—just in a different way. What do you include and what do you leave out? Where do you place the subject for a relaxed scene and where do you position it to create more tension? These are all decisions that determine the composition of an image.

The guidelines and rules of composition are the same whether you

The low sidelighting in this tight photo of a begonia makes the picture. Texture, shadow, and soft color all are emphasized by the light in this image. The petals in shadow keep the image from being too bright. I used a small f-stop to make sure everything was sharp, and a slight overexposure to keep the clean whites from going gray.

Canon 1Ds with 180mm f3.5 L macro lens, 1/3 second at f22 +2/3 stop exposure

Light on Your Subject

Put your hand in front of you and look at how the light changes as you move through different areas outdoors. Move your hand horizontally and vertically. Walk in the bright sun, then walk in the shade and notice the difference in how the light strikes your hand. See how sharp the line is between sun and shade when you're in the sun? Notice how it goes from a hard sharp line to a soft edge to almost disappearing as you go into the shade. Try the exercise at different times of the day. In early morning when the sun is low, you should be able to see the texture of your skin as the light brushes across the surface. At noon with the sun directly overhead, the texture is almost gone. If you have your own garden, cut a flower and do the same exercise. Just as the different light affects your hand, so too is your macro shot affected. Understanding the light on your subject and its qualities will help you capture the image you want.

are photographing landscapes or close-up images. For example, the rule of thirds suggests that you divide the image into thirds with imaginary lines both horizontally and vertically, like a tic-tac-toe board, and place the subject at one of the four points where the lines intersect to prevent images from being too static or flat. Another rule advises us never to place the subject in the center of an image, but then we see an image with the subject dead center that takes our breath away. Many times by its very nature, a close-up is going to have a dead-center composition. This does not make it a poor image. Rules are made to be broken. It's more important to follow the intent of the rules—that is, to find a way to keep an image from being static—than the letter of the rules.

Some composition choices can help to keep the image from becoming static when you go in close. You can do an edge-to-edge blossom shot with the very center of the blossom slightly off center. Or you can change the angle a bit to add impact, moving the camera higher or lower, right or left. How about adding the hint of another blossom in the background? Notice how the color of the background affects the subject. Can you change the depth of field to make the background go soft and thereby add depth to the image? Any or all of these choices add impact to a photo.

This cluster of Begonia 'Gumdrop Mandarin' blossoms was nicely framed by the leaves. The key, in my mind, was to have the front of the cluster and a little of the leaves sharp and let the background go soft. I wanted the cluster to stand out from the rest of the plant.

Canon 1Ds with 180mm f3.5 L macro lens, 1/10 second at f16 +1/3 stop exposure

I am not suggesting you forget about composition guidelines; just adapt those ideas to a smaller world. Make the S curve in a landscape shot become the curve of a rose petal. Or make the leading line the stem of a flower. Adjust to the smaller macro world and find the composition that works. Examine the total area in the viewfinder to see if that image is what caught your eye initially. If adhering to the rules creates problems, try something different. Better yet, shoot an image in different ways and decide which you like later.

Background

The background is one of the most overlooked parts of an image. It's easy to get so excited about a subject and where to place it in the frame that you forget to consider the background. But this supporting character in a close-up image can make or break a picture. Photographers

These two shots of blooms
of mountain bluet, Centaurea
montana 'Gold Bullion', are
another example of looking for
more than one image when you
find a good subject. I captured the
horizontal image with a medium
aperture to give it a more artistic
feel. The second image, which was
in closer, needed a smaller aper-
ture to get slightly more depth
of field. Other than the aperture
change, it was a simple matter to
rotate the camera and lens to take
the second image as a vertical.

Canon 1Ds with 180mm f3.5 L
macro lens, horizontal image 1/25
second at f11 +1/3 stop exposure,
vertical image 1/5 second at f22
+1/3 stop exposure

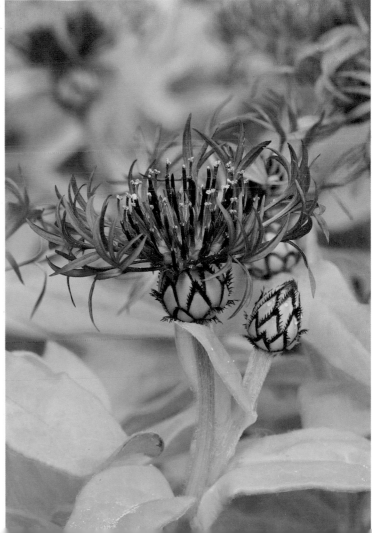

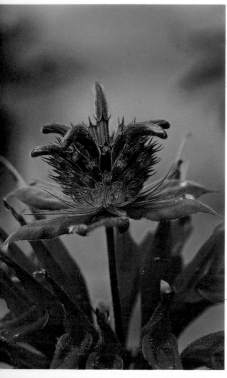

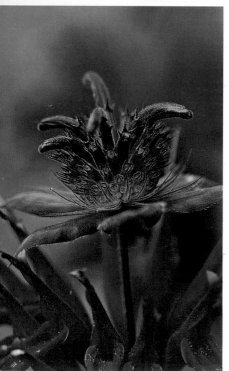

understand the importance of background intellectually but are still constantly surprised when unwanted features suddenly show up in an image. Photos with dead branches, faded blossoms, or bright spots off to the side come to mind.

Bright areas in the background are among the most frequently missed distractions. The eye tends to notice bright areas first. An image of a dark red blossom with white flowers in the background may not work. The white flowers may overpower the intended subject, the red blossom. If the image has bright areas, are they distracting? Do the elements visible in the background help or hurt the image? Can the camera be changed to a better position so the distractions are either out of frame or at least less noticeable?

Be careful of busy backgrounds that tend to confuse the viewer. Maybe a larger aperture will soften the background and eliminate the confusing details. Are the subject and the background the same color? Does the edge of the subject blend into the background so it's difficult to tell where the subject ends and the background begins? Can you change the composition so that a leaf is positioned in back of the blossom to prevent it from merging into the background?

It's a good practice to use the depth-of-field preview to check background and the area around the subject. While you may not be able to determine sharpness, the depth-of-field preview will reveal problems that may have escaped your notice. Bright spots that were nice soft areas may show up as trouble spots when viewed at the working aperture. The same is true with busy backgrounds. Even items around the subject that

Backgrounds and their effects on macro images are often overlooked. In the first image, I positioned the Monarda blossom against a green background to make the red of the blossom stand out. I used a medium aperture to keep the background out of focus. In the second image, I moved to the left and in closer so that the background became the red color visible in the upper-right corner of the first image. I used a larger f-stop to soften the background even more. These are two distinctly different images of the same blossom where the choice of background is the controlling factor.

Canon 1Ds Mark II with 180mm f3.5 L macro lens, green image 1/8 second at f11 –2/3 stop exposure, red image 1/30 second at f8 –1/3 stop exposure

Taking In the Whole Image

Pick a subject and set up your camera. Before pressing the shutter-release button, turn around so you are facing away from the camera. Close your eyes and describe everything in your viewfinder. Can you say what borders the right and left side of the image frame? How about the top and bottom of the frame? Can you describe everything in the background or did you miss seeing something? Remember the old photography adage that the photographer is responsible for everything in the viewfinder. Get in the habit of examining everything. Become aware of the entire image.

These two images of the terrestrial orchid Bletilla striata *demonstrate how a minor change in camera position can have a major impact on an image's background. In the first image, the blossoms are positioned against a number of other blossoms in the background. Even at a medium aperture, the background blossoms have enough definition to be distracting and take attention away from the main subject. For the second image I moved a few inches to the right in order to eliminate these distracting blossoms from behind the subject.*

Canon 1Ds Mark II with 180mm f3.5 L macro lens, both images 1/10 second at f11

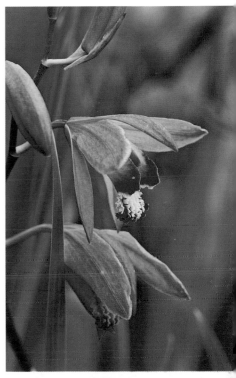

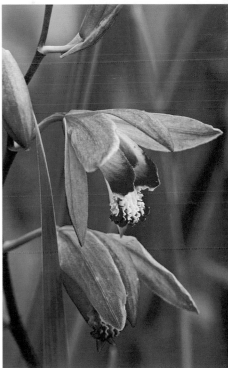

were not visible at the maximum viewing aperture become evident when stopped down to the working aperture.

Backgrounds can also be a major help in adding impact to an image. Colors that contrast in either value or tone tend to make a subject jump out. Placing a light subject against a darker background helps to isolate the subject. Similar flowers or parts of flowers out of focus will add depth and interest to an image. Before making adjustments, look at the background and consider the effect it has in the image. Try making changes to see if they help or hurt the image.

Movement

While movement and the resulting image blur problems have been mentioned previously, they create enough headaches for macro photographers that they deserve further discussion.

In addition to poor focusing technique, there are two main reasons for image blur. The first is camera movement. This movement can be the result of hand holding the camera, manually pressing the shutter-release button on the camera, or the motion of the camera's mirror. Good technique, using a tripod and cable release, will prevent most of these problems.

The second more noticeable and common problem is the movement of the subjects being photographed. It's the rare occasion when all movement stops in the field or garden. There always seems to be some breeze when you are shooting flowers. If you are out looking for insects to photograph, they never do cooperate by standing still. One common solution is

The florets of this Hydrangea *'Preziosa' blossom are very photogenic. An image of nothing but pink and white florets filling the frame can be static. Including a section of leaf adds a bit of contrast in color as well as some interest to the photograph.*

Canon 1Ds Mark II with 180mm f3.5 L macro lens, 1/40 second at f11 +2/3 stop exposure

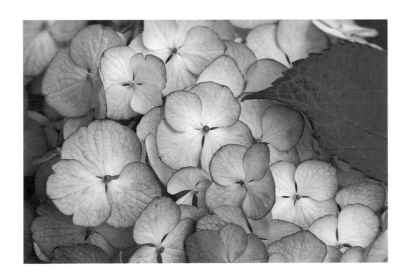

Patience is an essential tool in macro garden photography. I decided to capture an edge-to-edge image of a peony blossom. I liked the complexity of all the pink petals curving every which way with a touch of yellow in the center. A small aperture was needed to get everything sharp. The problem was that the small aperture resulted in a slow shutter speed. And, of course, there was a breeze. I focused on the center and turned off the autofocus. I set the exposure to overexpose to compensate for the darker center of the blossom and the light pink color. I waited until there was a lull in the breeze and pressed the cable release. I did this several times to make sure I got one good still capture among those with blur from the breeze.

Canon 1Ds Mark II with 180mm f3.5 L macro lens, good image 1 second at f22 +1 stop exposure, windy image 4/5 second at f22 +1 stop exposure

to go to a larger f-stop to get a faster shutter speed, but this changes the depth of field and maybe the total look of the image. Another solution is to raise the ISO setting, but that approach and its associated problems have already been discussed. There are better solutions.

One is to go out early in the morning or late in the day. Early morning, besides being one of the best times for quality lighting, is also the time when everything is calm before the change in temperature starts moving the air around. It may only last thirty minutes or less, but it will be calm.

Early morning is also prime time for photographing insects. Insects are cold blooded and are less active after a cool night. In the morning, bees and butterflies are cold from the night air and are forced to sit still until the warmer air gets their juices going and they can fly. It's amazing how close you can get to a bee or butterfly at this time. Late in the day, there's a period of time when everything once again seems to settle down. This may last for only a few minutes but it's another prime time for shooting plant portraits.

Patience is another solution to movement. If you find the perfect subject but a breeze is present, be patient. You may have to wait five or ten minutes but at some point there will be a lull or pause. Get your camera ready to capture the image. Find the section of the image that has the most movement and watch only that section. (Be careful not to breathe on the subject. When working in close, your breath can create movement.) When that section stops moving during a lull in the breeze, everything else will also be still. Press the shutter-release button then. Do this through a few lulls and your percentage of successful captures will rise greatly.

Another option for shooting on breezy days is to choose a subject that's more suited to the day's conditions. For example, look for images of tree bark where the breeze has little effect. Mushrooms and lichen also remain still on windy days. Another approach is to photograph in a valley or a depression, an area that's protected from the wind. Plants that are low to the ground or protected by other plants are also possible subjects. If all else fails, try shooting images that capture the motion of plants just as you would a waterfall.

Your vision as a photographer along with the proper exposure, good depth of field, careful focusing, special lighting, and well-thought-out composition are the essential ingredients of a good close-up photograph.

Careful Composition

Many images seem simple at first glance but in fact required a good amount of time and consideration before the photographer pressed the shutter-release button. This is one of those.

I was shooting in a very large greenhouse. There were rows upon rows of quality plants in full bloom. The plants were in peak condition without torn leaves or any hint of disease or insect damage. There was a profusion of perfect and near-perfect blossoms. The easy way would have been for me to just walk up and down the rows capturing hundreds of images. Set up the camera on tripod, compose, focus, press shutter. Elapsed time one minute, max. Move on to the next plant. The problem with that approach was that I wanted more than a production head shot.

So instead I walked the rows looking for something that caught my eye, something that set one particular plant and blossom apart from all the others. That special something turned out to be the addition of a bud—and not just any bud—to a perfect dahlia. The bud was in a place where it added a feeling, a gesture, an attitude, but did not distract from the blossom. Off to the side and lower, the bud was separated from the blossom but not so separated that the relationship was lost. And it had a little angle to it that added character.

Next I set up the tripod and camera. I wanted to avoid having any part of the greenhouse showing, and this meant that while I wanted a low camera angle for a more head-on look, I had to be careful about the position. Putting the blossom at the very top of the frame would solve the problem but cramp the subject too tightly in the frame. The solution was a slightly higher angle, which added some space around the plant and included at the top of the frame some of the plants placed behind the subject.

Next was a decision about the type of image I was trying to capture. Did I want a more realistic look with as much of the blossom in focus as possible, a clean crisp image? This would have the blossom sharp front to back. It would also mean that the blossoms behind the subject would have detail noticeable. Or did I want a more artistic rendering, with almost no depth of field but loaded with feeling? I decided I could do something in between.

My aim became to have the bud and only the front part of the blossom in focus. The back part of the blossom would start to go out of focus with the plants behind the blossom soft. This approach meant that choosing both the f-stop for my depth of field and the point of focus were critical decisions. The challenge of f-stop selection was easily met by bracketing my f-stops. (Yes, besides bracketing for exposure, you can bracket f-stops. In this case there were fans on in the greenhouse so I was limited in my bracketing due to shutter speed concerns.) To pick a focus point, I looked at my image from the side to determine where the halfway point was from the bud to where I wanted the blossom sharp. It turned out that the best focus point would be at the very front of the blossom.

I now looked at the lighting and decided not to do any adding or subtracting. I wanted the image brighter at the top without getting too dark at the bottom of the frame. The diffused light in the greenhouse was perfect.

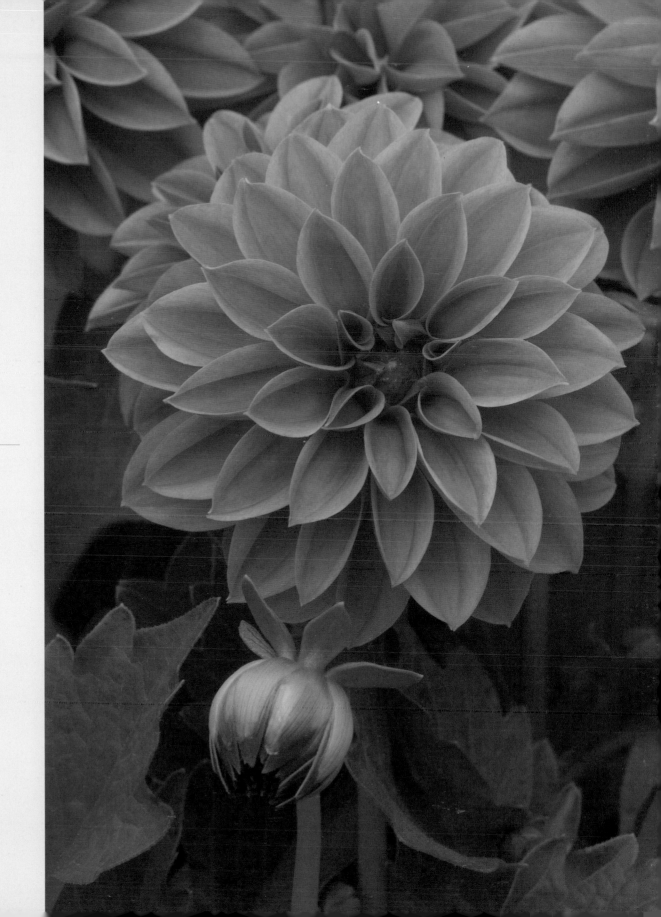

*A carefully composed
image of a dahlia.*

Canon 1Ds with 180mm f3.5 L
macro lens, 1/60 second at f11

Realistic or Artistic?

IN MY CLASSES, I ASK THE STUDENTS how many of them always shoot their macro images at f22. A large group of them usually raise their hands. I then ask how many always shoot at f5.6 or f8. Generally, most of the rest of the class raise their hands. Why is this important? Because it indicates that there are two common approaches to macro photography. The first is a realistic or editorial approach where the maximum depth of field is always used, and the second is an artistic approach where selective focus or very shallow depth of field is employed for almost every image.

It's difficult to pass up the opportunity to capture an image of Coleus 'Wizard Scarlet'. The color impact of this plant is the secret of its success. I decided to get a tight image of just a few leaves. I used a small aperture to make sure the leaves were sharp. I also positioned the camera in the same plane as the leaves to give a greater depth of field. This is a good example of a realistic image that isn't boring.

Canon 1Ds with 180mm f3.5 L macro lens, 1/3 second at f22

93

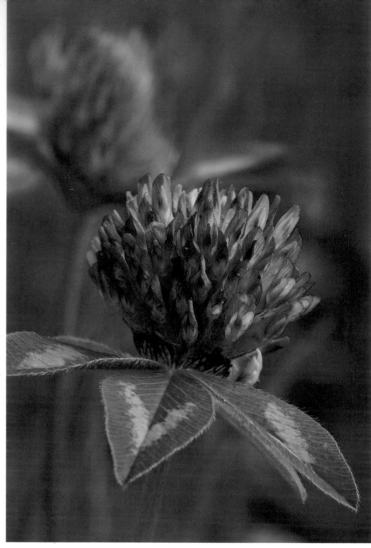

These two images of a red clover blossom are identical except for the depth of field. The first image was captured with a medium depth of field and has an overall soft feeling. Only a small portion of the flower and leaves are sharp. The second image was captured with a small aperture for a much greater area of sharpness. More of the flower and leaves are sharp and the background has much greater detail. Neither image is better or worse than the other. The first image is much softer in appearance, while the second has a harder edge.

Canon 1Ds Mark II with 180mm f3.5 L macro lens, first image 1/20 second at f8, second image 1/2 second at f 22

Ideally, the style of the image should be determined by the subject matter. Often, of course, weather conditions play a part in what you are able to do. What's important is that you understand that you have a choice of styles and more important, that you understand how to achieve each one. Unfortunately, the style of a macro image is frequently determined by which approach a photographer finds most comfortable rather than by a conscious decision.

For example, one group of macro shooters sets the camera to the smallest aperture possible (f22 or f32) for almost every image. They rarely try taking an image at f8 or f5.6. This technique captures a realistic or editorial image and may well be what the photographer intends. Sometimes, however, photographers set the aperture to the smallest possible opening because they lack confidence in getting the appropriate depth of field or have trouble focusing. They use the small aperture as their safety net.

I captured a number of different images of this ranunculus blossom, but this is one of my favorites. Each image took quite some time. The blossom was only 2 to 3 inches in diameter, so the depth of field was limited at any aperture. For this image, I wanted to get just the edge of a few petals sharp and keep most of the petals and background soft. It took time to position the camera to line up the edges of the petals in the foreground in the same plane as well as match the petals' pattern with petals in the background. I overexposed to keep the image light and airy.

Canon 1Ds Mark II with 180mm f3.5 L macro lens, 1/6 second at f11 +2/3 stop exposure

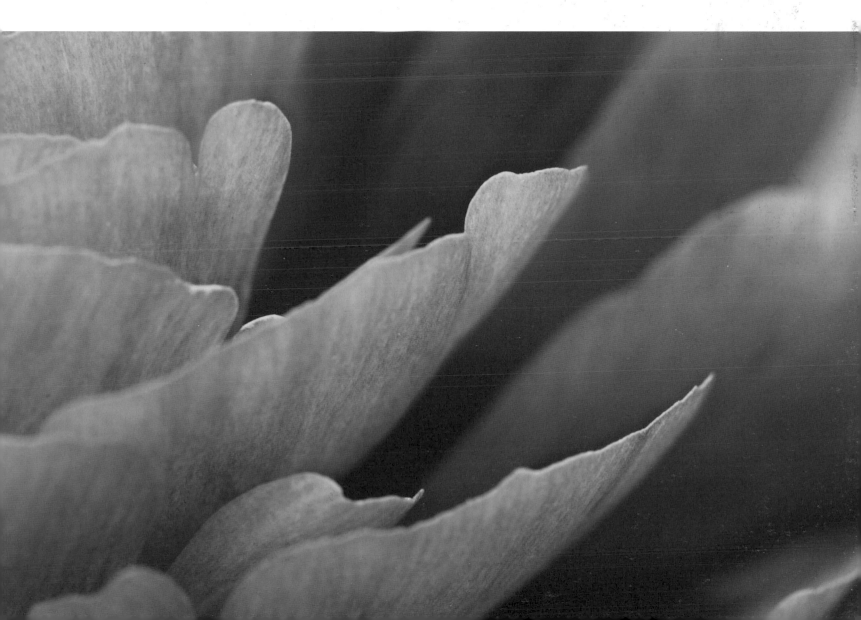

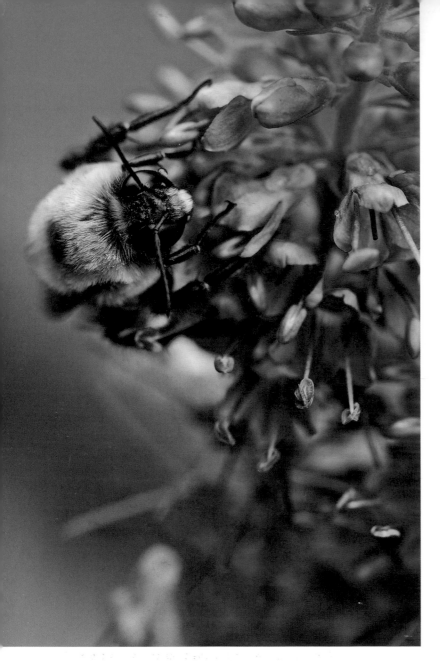

This image of a bee was captured early in the morning before it had gotten active. The low light levels meant an exposure with a shallow depth of field. The bee hadn't started moving so I was able to move the tripod and camera for a pleasant composition. I focused on the bee's eyes and let everything else go soft.

Canon 1Ds Mark II with 180mm f3.5 L macro lens, 1/3 second at f8

The second group concentrates on more artistic images at an f-stop of f5.6 or f8, with a shallow depth of field or selective focus. These images have a very dreamy feel to them with lots of character if done well. Look at the greeting cards that use artistic macro images as examples. Some photographers choose this approach because they don't like working with a tripod or are unsure of the depth of field.

Both the realistic and artistic approaches are valid. The group of artistic shooters may have difficulty taking the clean, crisp type of shot, just as the editorial or scientific type shooter might have trouble with the artistic approach. The problem is not with the approach itself but with the fact that if you belong for the most part to one group or the other, you are missing half of the wonderful macro images available. The editorial shooter misses the artistic images while the artistic shooter misses the more realistic possibilities.

The better course of action is to be able to handle any type of shot and decide which aperture or approach to use based upon the image and the field conditions. If you want to show all the details in a blossom and

Break Out of Your Comfort Zone

If you are having trouble breaking out of your comfort zone, try this. Pick whichever approach you use most often. Start by shooting every image at your usual f-stop and then after a few images, bracket the f-stop. For example, if you usually go with the realistic style, set the aperture at the usual f22, press the shutter-release button, then try an exposure of f11 and then one at f5.6. If you generally take a more stylistic image, shoot images at f5.6 and then every once in a while change your aperture setting and shoot the same image at f11 and f22. Make sure to use your tripod and cable release.

Review the images and see how the different aperture settings affect the look and feel of each. Repeat shooting the same image at different apertures each time you go out. Little by little, you will become more comfortable at the different f-stops and be able to recognize and take advantage of opportunities that are better suited to one style or the other.

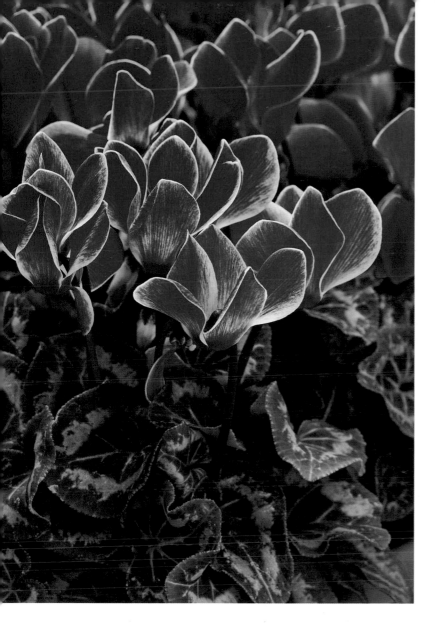

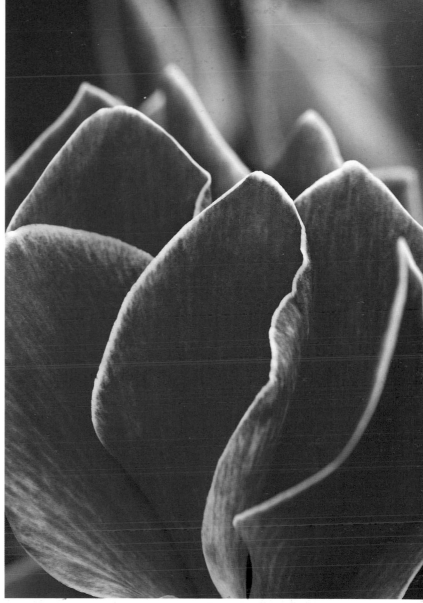

the conditions permit, take the small aperture approach that allows most of the image to be sharp. If there's a breeze or not enough light, look for an artistic possibility with just a small section of the image being in focus. Better yet, throw caution to the winds and try both styles on the same blossom.

No matter which approach you normally go with, the goal should be to reach a point where you are able to choose the style of an image based upon your vision, the image, and the weather conditions, and not just because the style fits your comfort zone.

These two images of the same cyclamen plant were taken within a few minutes of each other and were captured at the same aperture setting. The image showing more of the plant has enough depth of field to ensure that the blossoms and leaves are reasonably sharp. The depth of field, however, drops sharply the closer the camera is to the subject and is limited to just a few petals in the second photo. The image of the blossoms and leaves is more realistic, while the one of the petals is more artistic.

Canon 1Ds Mark II with 180mm f3.5 L macro lens, blossoms and leaves 1/30 second at f11, petals 1/10 second at f11

Some images grow on me, and this is one of them. At first glance, I was not happy with some aspects of this image of a petunia blossom. I considered removing it from the library but hesitated each time. Finally, the unusual angle and overall dreamy feel won me over. If you aren't positive about deleting an image, come back in a few weeks and review it again.

Canon 1Ds Mark II with 180mm f3.5 L macro lens, 1/60 second at f8 +1 stop exposure

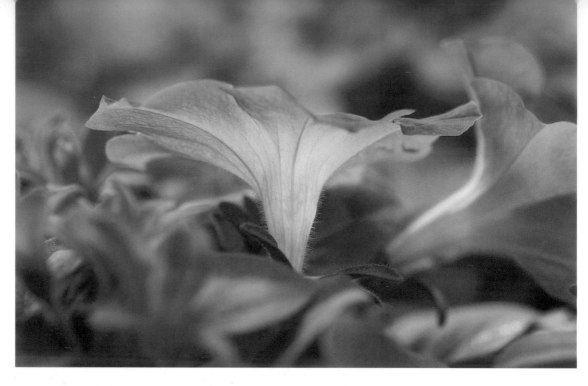

Pennisetum alopecuroides *'Hameln' is a beautiful ornamental grass, especially in the fall with the arching flower spikes. I wanted an image that was more than just a plant ID photo. In moving around the plant, I noticed the arcs of these four flower spikes seemed to mimic or echo one another. I chose to focus on the second spike from the front and have only that spike be tack sharp. I underexposed to accentuate the warm backlighting.*

Canon 1Ds Mark II with 180mm f3.5 L macro lens, 1/40 second at f11 -2/3 stop exposure

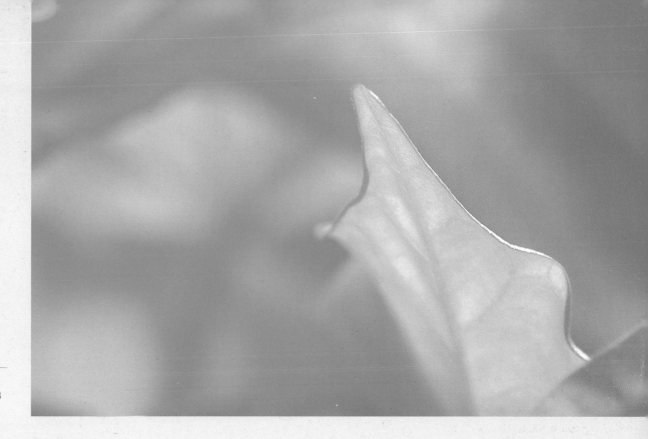

*A mosaic of greens composed
of potato vine leaves.*

Canon 1Ds with 180mm f3.5 L
macro lens, 1/15 second at f16 +2/3
stop exposure

A Vision in Green

This is an image of the leaves of a potato vine that was sitting in a container on a table in a greenhouse. However, I didn't see it that way when I was walking by. What I saw was the light coming through the leaves creating a mosaic of shades of soft green. It was monochromatic but with a lot of feeling. In my mind, I envisioned a very artistic interpretation. The challenge was to capture the feeling of the soft greens while keeping one detail in sharp focus.

I looked for a leaf section within the plant to add an anchor to the soft greens. I wanted the focus point leaf to be in the center of the plant so leaves would be out of focus in the foreground and the background. The leaf section also had to be separated from any other leaves. In addition, the tip of a leaf would not provide enough of an anchor so I looked for a leaf with a side view.

I couldn't get into position with the camera on the tripod so I hand held the camera for this image. In this close, every aperture setting has a fairly shallow depth of field. It was a juggling act between enough depth of field and a long enough shutter speed. I decided to set the aperture at f16 in order to add a safety margin to compensate for the imprecise focusing of hand holding and hoped that I would be able to steady the camera enough for a 1/15-second shutter speed.

I decided to position the section of the leaf in focus on the right side of the image and adjusted the focus point in the viewfinder to match this intended composition. I moved the camera in to get a feel for how large an area I wanted to include in the image. I pressed the shutter-release button halfway to prefocus on a section of the leaf. I then turned off the autofocus to prevent it from trying to latch on to any other leaf when I actually took the picture. The lighting on the leaf section where I focused had very pronounced glare on the edge. I decided that keeping the glare helped the image, so I didn't try to eliminate it by using a polarizing filter.

I braced my elbows on a table to steady the camera and slowly moved the camera in closer. By concentrating on the viewfinder I could see the line of the leaf come into focus. I took multiple exposures, repeatedly moving the camera in tighter and pressing the shutter-release button each time I saw the section of leaf come into focus. I did this to increase the chances that I would get one good exposure with the leaf section in focus.

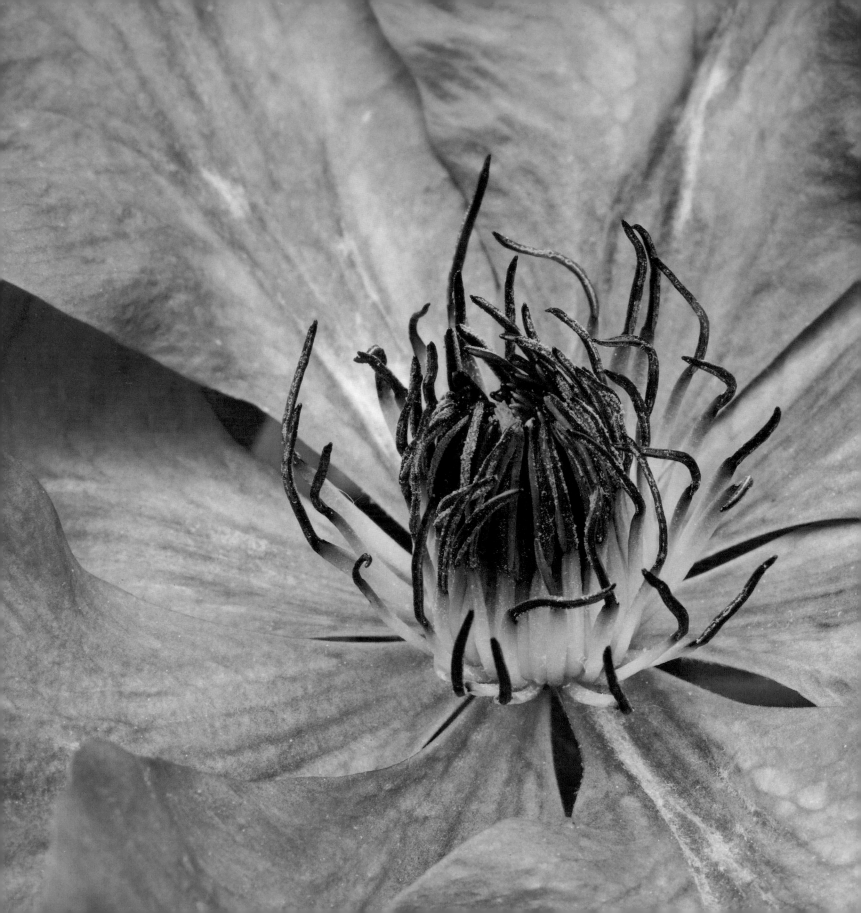

Flora, Fauna, and Beyond

ONE OF THE MAJOR ADVANTAGES OF MACRO photography is that there's no limit to the possibilities close to home. You don't need to worry about what equipment to bring, what the weather might be, or any of the other details associated with traveling. In fact, you may not have to venture beyond your own backyard. Even the apartment dweller can find macro photography opportunities within walking distance. If you don't have your own yard; you can photograph houseplants or visit a public garden near your home.

I found this blossom just before dawn. The color of this clematis is good enough all by itself, but the addition of the little patches of green really raise it to the level. I raised the ISO to 320 to compensate for the almost pre-dawn darkness. Everything was very still so I used a small aperture and long shutter speed.

Canon 1Ds Mark II with 180mm f3.5 L macro lens, 1.6 seconds at f22 +2/3 stop exposure, ISO 320

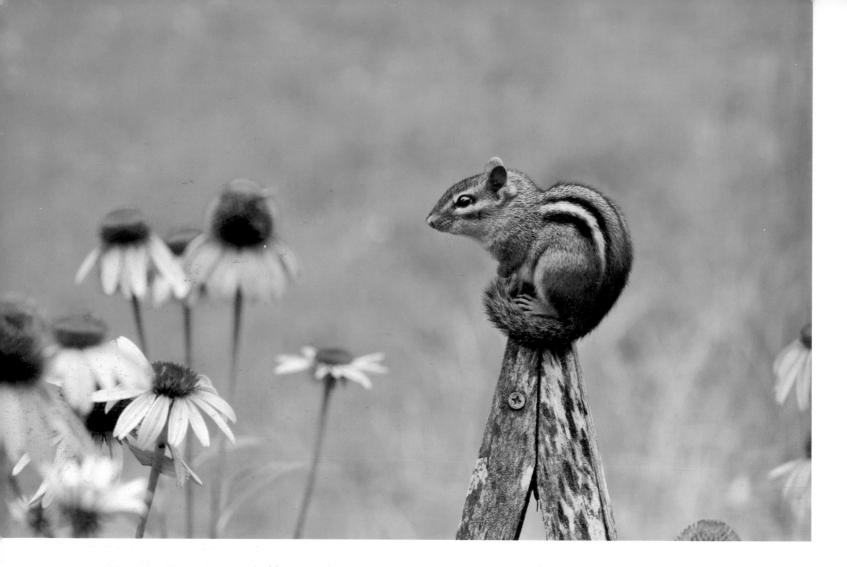

In addition to convenience, there are other advantages to working close to home. Photographing outside in familiar surroundings offers the greatest opportunity to get the best images throughout the year. Changes in the light from morning to evening are a known factor as opposed to a guessing game. For example, you know that tall trees block the early morning light in your garden so any macro images in this location are better taken in the afternoon. Day by day you can assess the conditions of the plants as well as observe the conditions of the light. Another plus is the ability to plan ahead. A quick walk around the yard tells you which plants will be coming into bloom or are at their peak, as opposed to traveling a long distance only to find that flowers are already past their prime. Unwanted surprises are kept to a minimum when you photograph close to home.

How do you decide what to photograph? Photographers choose a subject based upon an emotional response, whether to a flower or an

Early one morning, I was looking out at the garden and deciding if I should grab the camera and do some photography or go to the office and work on the computer. As I glanced around, I noticed this chipmunk sitting atop a plant support also checking out the garden scene. Both the chipmunk and I were making decisions. My decision was to set up the camera to capture this image. His decision was to rest until I got the photograph.

Canon 1Ds Mark II with 70-20mm f2.8 L zoom lens with a 1.4‡ extender, 1/8 second at f11

Photographing in Public Gardens

Public gardens offer year-round photographic opportunities. Many gardens have certain days when they open early or, in the warm weather, evenings with extended hours. The hours as well as what's in bloom each month of the year is usually available on their Web sites. If you are going to be photographing in a public garden, make sure to check on its tripod policy. Many gardens require a tripod permit or may allow tripods only during certain hours. Whatever the case may be, make sure you remain on the paths and take care not to put your tripod in the beds. Some public gardens also require the photographer to sign an agreement that any photos taken in the garden will not be used for advertising purposes without permission. Please respect the policies of any garden you visit.

insect or animal. In this chapter we will take a look at some possible photographic approaches for capturing each. Whether shooting in your own backyard or in a local garden, practicing new techniques close to home prepares you for that special trip so your time and energy can be spent on making images and not on trying to decide what to shoot and how to shoot it.

Flora

The botanical world is an unlimited treasure trove for macro photography. There's not a single part of a plant that hasn't been photographed. In addition to flowers, there are leaves, bark, buds, stems, seedlings, seedpods, and more to consider. All are good subjects for macro images.

I photographed this begonia hybrid indoors. I included a small section of container to indicate to the viewer that it's a container plant without the image becoming dominated by the container. The camera was metering the shadow area and gave an exposure that would open up the shadows too much. I adjusted the exposure to slightly underexpose so that the side-lighting would be obvious and the shadows wouldn't get too bright.

Canon 1Ds with 180mm f3.5 L macro lens, 1/8 second at f16 –1/3 stop exposure

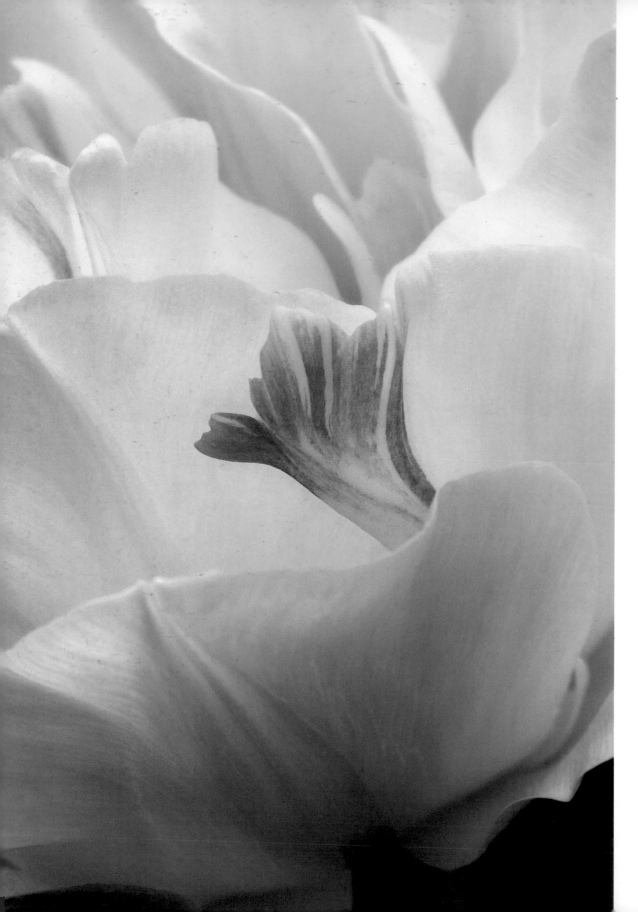

The splash of color in this tulip caught my attention. Even though the color is a result of a virus in the plant, I decided it made a nice image. I tilted the camera on an angle so the image wasn't straight up and down, and included a portion of the stem to prevent the image from becoming nothing but petals. To make sure the stem and the bottom of the blossom didn't disappear in the shadows, I added light with a reflector. The bright yellow misled the camera's meter into thinking there was more light than there was, so extra exposure was needed to keep the yellow clean.

Canon 1Ds with 180mm f3.5 L macro lens, 1/20 second at f16 +1/3 stop exposure

This image of hosta leaves and dewdrops required some tough decisions. A high, tight camera angle would get the large leaf sharp but lose the shape of the dewdrops as well as some of the curves of the other leaves. A low camera angle would work for the dewdrops but eliminate the curve of the large leaf. I pulled back to include the curves of the surrounding leaves and set a medium-low camera angle for the drops. I used a small aperture to get the drops sharp and still maintain the detail of the leaves. Focus was on the large drops.

Canon 1Ds with 180mm f3.5 L macro lens, 1/8 second at f16

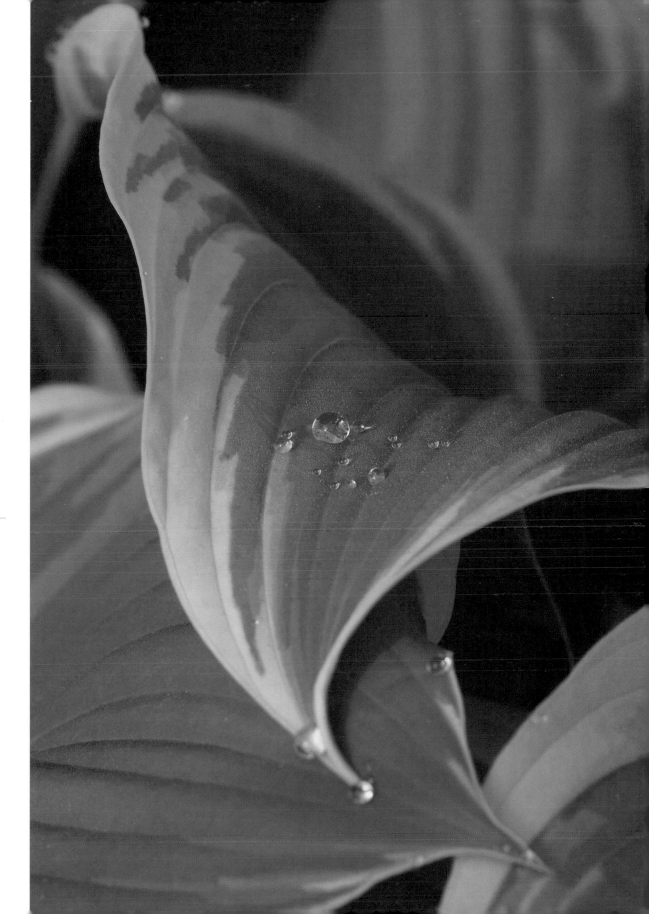

The relationship of bud to blossom is always good material for a photo-graph. Most times, the large blossom takes center stage with the bud providing support. In this case, the blossom provided the background and the bud was in the spotlight. I tried many captures to make sure I was successful on at least one. The captures were varied with different exposures, focus points, and apertures. Because the background was dark, I bracketed the exposure. Sharp detail in the background would make a very busy picture, but the bud needed to appear sharp, so I bracketed both focus points and apertures. I used a polarizing filter to eliminate some of the glare on the bud. This image is my favorite of the session. The bud is sharp, the background has enough detail to make the blossom recognizable, and most of the glare on the bud is eliminated.

Canon 1Ds Mark II with 180mm f3.5 L macro lens, 1.6 seconds at f16 +1/3 stop exposure

Flowers

Initially it may be a flower or its color that catches your attention. Flowers can be bold, dramatic, subtle, shy, monochromatic, vibrant, colorful, round, narrow, upright, nodding, tubular, or any of a hundred other things. Besides offering single, double, or triple blossoms, a flower may afford multiple views within a single blossom that would make exciting macro images. The petals, stamen, and anthers are wonderful subjects and can be dramatic images in their own right. With their widely varying shapes, sizes, and colors, flowers provide a never-ending source of mate-rial for macro photographers.

There are no hard-and-fast rules for photographing flowers. Keep in mind that you want the image to appear as beautiful as it is in the garden. You want viewers of your image to be so excited when they look at your photo that their response is "I have to have that flower in my

How Many Blossoms?

How many blossoms to include in a photograph may seem to be a strange question, but I have heard numerous photographers comment that they do not like a certain image because it shows an even number of blossoms. The thinking behind this is that an odd number of flowers appears to be less static than an even number of flowers. If everything else is equal, an image with an odd number of flowers has more visual impact and is less static than an image with two or four blossoms. Besides, an image of two blossoms may have the viewer trying to guess which blossom is the star and which one is the supporting character. This is especially true if the two are similar in size. In situations where there's an obvious difference in size between two blossoms, it's easy to tell which flower is the main subject. Don't spend too much time trying to decide whether to include an odd or an even number of blossoms in your picture. Look at both options. The odd-or-even rule is only a guide.

garden," or maybe "I want a print of that image in my house."

First, try to analyze whatever it was that initially caught your attention. The flower is stationary and is not going anywhere. You should be in no rush to press the shutter-release button and move on. What makes it worthwhile for you to spend your time capturing this image? Look at every characteristic and detail of the flower. Is the blossom in prime condition without any tears or faults? Is the flower tiny as a small violet, or big and bold as an old-fashioned hibiscus? Is it flat like some of the dahlias or does it have a structure more like a daylily? Is it a soft pink rose or a bold red begonia?

Get a vision in your mind of how you see the final image. Think about some of the major considerations. What have you included in the frame? Have you included a single blossom or multiple blossoms? Where are you going to place the blossom in the composition? Is the background helpful or is it a hindrance? Are there any dead leaves or spent blossoms that will detract from the image? Does the lighting work for or against your vision?

This image of polka-dot plant (Hypoestes) and primrose (Primula) is all about color. The color of the primrose is so strong that I included more of the polka-dot plant in the picture to keep a balance. I looked for a composition where the transition from one plant to the other would be a curve rather than a straight line. I used a small aperture to get everything sharp.

Canon 1Ds with 180mm f3.5 L macro lens, 1/10 second at f22

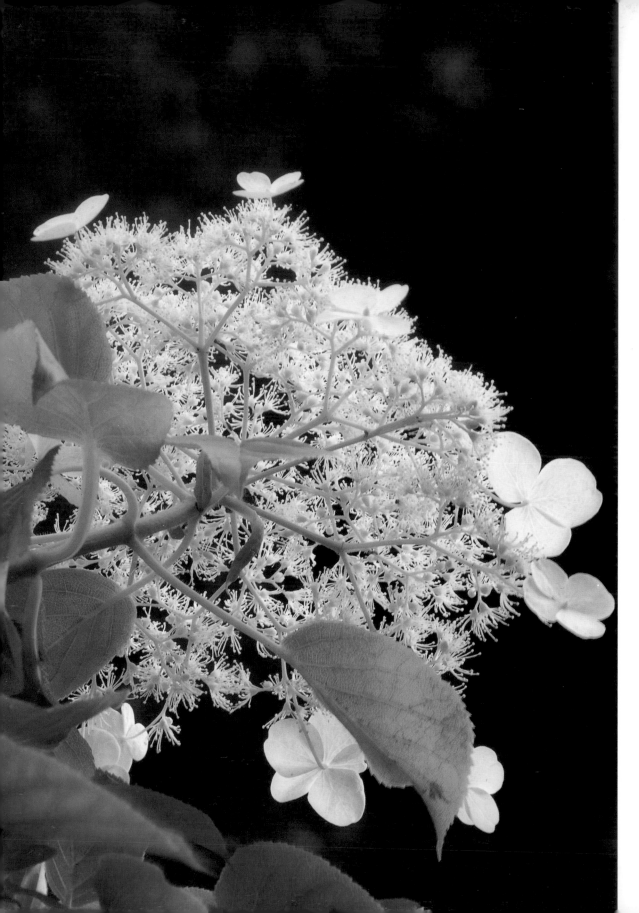

Photographing this climbing hydrangea blossom in the usual manner of looking down on the blossom with the leaves as background would not have been very exciting. Photographed from the backside with strong backlighting, the blossom is more dramatic. It was impossible to get the plane of both the blossom and the camera in line. A small aperture was called for to get the entire blossom sharp. I adjusted the exposure on this white subject to make sure the white came out as white.

Canon 1Ds with 180mm f3.5 L macro lens, 1/5 second at f22 +2/3 stop exposure

Now that you have a general idea for the image, here are a few tips. If you are shooting a group of blossoms, try having one blossom totally included in the frame with just small sections of the other blossoms evident. This acts as a frame directing the viewer's eye to the main blossom. When doing this, it's important to make sure that it's obvious to the viewer that you wanted to have only portions of the surrounding blossoms visible. Don't make the viewer guess whether you intended to include an entire blossom but mistakenly cut off the tip of a petal. When you include sections of other blossoms, you can move the main blossom off center. This makes a composition less static than if a single blossom were dead center. Try different placements to decide which is the most visually pleasing.

Framing a blossom like this aster with other blossoms in the background can be very effective. I placed the subject off center and used a small aperture with focus on the disc of florets in the aster's center to keep the subject sharp while the other blossoms were out of focus. The camera's histogram indicated that the metering was seeing more light than was present and added exposure was needed.

Canon 1Ds with 180mm f3.5 L macro lens, 1/10 second at f22 +2/3 stop exposure

True Flower Colors

With film, capturing the true color of flowers was a challenge and sometimes seemed impossible. The most common problem was the ageratum effect, where blue flowers turned purple. Digital photography has certainly made it easier to make the image color reflect the actual color of the flower. Perhaps the easiest and most practical way to match color is to shoot in the raw format using a color checker card or digital gray card.

Shoot the first frame with the color checker. Then shoot the next frames without the card. After downloading the digital files onto the computer, click on the color checker in the first raw file with the eyedropper in software such as Adobe Lightroom or Photoshop. This adjusts the file for both neutral color temperature (blue and yellow) and color tint (red and green). The adjusted digital image file (the one with the digital gray card or color checker card) will now have neutral color temperature and tint settings. These settings can be used to adjust the rest of the images photographed in the same lighting.

This is a second example of framing, but in a more open manner than with the aster. More background is shown and the framing is accomplished by including both foliage and blossoms. The subject is again placed off center.

Canon 1Ds with 180mm f3.5 L macro lens, 1/30 second at f16 +1/3 stop exposure

When including three or more blossoms, try to find an attractive arrangement. Maybe the blossoms form an arch or a triangle, adding impact to the image. Sometimes the camera can be angled in such a way that the blossoms form an S curve, leading line, or arc for better composition. This is also an opportunity to try out the rule of thirds. Move in a little closer or pull back a little. Remember that everything in macro is magnified. Small changes to the camera's position and the composition can result in a dramatic change in the look and feel of the image. Try a number of different setups to see what appeals to you most.

Many times it's a spot of color from a blossom in the garden that catches your eye. There's a direct relationship between the color of a flower and its background or surroundings. It's important to consider the effect of different colors in a photograph. Warm colors tend to come forward while cool colors tend to recede. An image with a warm-colored blossom in front of a cool-colored one has much more depth than a cool-colored blossom in front of a warm-colored one. Even a blossom with cool

This group photo of Osteo-spermum has four arcs hidden in its composition. The arcs, formed by the blossoms, start on the left side and move to the right. These arcs are what add motion and interest to this image. Without them, the image would become static like toy soldiers all in a row. When capturing images of groups of blossoms, look for some composition feature that raises the image out of the ordinary.

Canon 1Ds with 180mm f3.5 L macro lens, 1/3 second at f16

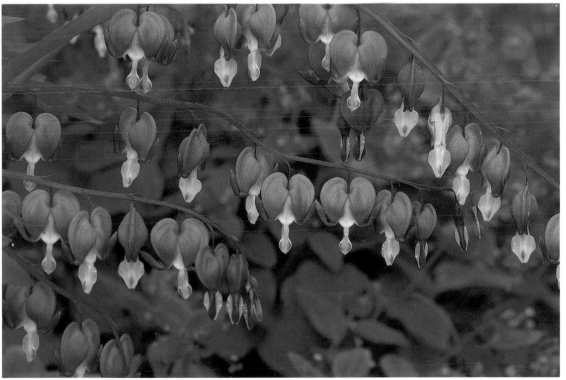

Look at this image and imagine what it would be without the blue forget-me-nots in the background. The small amount of blue comple-ments the pink bleeding hearts and adds depth to the image. Without the blue in the background I might have elected a different approach. The stem on the right slanting down helped with the framing. I used a small aperture to get all the bleeding hearts sharp.

Canon 1Ds with 180mm f3.5 L macro lens, 1/3 second at f22

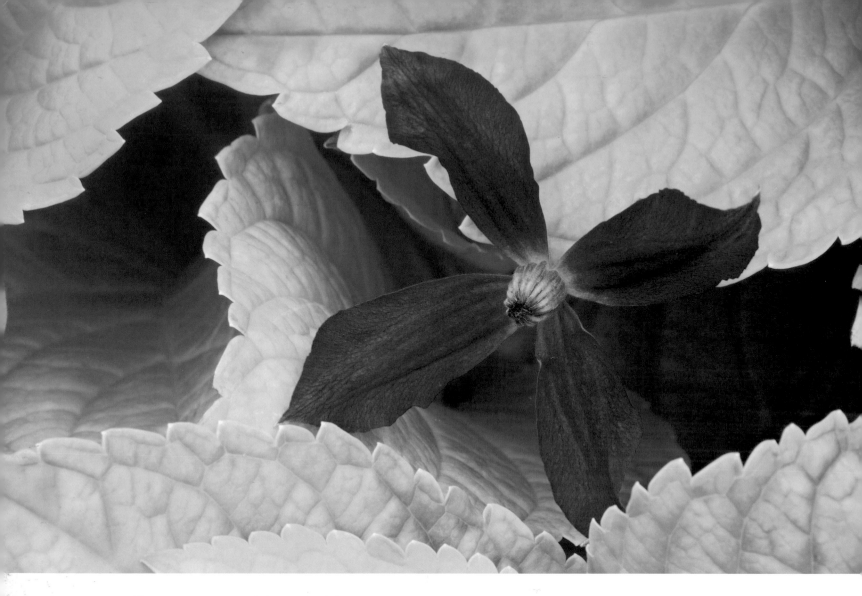

This small purple star-shaped clematis blossom peeking up through lime green coleus leaves could not be passed without capturing the image. Usually a light background doesn't work, but this flower jumps out. The image serves as a good example of complementary colors. I bracketed the exposure because of the strong colors

Canon 1Ds Mark II with 180mm f3.5 L macro lens, 1/2 second at f16 -1/3 stop exposure

foliage behind it is more dramatic. Images with brightly colored blossoms in front of less vibrant colors will also have more impact.

If you find the perfect subject but the background presents problems, consider blocking the light behind the subject to tone down the background and keep it from competing with the subject. If the lighting isn't right, try to diffuse or block it to help the subject stand out, or move around the subject with your camera so it's backlit.

Next look at the shape of the flower. Is the light on the flower coming from the side so it defines the shape? Is there one camera angle that shows the shape to better advantage? Is the structure flat so the entire blossom can be in focus (sharp), or is it very dimensional so you have to decide what to have sharp and what can be soft? The same considerations hold true when you are thinking about how to capture the texture of a flower.

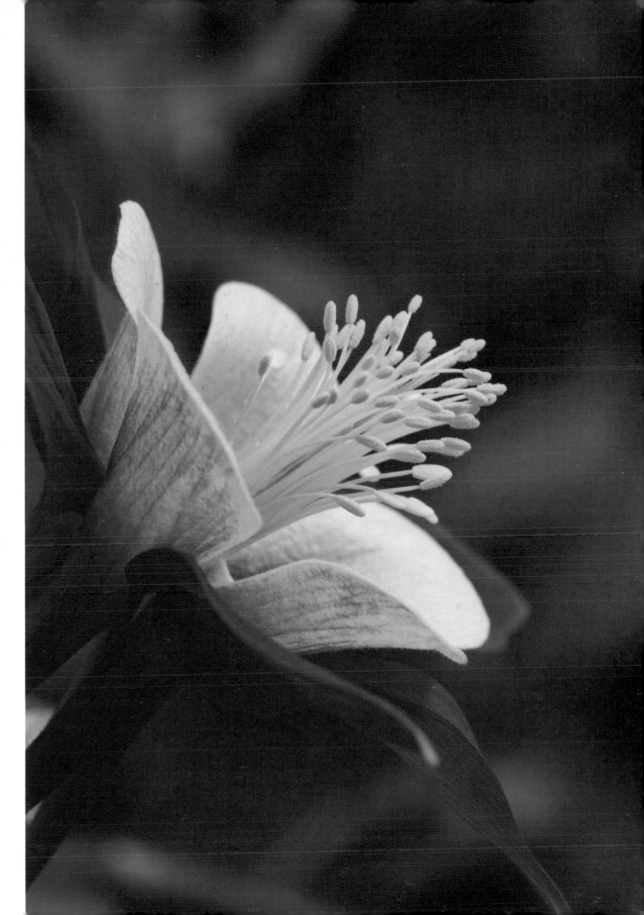

On some columbine blossoms, such as this bloom of Aquilegia *caerulea 'Origaml Rose and White'*, the spurs open so that there are two planes to the blossom. *Shooting this image from the side minimized the spurs so the viewer's attention is focused upon the flower. This variety has an upward-facing flower as opposed to the usual pendant blossom. Photographed in tight, it gives the image an optimistic feel.*

Canon 1Ds with 180mm f3.5 L macro lens, 1/10 second at f16

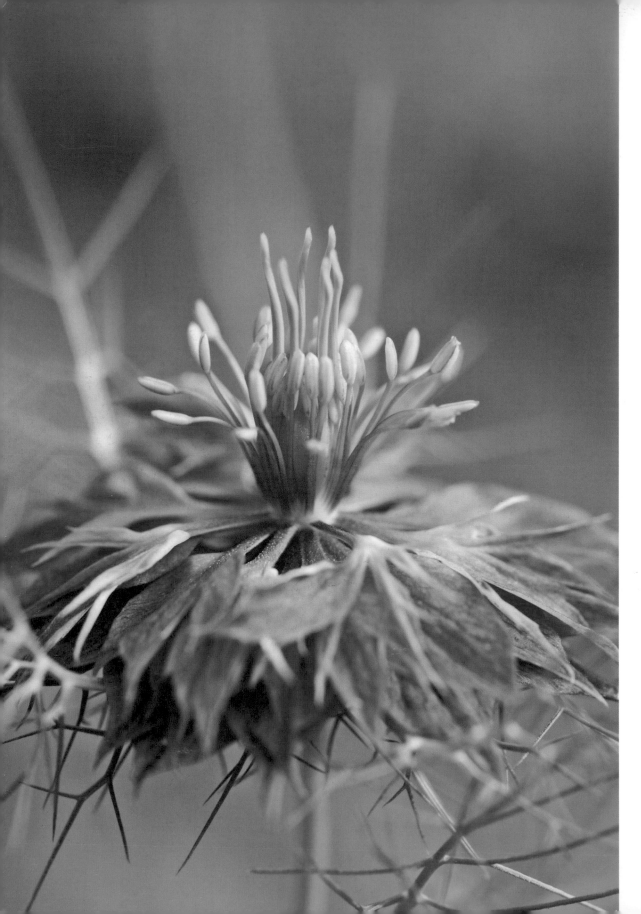

Nigella damascena *'Miss Jeykll'*
is a lovely annual that keeps
reseeding itself in one corner
of our garden. Every year I get
an opportunity to capture more
images in a variety of ways. The
foliage is attractive in a garden
image but is so dissected that
it's difficult to get a macro image
of one blossom without a busy
background. A shallow depth
of field softens most of the
background and eliminates the
feeling of clutter in the image.
The two soft flowers in the back-
ground help frame the subject.

Canon 1Ds Mark II with 180mm f3.5
L macro lens, 1/50 second at f5.6
+1/3 stop exposure

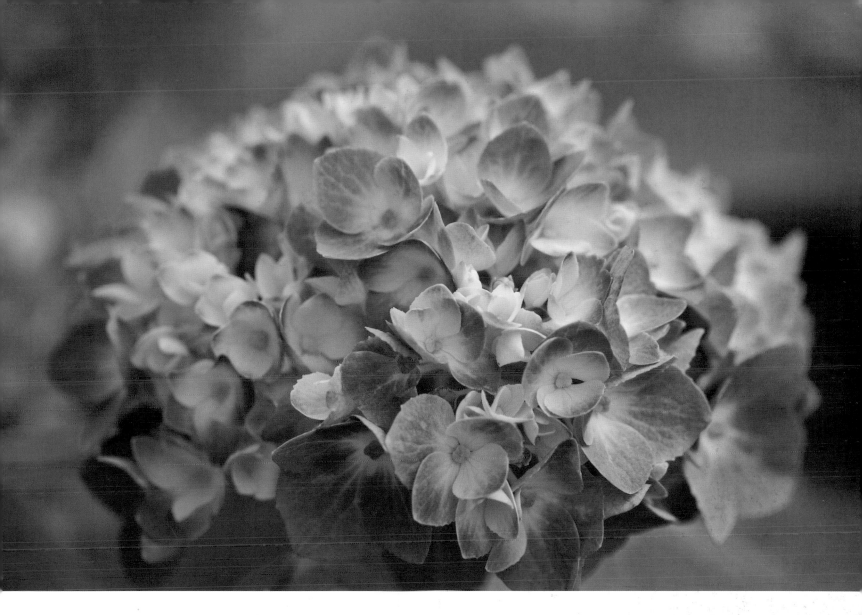

Adding a sense of depth to a flower photograph gives it more visual impact than an image that appears flat. In landscape photography, an easily perceived change in size from the foreground to the background of a scene creates a sense of distance and depth. Macro images, lacking a dramatic difference from front to back, require different techniques to create this feeling.

One of the landscape photographer's tools that works in macro photography to create the feeling of distance, even though you are shooting in a very small area, is using a shallow depth of field to keep the foreground sharp while letting the background go soft. The transition from the sharp foreground to the soft background causes the viewer's eye to move from front to back in the frame. The distinction between sharp and soft should be evident. This type of transition can also be used

This hydrangea blossom is another image with very shallow depth of field. In this case, I used a large aperture and slight overexposure to give the image a soft, dreamy, airy feel.

Canon 1Ds Mark II with 180mm f3.5 L macro lens, 1/50 second at f5.6 +2/3 stop exposure

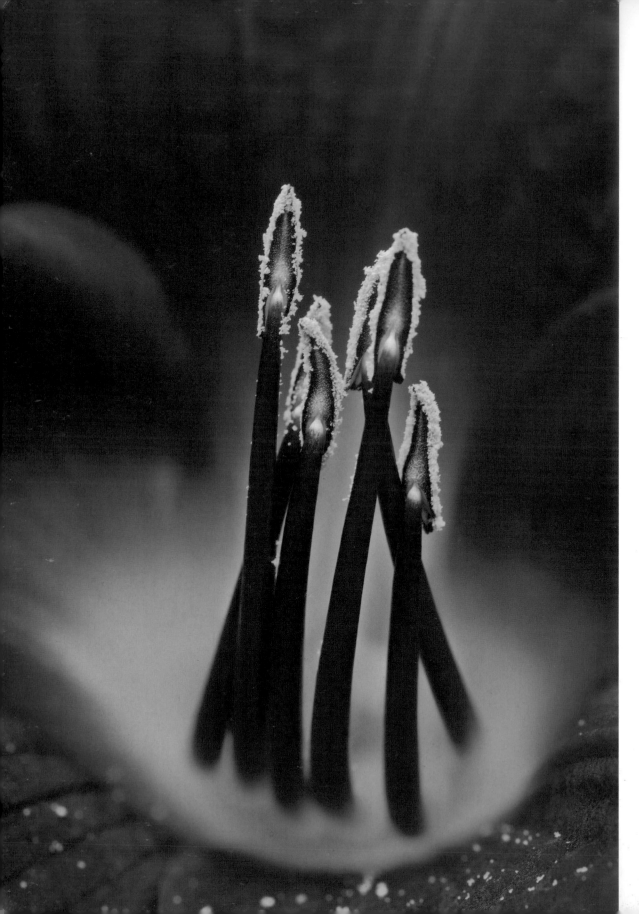

I noticed that the stamens of this daylily were growing almost straight up and decided to try for an unusual image of the stamen and throat area. Going in this close, there was no way to get the stamens sharp all the way from anthers to base. Adding depth of field would only add detail around the stamens that wasn't needed. I decided to get some of the stamen stem and the anthers with the pollen sharp and let everything else go soft. A bonus turned out to be the pollen that had fallen onto the petals.

Canon 1Ds Mark II with 180mm f3.5 L macro lens, 1/4 second at f11

to separate one blossom from another. Even when you are working with just a few petals of a flower, it's possible to go from sharp to soft.

You can also use lighting to keep an image from appearing too flat or one-dimensional. The play of light between bright areas and shadows gives depth to a photograph. Sometimes if a blossom or a group of blossoms is evenly lit, adding shade to a small portion of the image will change it subtly. In the same manner, highlighting one blossom or a section of a blossom will move it forward in the image. Just as you block light to add shadow on a subject, you can reflect light onto a small portion to create a highlight.

There isn't just one way to photograph a flower. Each situation is different, depending upon the blossom, the light, and the photographer's vision. My suggestions are not rules but merely ideas on how to approach each image. The key is to take your time and make decisions that help you reach your goals.

Ornamental kale is a very popular addition to gardens for winter interest. This straight-on camera angle, while somewhat flat, does the best job of showing the frost and the geometry of the plant.

Canon 1Ds Mark II with 180mm f3.5 L macro lens, 1/4 second at f22

Foliage

When photographing flora is mentioned, everyone immediately thinks of flowers. Flowers are colorful and exciting, it's true, but they're in perfect, peak condition for a relatively brief period. Most of the season, gardens are dominated by foliage. There are whole families of plants, such as ferns, hostas, lamb's ears, and coral bells, that are grown mainly for their interesting foliage. These subjects are often overlooked as good candidates for the macro photographer.

I was looking for a good example of a fiddlehead to photograph when I came upon this frond starting to open directly in front of another frond already opened. It was positioned as if it were a mirror in time. Composing the fronds on an angle kept the image from being too static. I selected a small aperture so that the opening frond would be sharp and the back frond would also be as sharp as possible. I bracketed the exposure toward overexposure because of the light green of the subjects.

Canon 1Ds Mark II with 180mm f3.5 L macro lens, 1/4 second at f22 +2/3 stop exposure

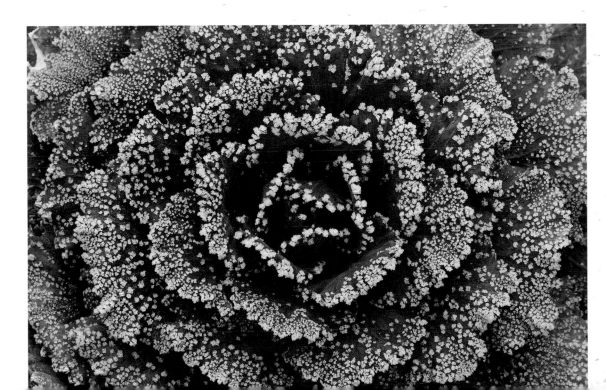

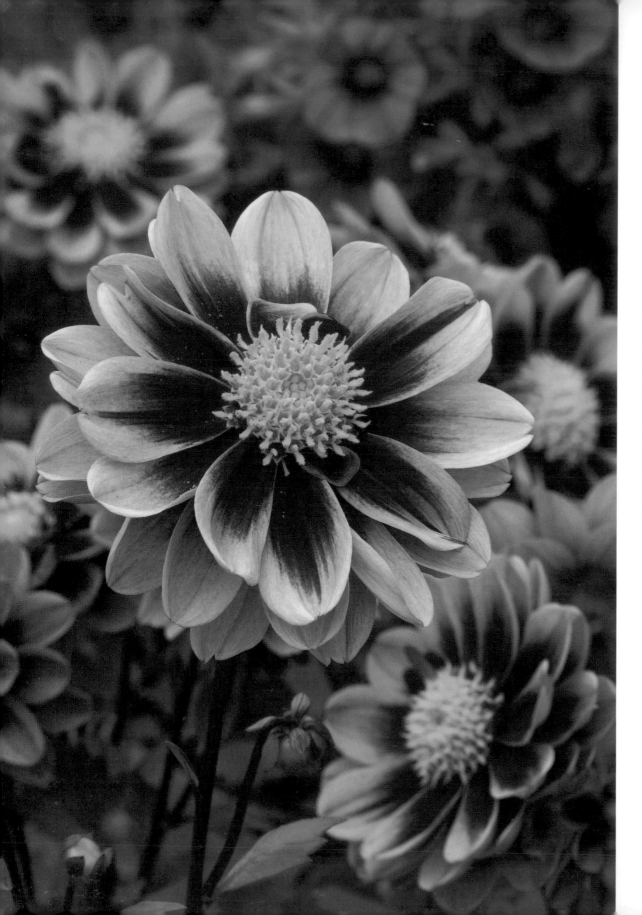

This dahlia image was captured in a greenhouse. I had permission to move plants and was able to position different plants to achieve the composition I wanted. The first plant provided the main subject. Additional plants were moved into position to provide blossoms at different angles. The last plant I moved into the scene was a cool-colored petunia in the upper-right corner of the frame. I used a small aperture to make the sharpness gradually lessen from the subject to the petunias.

Canon 1Ds with 180mm f3.5 L macro lens, 1/20 second at f22

The same principles of color, shape, and structure apply to photographing foliage as to photographing flowers. Try to find subjects in lighting conditions that bring out the shape and structure of the plant. Look for opportunities where shapes are repeated in the foliage. Keep an eye out for special qualities like the grace of an ornamental grass, the appealing curl of a hosta leaf, the soft texture of lamb's ears, the dramatic spines of a cactus, or the beautiful gesture of a fern frond.

Look at every part of the world of flora as a photographic opportunity. If you find you are only making flower close-ups, challenge yourself to find an image you like without a blossom as the subject. Conversely, if you shoot only foliage or large subjects, try shooting the delicate flower of a columbine or an abstract image of a rose petal.

Special locations

Sometimes an opportunity will arise to photograph in a greenhouse. At first glance this seems like the best of all worlds. The greenhouse has quality plants with blossoms in prime condition. The lighting in many cases is diffused. And the plants are waist high so limited bending of the knees is required. Unfortunately, there are some hidden problems for photography in greenhouses that are often overlooked.

The first problem involves the background of straight lines from the support structures and bright squares of glass. Unless you are trying to show an image of plants in a greenhouse, bright squares and straight lines are major distractions. Ask if it's all right to move plants. Maybe additional plants can be placed in the frame to hide these elements. Try a higher camera position or use a longer lens for a narrower field of view to eliminate the greenhouse walls in the picture. Take extra care and pay extra attention to what's included in the image.

The next concern is the ease of movement of both you and your equipment in a greenhouse. Many times, using a tripod in a greenhouse is cumbersome. The aisles between plants are narrow and getting the tripod into position can be difficult. This is where a tripod with independent legs is needed. Use extreme care when moving your tripod and camera. Make sure that no plants are affected by your actions and always ask permission to use the tripod.

The third problem in greenhouse photography is air movement. This is very deceptive. During the main part of the day, there's always a cooling or warming movement to the air. It may be a very subtle movement that goes unnoticed until it shows up as a blurred image. Locate any fans or heaters and look for subjects away from that area, where the plants are least affected. Examine your subject in the viewfinder to see if leaves or petals are moving before pressing the shutter-release button.

There may be times when you are invited into someone's home to

The color combination and lighting in this tight photo of impatiens and lobelia in a container is very attractive. The directional side-lighting on the lobelia highlighted them without overexposing the impatiens. The depth of field, even with a small aperture, was about 2 inches. I bracketed the exposure.

Canon 1Ds with 180mm f3.5 L macro lens, 1/6 second at f22

photograph a collection. In your own home, you know which room has the morning light and which part of the house has the afternoon sun. In an unfamiliar location, one of the first things to do is to look for where the best lighting will be for morning and afternoon photographs. Look for opportunities to use sidelighting from a window or even a backlit image. Check with the owner to see if any of the plants can be moved.

When shooting in a house, whether your own or someone else's, don't worry about trying to eliminate all the background. It is, after all, a houseplant image. Keep the background simple, uncluttered, and out of focus. Houseplant images have a special feel, and houseplants are good subjects for the winter months.

Fauna

Insects are one of the most successful living groups on the planet. Finding them and photographing them, however, is a challenge. Whereas plants are rooted in one place, animals have no such anchor. They are programmed to be ever alert for any danger. For the most part, insects try to stay hidden or use camouflage as a defense mechanism. There are times, though, when you can capture images, such as when they feed or when climate conditions force them into behavior patterns that give you a chance to photograph them. Even then, when they're out in the open,

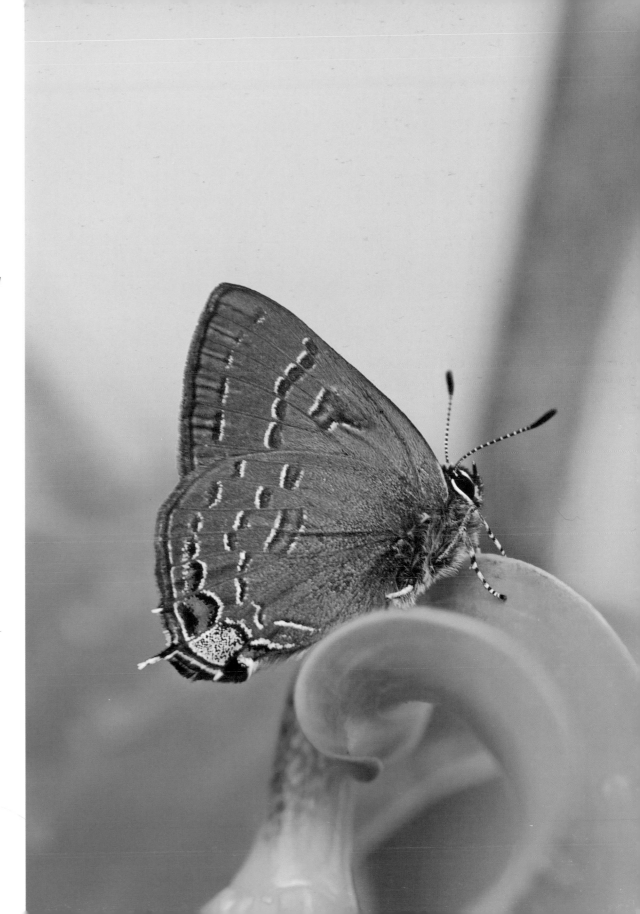

When I came upon this hairstreak butterfly in our garden, it was in full sun. The butterfly never stayed in one place long enough for more than one exposure. This meant I was constantly repositioning the tripod and camera to keep the butterfly and the camera parallel. I captured a few images but knew they would have too much contrast from the bright sun. As plan B, I slowly moved a reflector to block all sunlight from the butterfly. I managed to press the shutter-release button a few times and bracket the exposure before the butterfly flew away. Using a diffuser to soften the light on the butterfly, rather than blocking the sunlight, wouldn't have given enough difference between the butterfly and the background. This image was taken at the camera's recommended settings.

Canon 1Ds Mark II with 180mm f3.5 L macro lens, 1/6 second at f11

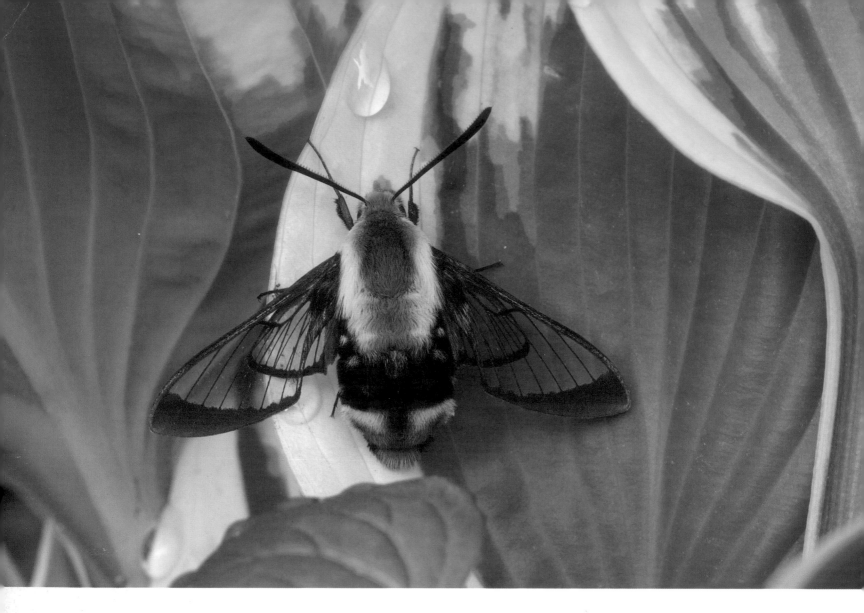

Early one morning I found this bumblebee moth resting on a hosta leaf. The lighting wasn't especially attractive but I had never seen this insect before. In fact, at the time, all I knew was that it resembled a humming-bird moth. I was able to set the tripod and camera for an image to show all the features of this new discovery before it took flight.

Canon 1Ds with 180mm f3.5 L macro lens, 1/2 second at f22

it's only natural that subjects scamper away when they sense a huge photographer with a tripod advancing toward them. Great macro images of animals are possible, but it takes more work.

To start off, keep in mind everything you have learned about photographing flowers and plants. In fact, the best practice for shooting insects is the work you do in macro flower photography.

The best time for locating and photographing insects is the very early morning hours. Insects are cold-blooded and the cool night temperatures keep them stationary or at least slow them down. Compared to an insect's size we have a very large profile, so we have to work to minimize that presence. Avoid wearing brightly colored clothing and move slowly. Most animals are more aware of danger coming from above them, so try to approach any potential subject at its own level or below. Use any

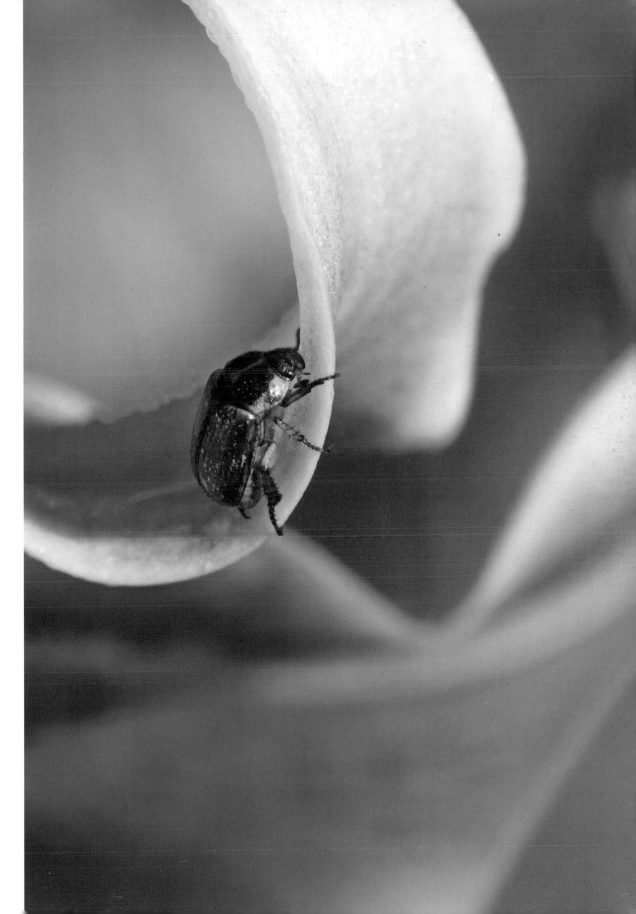

There are always going to be pests such as this oriental beetle, caught hiding in the curve of a lily petal, in any garden. Before giving this beetle an eviction notice, I photographed it in an artistic manner. The sunlight was just brushing the edge of the petal and the beetle. A medium aperture kept the edge of the beetle and the petal sharp while letting everything else go soft. I used a slight overexposure. I pressed the shutter-release button and removed the beetle.

Canon 1Ds Mark II with 180mm f3.5 L macro lens, 1/40 second at f11 +1/3 stop exposure

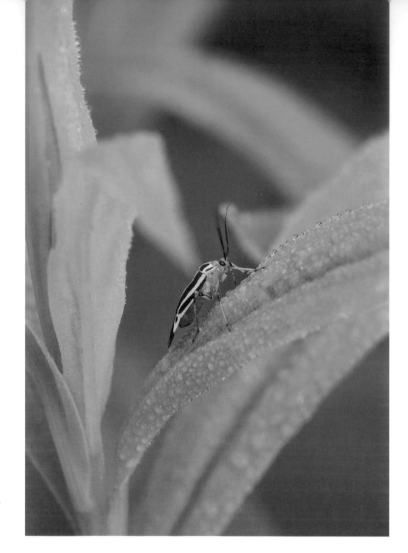

This four-lined plant bug is only 3/8 inch long but its color-ation makes it very visible in the garden. By staying low and moving very slowly, I was able to get the camera and tripod into position for a few images before it scurried away.

Canon 1Ds Mark II with 180mm f3.5 L macro lens, 1/6 second at f16

structure to hide your form. Even standing behind your tripod is better then letting your shape be totally visible.

If you sense your subject getting nervous, stop moving. Also, if it has hidden, wait it out. Sometimes if you get very still the sense of danger will pass and the subject will relax and return to its activity. If it remains hidden, you can often use your presence to move it into camera range. For example, many insects run to the underside of a leaf when they sense danger. Set up the camera for an image as if the insect were still on the top of the leaf and slowly move your hand toward the underside of the leaf to see if it will climb back on top. If you are ready, you may get the image. Remember, try to keep everything slow and careful.

If you missed the early morning opportunity, consider this. All animals are like humans in that some will tolerate closer proximity to you than others. So if you have more than one possible subject, find the one that's the friendliest. Start pressing the shutter-release button as you move in on the subject. Don't wait until you have your life-size image

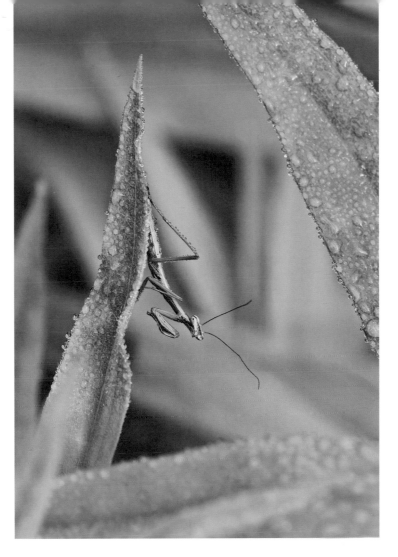

After finishing up the image of the four-lined plant bug, I glanced six inches to my left and noticed this immature praying mantis. It must have been watching me the whole time I was capturing the bug image. I rotated the tripod head and was able to capture this image without having to move the tripod. Many times, when you have moved into position and remain still, other opportunities will present themselves. If you have been in one place for more than a few minutes, look around before leaving your position.

Canon 1Ds Mark II with 180mm f3.5 L macro lens, 1/6 second at f16

to begin pressing the shutter-release button. Once you have one image, move in slightly closer to take another. Keep moving in until either the insect gets frightened and disappears or you get the close-up photo you wanted.

I try to do my insect photography with a tripod. Sometimes the tripod and camera can be set up in position ahead of time and, with patience, the insects will come to you. For example, choose a location next to a butterfly bush with several blossoms close to your tripod. If you remain still, butterflies may accept you as part of the environment and land on one of the blossoms. While you are focused on one butterfly, another may land near you. Take care to move slowly to prevent scaring any butterfly that may have gone unnoticed.

If using a tripod isn't possible, try hand holding a shorter lens, like a 100mm macro. Instead of setting the camera on aperture priority, you may have to set it on shutter priority to guarantee a faster shutter speed. In regard to camera settings, you need to be ready to press the shutter-

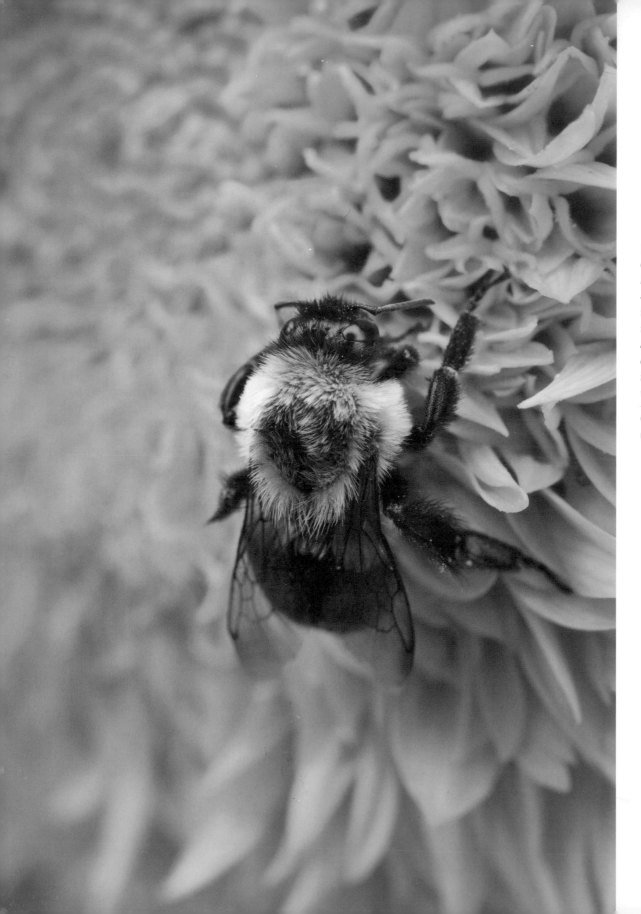

This image was captured very early in the morning, before dawn. Even with increasing the ISO to 400, I was still limited in aperture and shutter speed possibilities. I decided to use a medium aperture and focus on the bee's eyes. I also positioned the camera for an angled view to go along with the shallow depth of field.

Canon 1Ds Mark II with 100mm f4 macro lens, 1/8 second at f11

Lenses for Photographing Insects

Photographing insects calls for using longer lenses. Anything that increases the distance between you and the subject helps to keep the subject from getting frightened by your presence. The long 180mm or 200mm macro lens on a tripod works for shooting in the early morning. Later on during the day when the insects are more active, a 100mm macro lens handheld might work better. Another popular setup for photographing large insects such as butterflies is to use a long telephoto lens, such as a 300mm, with an extension tube or an extender.

release button at a moment's notice. Turn off the mirror lockup feature when you are photographing insects.

Photographing insects or any moving creature takes practice and patience. A smaller percentage of your insect images than your plant images will be successful. But a few good images of insects will make you forget the attempts that didn't work out.

Beyond

Once you have an understanding of capturing macro images and have developed a certain level of confidence, you will have opportunities to expand your horizons and go beyond the typical image. Advanced approaches to digital macro photography begin in the photographer's mind and vision. These approaches are about pushing the boundaries of all that you have learned in order to capture images that cannot be achieved by following the normal shooting guidelines.

For example, many photographers set their exposure to produce a "good" histogram, one having data from 0 to 255 for every image. The image you envision, however, may call for the data to be concentrated to the left or right in the histogram. When I saw an image of an ornamental grass flower stalk, I envisioned it as dark with only a small area highlighted. I wanted it to reflect the setting sun, the last rays of light. If I made exposure adjustments based on a "good" histogram on the camera or in the computer, all the lighting effects I wanted would disappear. If I intentionally underexposed this image by one or two stops, the graph on the histogram would be bunched to the far left, indicating that I didn't capture all the available information. The solution was to slightly underexpose the capture to get more information in the raw file and then lower the exposure additionally in Lightroom. This resulted in the same total underexposure as the first method but captured more information in the digital file.

The same thinking holds true in cases where the image has sections that are too bright. If you examine the histogram and see the flashing signal indicating overexposure or see clipping of the histogram on the right side, you know the image will be overexposed. Maybe the blown-out highlights or overexposure adds the feeling you intended to the image. When you already know the basics, you can break the rules and achieve images beyond the ordinary.

The accompanying examples will give you some different directions to explore when you work with lighting, light modification, the histogram, and composition. Use them as inspiration to push the limits of your macro work.

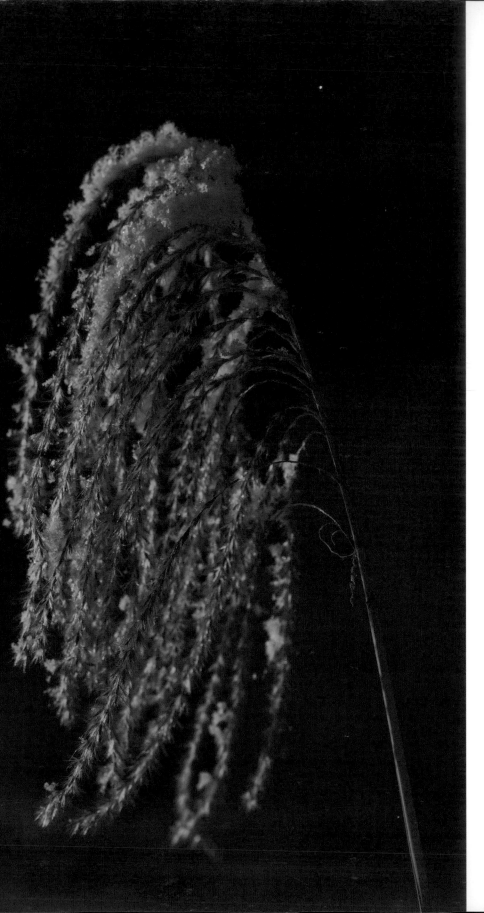

The perfect histogram does not always lead to the image you want. In this image, I wanted to capture the last rays of the winter afternoon sun on the ornamental grass flower stalk. A "perfect" exposure might result in lost detail in the sunlight. I bracketed the exposure from –1/3 to –1 stop and selected the –2/3 stop exposure based on the computer histogram. Then I lowered the exposure 1 full stop in Lightroom to reach the look I wanted, added some saturation, and converted the raw file to a TIFF.

Canon 1Ds Mark II with 70–200 f2.8 L zoom lens with D500 diopter, 1/800 second at f8 –2/3 stop at exposure and –1 stop in Lightroom

Histogram	
Channel: RGB	

Source:	Entire Image
Mean: 223.69	Level: 133
Std Dev: 26.38	Count: 119
Median: 230	Percentile: 1.51
Pixels: 259584	Cache Level: 4

Some columbine hybrids have flowers that face upward. This blossom was almost vertical. In tight, the stamens and pistil took on the appearance of a fountain. As in the previous example, following the camera's histogram and normal exposure settings would have produced a digital file quite different from this image. Clean white color along with vibrant yellow and light green colors were vital if this image was to be successful. I bracketed from one to two stops overexposure. I chose a medium aperture to keep the background soft yet have enough of the stamens and pistil sharp. Look at the histogram of this image to see how far to the right the data is concentrated. Still, it's not overexposed.

Canon 1Ds Mark II with 180 f3.5 L macro lens, 1/25 second at f11 +1-2/3 stop exposure

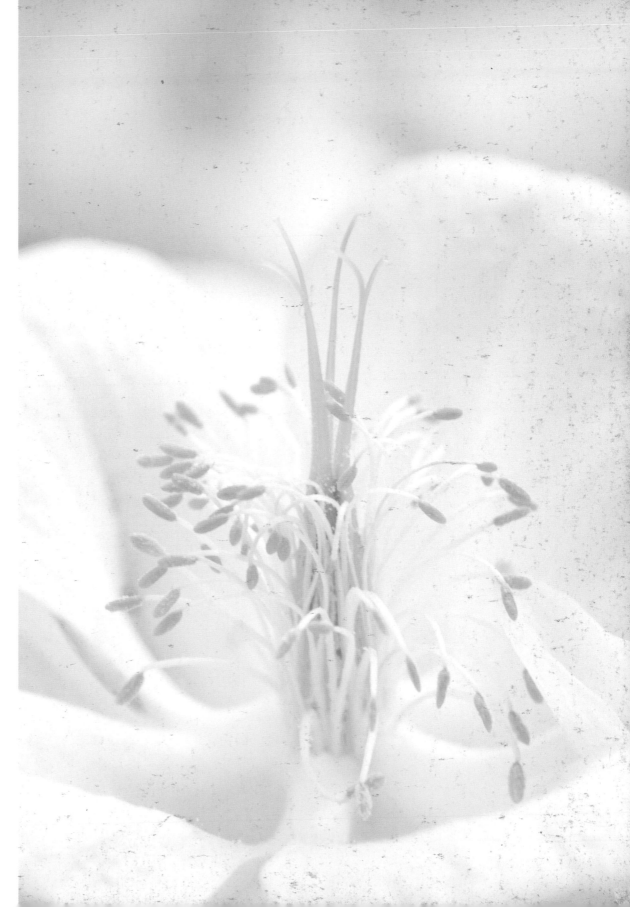

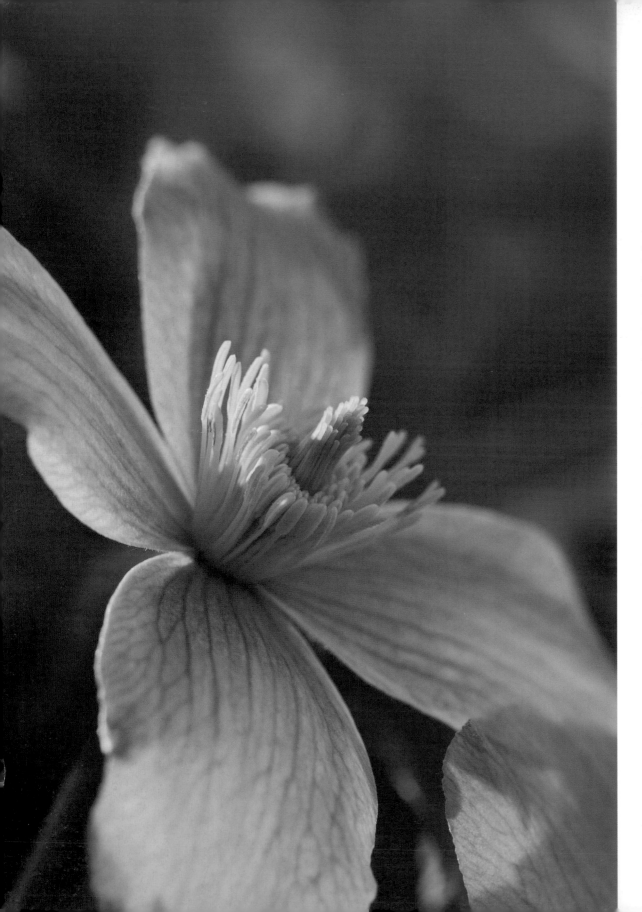

Small areas of soft sunlight can be very effective in an image. This Clematis montana *blossom is almost all in shadow yet the viewer does not perceive the image as being dark. The small amount of light coming through the translucent petals and the bright splash of sunlight on a few stamens add the interest to this image. The background, while in shadow, still has detail. Reflecting light to the stamens, the petals, or the background would have eliminated the interplay of light and shadow. For the light on the stamens to have the impact it does, the blossom had to be photographed from the side. I positioned it in the frame facing up with more space on the right than on the left side.*

Canon 1Ds Mark II with 180mm f3.5 L macro lens, 1/40 second at f8

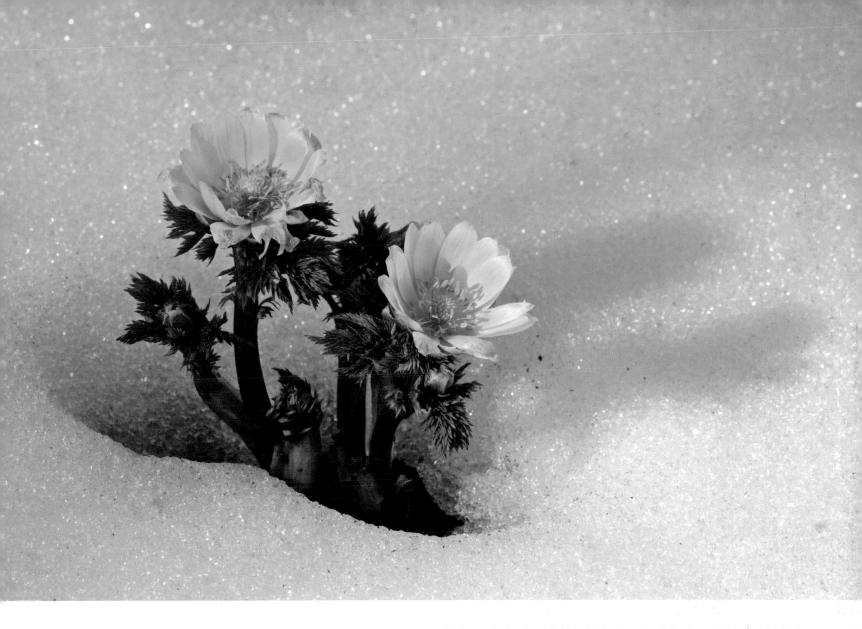

Photography is about light but it is also about shadows. This pair of Adonis amurensis *poking up through the snow would have been worth photographing under any conditions. The shadows cast by the two blossoms in the late afternoon sun create added interest. The lighting also brushes the snow and gives the image some sparkle. The low angle of the light keeps most of the bright yellow blossoms in part sun. Yellow is such a strong color that yellow blossoms in full sun are difficult to capture without the image becoming overpowering. In a vertical format, the blossoms' shadows would be missing and the image would not be nearly as strong.*

Canon 1Ds Mark II with 180mm f3.5 L macro lens, 1/2 second at f22 +2/3 stop exposure

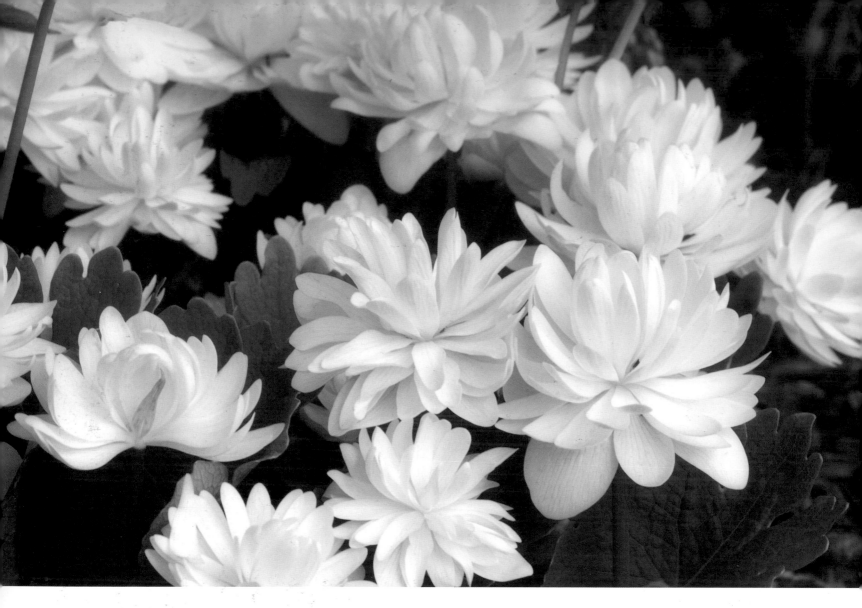

Mention light modification and most photographers typically think about
adding or diffusing light on a subject. Blocking light, however, can also
have a dramatic effect on an image. This group of bloodroots (Sangui-
naria) was bathed in the afternoon sun. While it presented a nice image,
I wanted to accent the effect of the light. I used a reflector to block the
sunlight on the back portion of the blossom group so the sunlight in
the foreground would become more pronounced. The sunlight shading
from warm in the front to cool in the back also added depth to the
image. I needed to add exposure to keep the blossoms a clean white.

Canon 1Ds with 180mm f3.5 L macro lens, 1/25 second at f22 +1 stop
exposure

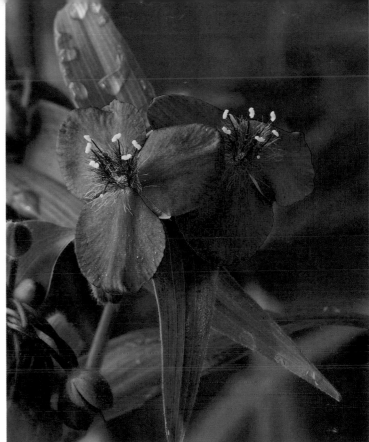

The photographer doesn't need to be limited to using just one light modification tool. Sometimes it's necessary to use both diffusers and reflectors. I took the first Tradescantia image in full sun without any reflector or diffuser. Even though it was early in the morning, the sunlight robbed the plant of its rich color and vibrancy. For the second image, I used a diffuser to soften the sunlight. This image is a much better image than the first. The richness of the blossoms is more evident, but the blossom on the right is in shadow and almost merges into the background. There are also a few stems in the image that are distracting. For the third image, I used a diffuser to soften the sunlight as well as a reflector to add light to the right side of the blossoms and stems. Very little light was added to the background. The additional light from the reflector pulls the second blossom out of the shadows, softens the stems, and separates the subject from the background.

Canon 1Ds Mark II with 180mm f3.5 L macro lens, sunlight 1/6 second, diffuser 1/2 second, diffuser and reflector 1/3 second, all at f22

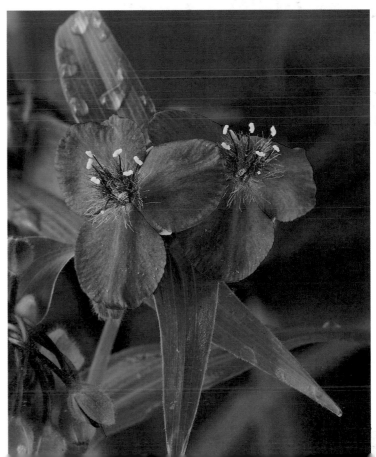

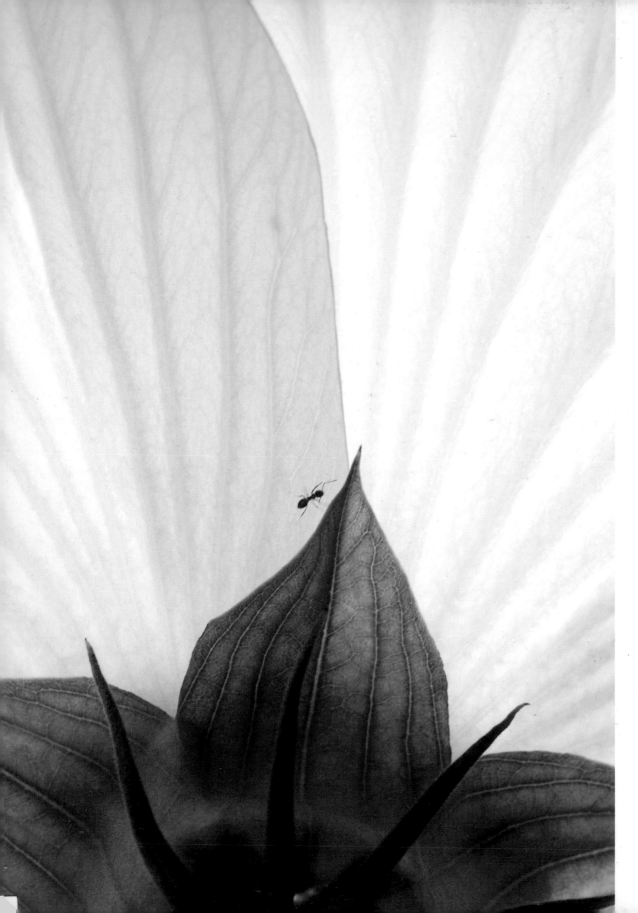

This image could be titled "Little Things Mean a Lot." It's also an example of turning a problem into a treasure. I was trying to get a good vertical image of the sunlight coming through a hibiscus blossom. Just as I was ready to press the shutter-release button, I noticed an ant meandering across the petals. My initial response was to brush the ant out of the image. Then I realized that even though the ant was a tiny speck in the image, it had a major impact. I changed from trying to get a vertical image of the hibiscus to an image of a tiny ant on a blossom. The ant was a silhouette so the exposure did not have to change. I just had to wait until the ant paused before pressing the shutter-release button. I took about six captures before the ant disappeared. This is the only capture where the ant paused long enough and everything fell into place.

Canon 1Ds Mark II with 180mm f3.5 L macro lens, 1/80 second at f16

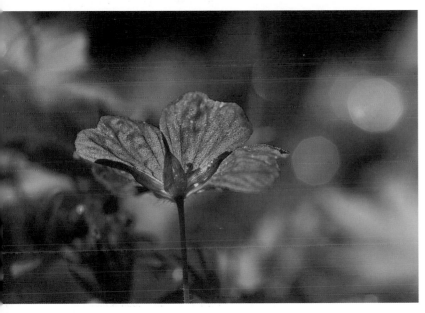

Sometimes spectral highlights, caused by drops of water in this series of images, surprise the viewer as strangely shaped bright spots. What the viewer actually sees are the shutter blades of the lens in the form of an octagon. The smaller the aperture and the greater the depth of field, the more noticeable and prominent the octagon will be. This series was taken at apertures set at f8, f11, and f5.6. The highlights start to lose their shape at f5.6. These bright spots are not noticeable through the viewfinder. You can only determine if there are spectral highlights on the final image by using the depth-of-field preview.

Canon 1Ds Mark II with 70-200mm f2.8 zoom lens, 1/400 second at f8, f11, and f5.6

Camera position is important in getting the greatest depth of field at any aperture setting. This image demonstrates that it's equally important when you want less depth of field. The flowers on this crocosmia are tightly bunched and grow off both sides of the spike. If the camera is placed parallel to the spike, there's no separation between the flowers on one side of the spike and the flowers on the other side. Only if they are photographed on an angle can all the flowers have separation. The problem with this, however, is that some camera angles will include flowers on both sides of the spike in the plane of focus. If you count the five flowers from left to right, the camera is carefully positioned with the plane of focus on flowers three and five. Flower one is in back of the plane of focus and flowers two and four are in front. Because flowers three and five are in the sunlight, the viewer is fooled into thinking they are nearest to the camera. In fact, flowers two and four are closest. I underexposed the image to keep the background subdued without losing the red impact.

Canon 1Ds with 180mm f3.5 L macro lens, 1/25 second at f8 -2/3 stop exposure

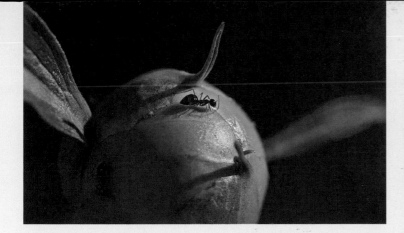

Capturing a Symbiotic Relationship

I have always been intrigued by the relationships between plants and animals. One that I see every spring in my own backyard is the symbiotic relationship between ants and peony blossoms. As the peony buds begin to mature, they secrete a waxy substance. Ants find the secretion highly attractive. Because ants often will aggressively defend a food source, predatory insects are deterred. Both the peony and the ants benefit.

I generally don't try to plan the details of any shot ahead of time, but over the winter one year I thought an image of an ant on a peony bud would make a nice image depicting this symbiosis. I wanted the image to tell the story but not come off as a cold scientific image. I wanted some feeling to the image. My solution, in my winter mind, would be to have an ant on the bud eating the secreted wax at a petal's edge in some dramatic late-day lighting.

As spring progressed I kept careful watch on the peonies' progress. The buds developed, the ants arrived, and I had a sunny day. Then came the actual decisions.

The image I wanted was one of an ant on a bud. I didn't want a complete side view, as that wouldn't show the petal's leaf edge and therefore wouldn't tell the full story. So an overhead view depicting the entire bud with an ant would be my first choice. I needed the bud selected to have minimal background so that the final image would not be too busy and distract from the ant. This would mean a fairly shallow depth of field. The aperture setting for a shallow depth of field would also give me a faster shutter speed. The faster shutter speed would help, as the ants are always in motion and there's an ever-present breeze in the spring. The depth of field couldn't be too shallow because I was working with the rounded sphere of the peony with the ants on top constantly changing position.

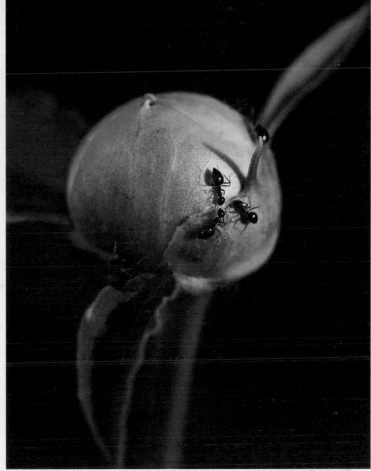

Ants on a peony bud.

Canon 1Ds Mark II with 180mm f3.5 L macro lens, first image 1/80 second at f8, second image 1/30 second at f8

The first few exposures caught one ant with a diagonal shadow. After some minor adjustments in camera position and a number of shutter releases, I felt I had at least one good capture. If I had stopped then, I would have gotten the image I set out to capture. But when you have good conditions and willing subjects, it's always a good idea to be patient and keep looking for the opportunity to add captures to the flash card.

As I watched, groups of ants began to feed on an adjacent bud. By slightly adjusting my camera position I was able to capture groups of two and three ants feeding close to one another. A group of three ants in perfect relationship to one another feeding on the bud's secretion lasted a few seconds. Keep taking exposures under these conditions. Keep making adjustments to give yourself the best chance to get good captures. I pressed the cable release thirty times over ten minutes as the light and the ants changed position. I got the shot from my winter daydreams as well as two additional ones.

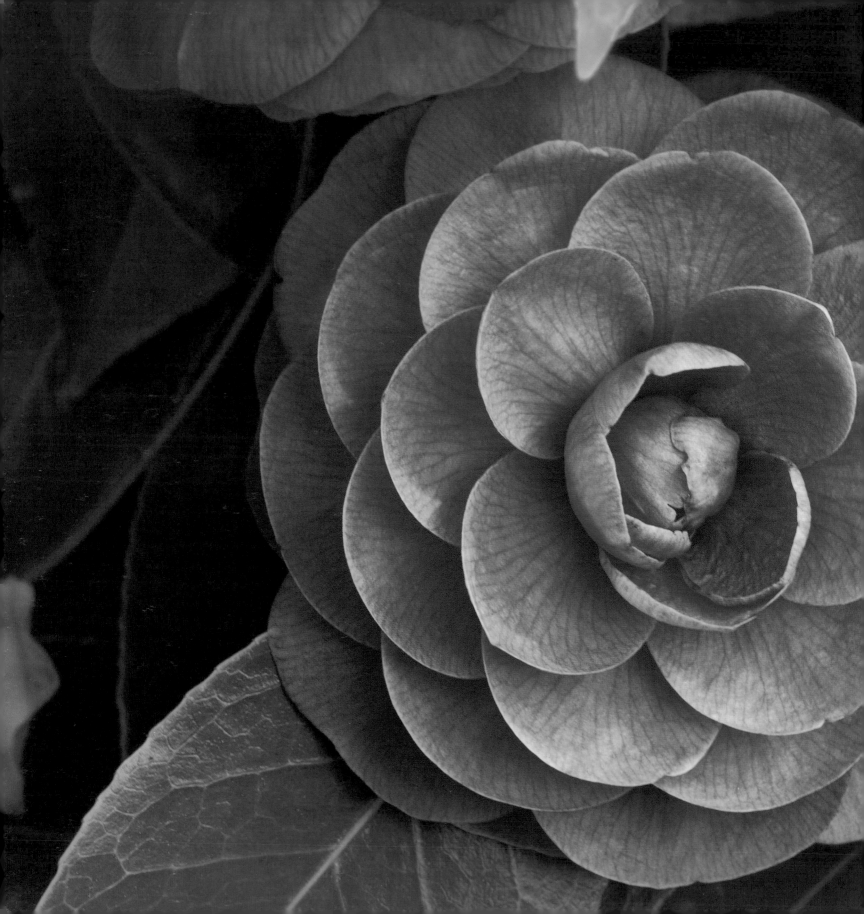

6
Digital File Basics

WITH DIGITAL TECHNOLOGY, PHOTOGRAPHY HAS become both more accessible to beginners and more challenging for advanced photographers. People who never picked up a camera before can capture images on a tiny point-and-shoot camera, download the image files onto a computer, and e-mail the images immediately to family and friends. There's no need to buy film or go to a lab or store for processing. At the other end of the spectrum, the photographer who demands the ultimate image quality and wants to get the optimum result from all the digital process has to offer now has the responsibility of being both the creator and the lab.

Early-season camellia blossoms are always fun to photograph. Most of the leaf- and flower-chewing insects have not made an appearance yet so finding good leaves and blossoms is easy. Camellias are woodland shrubs so there's never much light on them. Even so, as you can see in the image, there's always some direction to the light. The strong pink and green color combination is a winner.

Canon 1Ds Mark II with 180mm f3.5 L macro lens, 1/6 second at f11

139

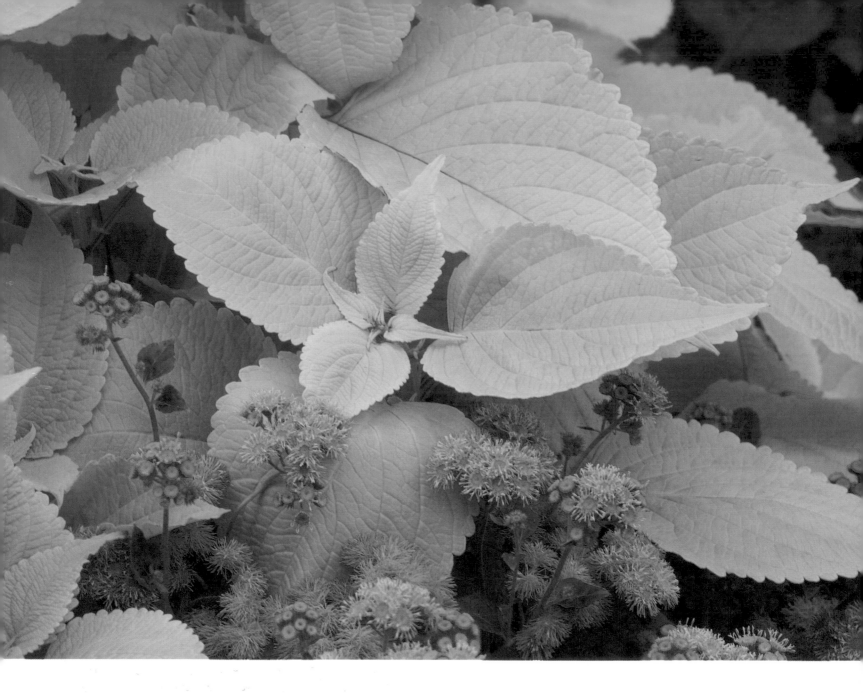

This image of coleus and ageratum is striking because of its color combination. Strong colors, however, can overpower an image. Shifting the composition to the left where the light was hitting the plants and letting the shadows show on the right offsets the color of the coleus. Even so, the camera's meter was fooled and exposure compensation was needed.

Canon 1Ds Mark II with 180mm f3.5 L macro lens, 1/8 second at f16 +2/3 stop exposure

Everyone thinks immediately of maple trees and pumpkins when they think of fall color. However, the fall color display of the fruit of some shrubs is also impressive. This image of Callicarpa berries proves the point. The difficulty is finding an intact berry cluster without too many leaves damaged by insect activity. Even though it was threatening to rain when I spotted this perfect group, I had to stop and get the picture. I added exposure compensation to slightly brighten the berries.

Canon 1Ds with 180mm f3.5 L macro lens, 1/13 second at f16 +1/3 stop exposure

Some insects have great defensive camouflage while others jump out at you with their bright colors. This squash vine borer with its bright orange splashes is hard to miss. Its location in the curl of the leaf made getting a good camera position difficult. If the camera had been positioned parallel to the insect, the leaf curl would have hidden half of its body. If I had photographed the bug head on, its distinctive coloration would have been hidden. The quarter angle was the best compromise. While the insect isn't sharp front to back, its shape and coloration are visible enough to make it clearly identifiable.

Canon 1Ds Mark II with 180 f3.5 L macro lens, 1/6 second at f22

Taking on the laboratory's role requires time to learn and practice new procedures. At this level, the photographer spends at least as much time in front of the computer as behind the camera.

No matter where you fit in the range of possibilities, no matter how technically involved you want to be, you need at least a basic understanding of the digital world. In this chapter we focus on the digital equivalent of the slide or negative that you could see and hold in your hands: electronic data called the digital file. This file that you download from your camera or compact flash card onto the computer contains the information that is your image. Understanding the digital file is important. For some, the basics will provide more than enough information to reach their goals. For others, it will only scratch the surface.

To begin your education about the digital world, let's start with the

In this image, I wanted to show
the tightly packed flowers on
a foxglove stem. I decided to
eliminate the background and fill
the frame with flowers. Even so,
I had to think about how many
complete flowers to include. I
elected to have one full blossom
surrounded by parts of its neigh-
bors. I used a small aperture with
some exposure compensation.

Canon 1Ds with 180mm f3.5 L
macro lens, 1/10 second at f22 +2/3
stop exposure

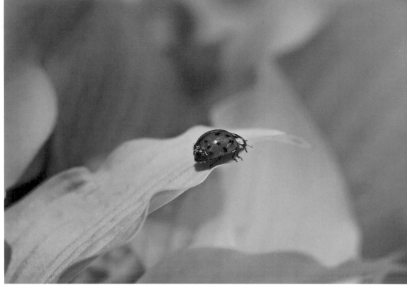

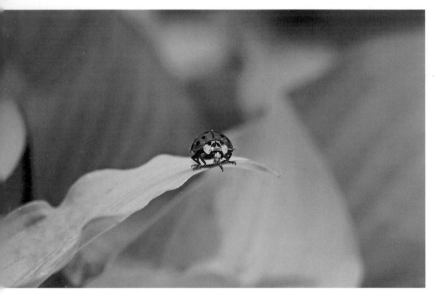

One of the keys to photographing insects in the field is to take multiple images as you move in closer. This series of images demonstrates that point. The ladybug was nervous but not enough to fly. I took a number of photos, after which I edged the camera and tripod slowly closer. I took more captures and edged in still closer. When I tried to move closer after the last image, the ladybug couldn't stand it and took off.

Canon 1Ds Mark II with 180mm f3.5 L macro lens, 1/25 second, 1/40 second, and 1/30 second at f11 –1/3 stop exposure, ISO 200

four basic attributes of digital image files: resolution, color, file mode (8-bit or 16-bit), and file format. The better you understand these basics, the easier it will be for you to see how camera, computer, monitor, printer, projector, and the Web are related.

Resolution

Resolution can mean many things. We are going to confine ourselves to using *resolution* to describe two different characteristics of digital image information. In one instance it's used to describe the maximum amount of information per image a digital camera can capture. For example, a camera with a resolution of 10 megapixels has a digital sensor capable of capturing 10 million pixels per image. In the second instance, *resolution* describes the density of information in a digital image file as well as for monitors, printers, and projectors. The density of information in digital files can easily be changed with editing software.

Digital files are sometimes classified as hi res (high resolution) or lo res (low resolution). A hi-res file is usually considered to be a digital file with a resolution of 300 ppi, while a lo-res file has a resolution of 72 ppi.

On a monitor, the resolution numbers indicate how many pixels will be displayed on the screen. There are two numbers: the first represents the number of pixels along the horizontal axis, and the second the number of pixels along the vertical axis. Most monitors have more than one possible setting. For example, my 23-inch monitor displays digital

dpi Versus ppi

The density of digital information in an image is expressed as either ppi (pixels per inch) or dpi (dots per inch). To be technically correct we should use *ppi* to describe the density of any image file in the computer, on a CD, on a DVD, or on the Internet, while *dpi* is the correct term to describe the density of an image printed on paper where dots of ink produce the print. In the real world, though, people commonly use *dpi* to describe the density of digital information in all these situations.

These succulents and begonias in a container begged to be photographed. I chose to highlight the color palette of the greens and reds with the texture by going in tight. I wanted the important portion to be the lower two-thirds of the image. Selecting a medium-small aperture caused the top third of the image to start to go out of focus. The lack of symmetry of the begonia blossoms keeps the image from being static.

Canon 1Ds Mark II with 180mm f3.5 L macro lens, 1/2 second at f16

files at any one of eighteen possible resolutions, ranging from 640 by 480 pixels to 2048 by 1536 pixels. The higher the numbers, the greater the amount of information is contained in a given space.

Printers have resolution specifications stated in dots per inch (dpi). These specifications usually give the range from the minimum to the maximum possible settings. The greater the resolution, the more dots of ink per inch are put on the printing paper. Printer resolution is usually controlled by computer software.

A digital projector's resolution settings indicate the density of information the projector is able to display both for the horizontal and the vertical axis. An XGA (extended graphics array) resolution for a projector means that the maximum density of information it can project is 1024 pixels horizontally and 768 pixels vertically. An SVGA (super video graphics array) resolution is 800 pixels horizontally by 600 pixels vertically. The quality of the image on the screen is directly related to the number of pixels projected.

Digital projectors display images in a horizontal rectangular format only. Thus, the number of pixels along the horizontal axis is always larger than for the vertical axis. For the best image quality, size the file on its longest dimension to the same size as the projector's top resolution. For an XGA projector, the image's longest dimension would be 1024 pixels for a horizontal image or 768 pixels for a vertical image. To understand this concept, try sizing a vertical image incorrectly at 1024 pixels on the vertical side. The projector will show 768 of the 1024 pixels—only a portion of the whole image.

Color

Color is an area of great mystery. It's also where any error is most noticeable on your monitor or in the print you were giving to a family member. Ideally, you would like the colors captured in your digital image file, and either displayed on a monitor or screen or printed out, to match what you saw when you initially composed the image. To achieve this result, you need to know something about color modes and color spaces, and about color management.

Color modes and color spaces

Color modes describe the different color values of the pixels in a digital file. There are four common color modes: RGB, CMYK, Grayscale, and Lab. Within a color mode there may be one or more color spaces. You select which color space to use at capture when shooting JPEGs or through the computer software when converting a raw file to a TIFF or PSD file. Most image-editing programs allow you to save or convert to the color spaces of your choice. The end use of the digital file is the determining factor.

The most frequently used mode is RGB, a three-channel mode with separate red, green, and blue channels. Within the RGB color mode are four major color spaces: sRGB, Colormatch, Adobe 1998, and ProPhoto. The four color spaces are differentiated by size, by number of different colors included, and by which colors are included. The color spaces within RGB run from very small with few colors to very large with many colors. To better understand the different color spaces, try to picture different-sized boxes of crayons. You can buy boxes with 24, 48, 92, or 240 crayons. Sometimes the box of 24 colors offers enough choices, and other times 92 or more colors are necessary to accurately represent an image.

Here is a summary of the differences:

- sRGB is the smallest color space with the fewest colors. This is the color space used for all the images on the Internet or Web and is often the default color space for shooting JPEGs (more on this later, under "File Format") on many cameras.

Backlighting on the golden brown disks of coneflower is always dramatic. In this image the tiny floret, flexing up instead of down, added an important gesture. I used a medium aperture to keep the background blurred with little or no detail. Focus was on the perimeter of the disk. The dark background and the shadow side of the blossom fooled the camera meter into calling for much more exposure than was needed so I bracketed the exposure. I selected the exposure in raw, showing a touch of overexposure in the histogram, and lowered that exposure in Lightroom for the effect I wanted.

Canon 1Ds Mark II with 180mm f3.5 L macro lens, 1/8 second at f11 −1/3 stop exposure at capture and −1-1/3 stops in Lightroom

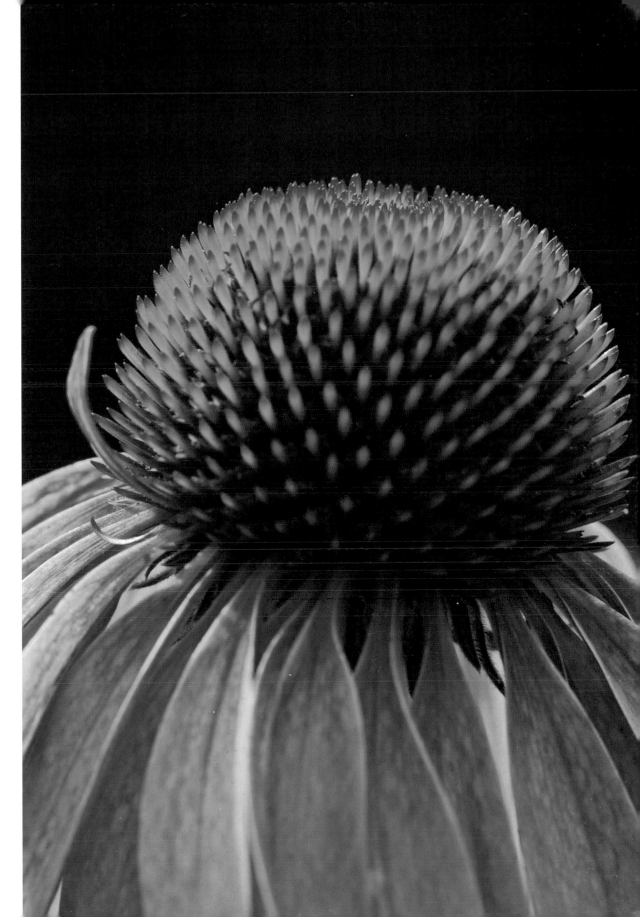

- Colormatch, the second smallest space, is based upon the Radius monitor that used to be the standard in the publishing industry. It's larger than sRGB and most closely resembles the CMYK color mode (described shortly). Some photographers prefer to use Colormatch for delivery of digital files where the printer will convert the file to CMYK.
- Adobe 1998 is the current standard color space for digital files for print publication. It has many more colors than either sRGB or Colormatch. This space can also be selected as a capture color space when shooting JPEGs.
- ProPhoto is the largest of the color spaces. It has more colors than can technically be printed or displayed. Even so, many photographers convert their raw files to ProPhoto for their master files because they believe the larger color space might be more fully handled in the future.
- Grayscale, CMYK, and Lab are the other three color modes. Grayscale is the color mode for black-and-white files. CMYK (which stands for cyan, magenta, yellow, and black ink) is the mode for commercial printing presses. Lab is a three-channel mode having one channel for dark-light (luminosity), one for red-green, and one for blue-yellow. Lab is often used as a reference for converting other color spaces.

One other matter concerning color has to do with white balance, a camera setting that compensates for the differences in color temperature of the surrounding light so that any white in the image subject appears white in the captured image. With film, filters were screwed onto the lens to correct color casts such as the orange cast when shooting daylight film in indoor tungsten lighting or the blue cast to an image shot in the shade. Digital cameras can be set to match the color temperature to the scene. The result is that the white areas in JPEG images appear white without any color cast. You can also set the camera to auto white balance (awb) so that the camera automatically perceives a white area in the subject and adjusts the color temperature accordingly. White balance and auto white balance (awb) are applicable only when shooting JPEGs.

Color management
No matter which color mode or color space you use, you need to ensure that the colors displayed and printed from your digital image files are consistent and accurate throughout the processing of your images. This is called color management. This step is often ignored, especially when a photographer is just starting out, but it's of key importance.

Think of it this way. Have you ever seen twenty TV sets in an elec-

CRT Versus LCD Monitors

CRT (cathode ray tube) computer monitors were the standard for many years. Then the small, bright, flat-panel LCD (liquid crystal display) monitors arrived. At first LCDs did not have the color accuracy or the ease of calibration offered by CRT monitors. They were also very expensive. Today, color accuracy, the ability to calibrate an LCD, and cost are no longer issues. LCDs dominate the monitor market and the CRT-versus-LCD discussion is history.

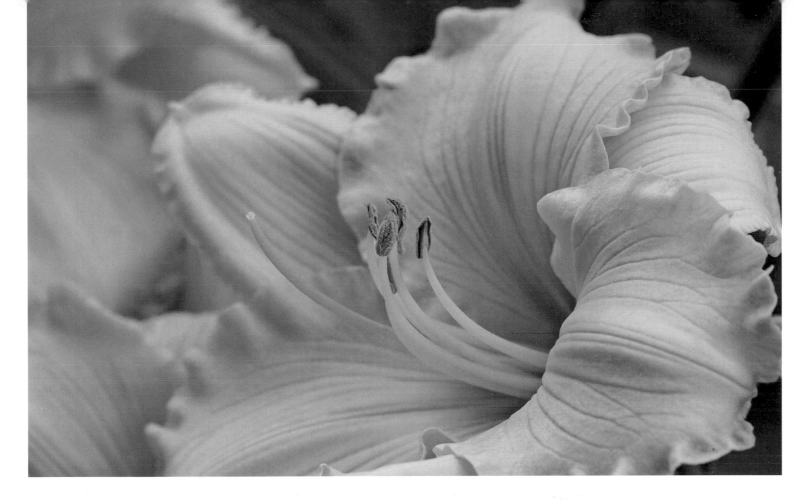

tronics store all tuned to the same program and noticed that there can be major differences in color accuracy from one set to the next? The output devices in digital photography have the same problem. Even though monitors, printers, and projectors are all working with the same information from the digital file, image output from each may differ slightly. What you see on your monitor may be different from what your printer produces or how the image from the projector appears on the screen. At one time digital photography had the reputation of producing poor-quality images, not because the digital files were bad but because output devices did not create consistent results—a printer might produce a print with colors that looked far different from what was seen on the monitor. Because devices have improved considerably, this problem is not as dramatic or widespread as it used to be, but it's still vital to make sure that your digital file and how you view that file are adjusted to some common standard.

The starting point is color management of your monitor, since this is the first piece in the imaging chain. The colors displayed by monitors, whether of the CRT or LCD variety, change with use and time and need to be calibrated to a given standard on a consistent schedule (a few times a

Daylilies are easy to photograph in larger images but their structure makes them difficult to shoot in tight. If you shoot them facing head on, you miss the grace of the curved petals, and the image seems flat. If you photograph them from the side, you miss the throat and the way the petals seem to welcome you. In all cases, it seems impossible to get everything sharp. For this photograph, I decided to give the viewer just the impression of the curves of the petals and the view of the throat. I included a portion of another blossom as well as some green leaves to add color contrast. This image was taken with a medium aperture with the focus on the anthers, providing the important separation of the anthers from the petal behind. The plane of focus also included a portion of the right petal. The soft diffused lighting showed the texture and color of the blossom.

I shot this image in raw and then converted it to a 16-bit 95-megabyte file in ProPhoto color space. After final edit and adjustments, I converted the color space from ProPhoto to Adobe 1998 and changed the mode from 16-bit to 8-bit. The archived master file of this image is an 8-bit 47.5-mega-byte file in Adobe 1998 color space.

Canon 1Ds Mark II with 180mm f3.5 L macro lens, 1/20 second at f11 +1/3 stop exposure

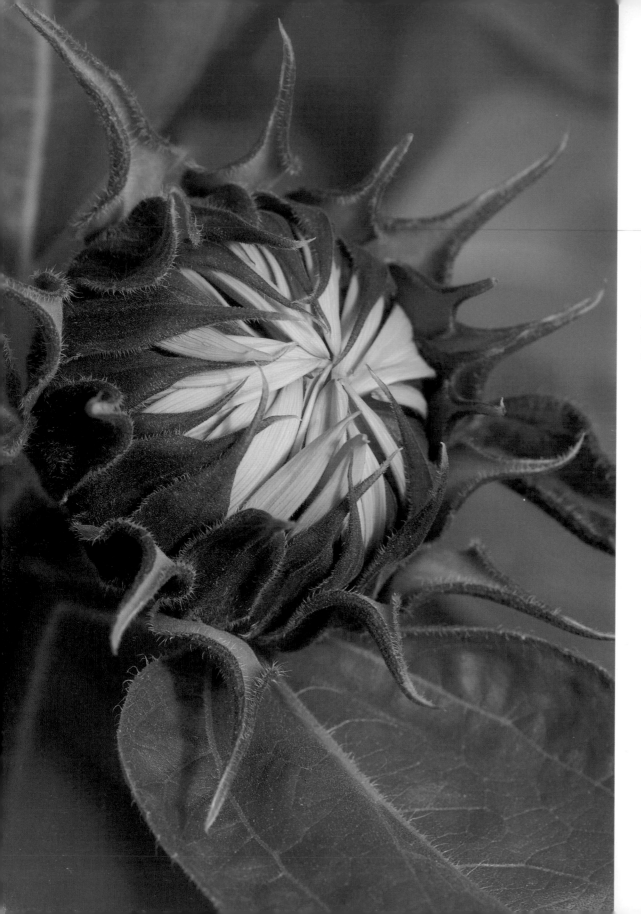

Sometimes the promise is as exciting as the actual event. This sunflower bud tells of good things to come. The image was used in an ad for the opening of a new hotel.

Canon 1Ds with 180mm f3.5 L macro lens, 1/125 second at f11

How to Calculate Image File Size

Sometimes you need to know how big an image file should be to make a print with certain dimensions and resolution. The size of an image file is the total amount of digital information it holds. Use this formula to calculate needed file size: length ✛ width ✛ resolution (ppi) ✛ resolution (ppi) ✛ 3 (RGB) all divided by 1 million. For example, say you need to print an 8 ✛ 10 at 300 dpi. The required file size is 8 ✛ 10 ✛ 300 ✛ 300 ✛ 3 divided by 1 million = 21.6 megabytes.

month is ideal). Calibrating a monitor isn't difficult and doesn't take much time, and after it's done you can be sure the image on the computer screen accurately represents the digital file. It's a waste of time to make any adjustments to your image file such as color adjustments in Photoshop without first calibrating the monitor.

Calibration devices from ColorVision, Pantone, and X-Rite are all reasonably priced and easy to use. These devices calibrate your display to a known and repeatable state and then build what's known as an ICC (International Color Convention) profile that describes how the display produces color. Once this is done, applications like Photoshop have the information they need to allow accurate image previews. The few minutes you will spend every week or so to adjust your monitor with one of these devices is time well spent.

File Mode

A bit is the basic building block of information in the computer world. Each bit can store two possible values, such as black and white. In digital photography, the image files are normally in either 8-bit or 16-bit mode.

An 8-bit file can store 256 possible values or colors, while a 16-bit file has a storage potential of 65,536 colors. Obviously the 16-bit file can store much more information than the 8-bit file, but it requires a more powerful computer, more memory, and a larger storage capacity. The greater amount of information in the 16-bit file permits more image adjustments without affecting the overall quality of the image file. It's good practice to do initial editing and adjustments in a 16-bit file and then change the mode from 16-bit to 8-bit to send to the printer.

File Format

You can record images in DSLR cameras in one of two different file formats: raw or JPEG. Some digital cameras offer a third choice of file format, TIFF. Selection of a format affects the file size, color space, and bit depth. For instance, JPEGs are small 8-bit files in Adobe 1998 or sRGB color space, while raw files are large 16-bit files. The format you choose will depend on how you plan to use your images once you have downloaded them. Consult your camera manual for instructions on how to select the image format. In addition, files can be saved on the computer in PSD and PDF. The format type is indicated by the image's file extension—for example, *xxx.jpeg* or *xxx.tif*.

Raw files

A raw file is a 16-bit file containing unprocessed digital data, as the name suggests. Once a raw file is downloaded onto a computer, it can be adjusted for exposure, color temperature, shadows, highlights, and many other attributes before saving it in one of the other formats. This results in a superior image. The disadvantage of using raw as your capture setting is that it requires more time and work in the computer. Regardless, the advantages of capturing images as raw files make it the choice for any photographer wanting the best digital has to offer.

JPEG files

JPEG (Joint Photographic Experts Group) is a compression format for 8-bit files. When you save an image as a JPEG, the computer compresses the file, making it smaller. However, this is a "lossy" compression, meaning that each time changes are made to a JPEG file and it's saved, information is thrown out. This makes it a poor choice for an image file that you plan to work on or make adjustments to. After four saves, a JPEG file will be noticeably degraded. This is a good format for images that are being sent via e-mail or those destined for use on the Internet.

TIFF files

TIFF (tagged image file format) is the industry standard format for service bureaus, photographic labs, stock agencies, and publications. It's a nonproprietary format, meaning that every computer should be able to recognize and read a TIFF file. A TIFF file can be either an 8-bit or a 16-bit file, and it's not compressed, so no information is discarded when the file is saved. This makes TIFF an excellent format for images you plan to edit.

Some, but not all, digital cameras offer the TIFF format as a capture choice. TIFF capture creates a very large file, many times larger than a JPEG file and about three times larger than a raw capture. File size is directly dependent upon the camera's resolution. The large file size and the increased amount of time it takes to write the captured information to the camera's memory card are two reasons to avoid using TIFF as a capture format. If you need large files for large prints or stock files, the better choice is to capture images in raw format, make adjustments to raw files, and then convert them to TIFF files.

PSD and PDF files

PSD is the Photoshop file format. A PSD file is similar in size to a TIFF file. Its drawback is that computers without Photoshop will not recognize the file.

PDF (portable document format) is used for document layouts or any file where text and images or illustrations are contained in one file.

Guidelines for File Choices

There are no hard-and-fast rules as to which resolution, color space, file size, or file format to use for any given image. Each intended use may have different requirements. In the absence of specific instructions from a publisher, an advertiser, or an Internet provider, here are some general guidelines to get you started:

- Internet use—Images for Internet use should be lo-res (72 ppi) JPEGs in sRGB color space. The file size depends upon how large or small the displayed images will be. As starting points, a small thumbnail would be 100 by 150 pixels, while a larger JPEG of 400 by 600 pixels would be appropriate for normal viewing.

- Book or magazine use—Publishers may have their own file requirements, but the current standard is an 8-bit hi-res (300 ppi) TIFF file in Adobe 1998 color space. The size of the file depends upon the size to be printed.

- Fine art printing—Printing is very dependent on the software, the paper, the printer, and personal preference. Any format—whether JPEG, TIFF, or PSD—can be suitable for printing with an ink-jet printer. Recommended resolutions include 240 ppi and 360 ppi. Choose a color space that closely matches the gamut of the printer's inks. Adobe 1998 color space is very popular, but the newest inks include colors beyond this space, which is why many photographers choose ProPhoto for their master files.

Digital Workflow

DIGITAL WORKFLOW REFERS TO THE SERIES OF steps from capturing an image to transferring the image to the computer to making global and local adjustments to the digital file and finally to storing or archiving the image files. Workflow depends on the photographer's needs and preferences. A photographer who shoots raw has a different workflow from one who shoots JPEGs. Those who need to keep certain images for future use must include storage as part of their workflow, while photographers who shoot for weekly Web columns may have no need for long-term storage. The key to good workflow is to be efficient while still including all the elements necessary for your situation.

If you think learning macro and digital photography is difficult, think of this little violet's plight. I found this example of persistence in my driveway. After I first spotted the seedling I watched it each day, hoping it would grow and produce a blossom. One morning I looked out and there was my flower in peak condition. A low angle at a small f-stop was all that was needed.

Canon 1Ds with 180mm f3.5 L macro lens, 1/13 second at f16

Although digital photography is an entirely new world, in some ways the workflow mimics that followed in the early days. Consider the example of William Henry Jackson, who traveled throughout the West in the 1870s photographing grand vistas for the United States Geological and Geographical Survey of the Territories. All his equipment—including his camera, lens, glass plate negatives, laboratory, and chemicals—accompanied this early photographic pioneer. The day's shots were developed in tents set up as the laboratory on-site. Now traveling photographers download the day's captures into their laptop computers and fly home knowing they got the shots. The workflow is the same; only the tools have changed.

Ansel Adams, perhaps the best-known American landscape photographer, chose the exposure for his photographs based upon his evaluation of the scene and his knowledge of what adjustments could be made in the darkroom. To get the best print he considered every step of the process from setting up the camera to developing the negative to the final print. In digital photography, once again, the photographer is in control of the entire process—from capture to output. The film is now a compact flash card and the laboratory and the enlarger are the computer and printer. The general workflow, however, is comparable to the early photographers' routines.

Digital photography workflow can be broken down into its various elements, and there are entire books that go into great detail on each subject. This chapter will give you an overview of the basic elements. Be aware that even after you have your own workflow figured out, you will probably want to make adjustments to incorporate new products affecting workflow, accommodate additional needs, and make better use of time.

Capture

Digital workflow starts with capturing the image. Before pressing the shutter-release button, you must decide whether to capture images as JPEGs, TIFFs, or raw files, or some combination thereof. As explained in Chapter 6, the TIFF format is the largest file size, so using it for capture means an increase in the time it takes for the camera to write the data to the compact flash card. This can seriously cramp your ability to take a series of images in a short span of time. Thus, the TIFF format is better suited for editing images than it is for capturing them. The best choices for capture are to set the camera to shoot JPEGs or raw, or both.

Whether to capture JPEGs or raw depends upon the image quality requirements, the size of the digital file needed, and how quickly the

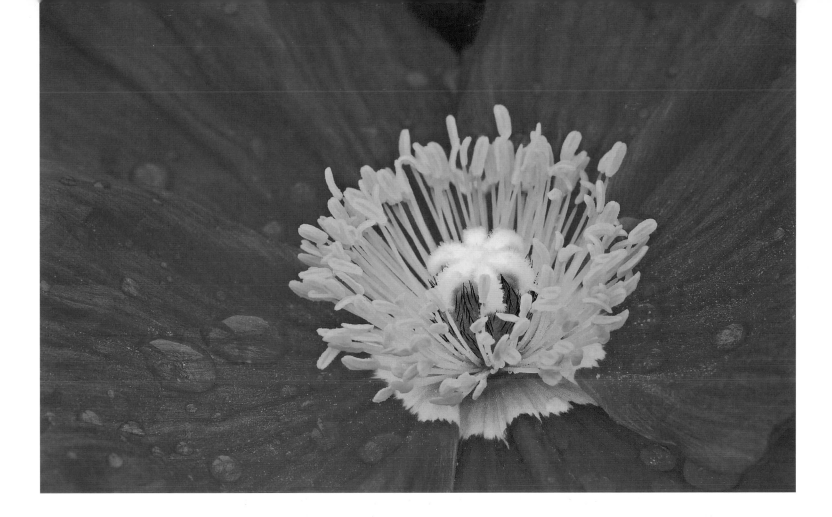

We planted a number of different poppies one year in the garden. When they started blooming, I couldn't stop taking pictures. Everything about poppies says, "Please take my picture!" This one called out to me with its combination of orange, yellow, and a touch of green. I chose a low camera angle in tight and shifted the center slightly to the right. I selected a small aperture and overexposed a bit.

Canon 1Ds Mark II with 180mm f3.5 L macro lens, 1/2 second at f22 +1/3 stop exposure

UPDIG Workflow Models

In the early years of digital photography, there was much confusion and misinformation regarding the new technology. In order to provide some semblance of standards, a number of professional groups involved in photography came together to form the Universal Photographic Digital Imaging Guidelines (UPDIG) Working Group. Among other things, the guidelines created by this group (available at www.updig.org) describe these four different workflow models based on the photographer's volume, quality requirements, and time constraints:

- High volume, quick turnaround—Photojournalism as well as public relations and event photography fit here, where speed of process is of paramount importance.
- High volume, moderately quick turnaround—In this workflow, the need for speed is tempered by a need for higher quality, as is the case for photography for monthly magazines, institutional brochures, and Web site use.
- Low volume, high quality—Advertising and top editorial photography fit here.
- High volume, high quality—This is the workflow for product photography.

These four categories illustrate that digital workflow depends upon the type of photography, the time frame, and how the images will be used. Photographers can assess their own situation in relation to the four categories and develop a workflow to fit their needs.

Edge-to-edge blossoms can be difficult to capture. I try to find lighting conditions that add sparkle to the image. In this case, soft sunlight on this geranium was hitting the lower two-thirds of the right side of the image. The light area and darker background took away the flat feeling. The sunlight added sparkle. I bracketed the exposure to compensate for the dark foliage and blossoms.

Canon 1Ds with 180mm f3.5 L macro lens, 1/30 second at f22 –1/3 stop exposure

Tips on Compact Flash Cards

Compact flash (CF) cards come in a wide range of memory capacities. I recommend that the size of the CF card match the camera, especially when shooting raw files. A 16-megapixel camera needs a much larger CF card than a 6-megapixel camera, but don't go overboard on the CF card size. One hundred raw files per card is plenty. Using CF cards that store hundreds of raw files may seem to be a good idea but may not be prudent in view of the fact that if something goes astray, all the image files could be lost. Keep this in mind when capturing the smaller JPEG files. Even at the highest JPEG quality setting, a large CF card of 4 megabytes may be able to hold thousands of JPEG files. A second reason to limit the capacity of the card is that the larger the card's memory, the longer it will take to download the image files.

Regardless of the size of the CF card you use, try not to fill it completely. If there isn't enough space for the last image to be recorded, an entire card's data may get corrupted. To prevent this, it's a good procedure to change cards when a card is close to its capacity. This practice is easier said than done. There are times when the light is changing and you're so busy getting images that you forget to check how much space is left on the CF card. Try to check the camera after capturing each series of images. If you have space for five or fewer images on the card, remove it and put in another card.

Another habit to get into when working with CF cards is to make sure you format the card each and every time you put it into the camera. Do not rely on deleting all the files from a CF card in your computer in order to empty the card. Formatting the card in the camera empties the card and lets the camera prepare the card to receive information the way it (the camera) wants it. Some photographers format twice each time they insert a card just to be extra safe.

Last, develop a system whereby you can determine which CF card is full of images but not yet downloaded and which card has been downloaded and can be used again. Some photographers put labels designating full or empty on each card's plastic container. Other photographers put the CF card label-up in the plastic case or compartment if it has been downloaded and label-down if not. I use two separate and different-colored holders for full and empty to be extra careful. Find a procedure that makes sense to you and use it to prevent yourself from formatting a full card in the camera by mistake.

This pineapple lily (Eucomis bicolor) stops everyone passing by. I wanted an image of this one in our garden but the single centered flower stalk always reminded me of a sore thumb sticking up. When I noticed a younger plant in back of it with a single floret hanging down, my problem was solved. I cut off the top of the background plant on purpose. I wanted the younger plant to play a supporting role and not take away from the subject. The directional light made the subject glow. A medium-small aperture was used to keep the background from having too much detail.

Canon 1Ds with 180mm f3.5 L macro lens, 1/4 second at f16 +1/3 stop exposure

finished image file is needed. If you need the highest quality and the largest file size, raw capture is the preferred choice. Raw file capture allows the most flexibility for making adjustments before converting the file to a TIFF or JPEG. If quality isn't an issue, but time and small file size are more important, JPEGs are suitable. JPEGs are also frequently used when all the photographic conditions can be controlled, such as in a studio environment, and little editing or adjustment of image files is anticipated.

Within the JPEG format, different quality settings are possible. You can shoot high-quality JPEGs of events or low- and medium-quality JPEGs if high volume and/or Internet use are planned. Assignment photographers sometimes shoot both a raw and a JPEG file. They send the small JPEG files to the photo editor for evaluation and convert the raw files for the shots that are selected to TIFF.

Don't Forget the Metadata

Metadata is information about an image, contained on a digital label that goes with the image file. Exposure data, information about the location, title, keywords, and copyright information are just a few of the items that can be part of the metadata for a digital image file. At the very least, the metadata should include copyright information. Make it a practice to add metadata early on in the workflow.

Programs such as Adobe Lightroom and Apple Aperture have templates that can be set up to add metadata automatically on import of the image files. This works whether you are importing raw, JPEGs, or TIFFs. Some photographers choose to add metadata after ranking and renaming their files. In any case, adding most if not all of the metadata early, at the beginning of the workflow, will save you time in the long run.

Download Files

After capture, the files have to be downloaded onto the computer. This can be done either by downloading directly from the camera onto the computer via cable or by inserting the CF card into a reader and downloading from there onto the computer. I prefer using a card reader, for three reasons. First, using a card reader doesn't tie up the camera. I can be capturing more images on another CF card while the already-captured images are being downloaded. Second, the card reader doesn't use the camera's battery power. Third, if there are any computer problems, the camera isn't connected to the computer and cannot be affected.

Do Initial Edit

Do a quick basic edit using the software of your choice. This initial edit is mostly for culling. Check for overexposure or underexposure that's beyond correction. Delete any files that are out of focus or have problems with composition. Keep only those images that are good or can be adjusted to meet your needs. Saving the "almost good enough" files wastes time and storage space.

After the files have gone through an initial edit, you should sort, rank, and rename them. Select a naming convention that works for you and that can be used year after year. I follow a convention suggested by Seth Resnick that uses the year, month, and day—for example, image file ald_070611_3 is the third image I captured on June 11, 2007. If you put the year first, the computer automatically sorts or lists all the digital image files chronologically. There are variations, such as ald_070611_t_3, which includes a *t* to indicate it's a travel image.

Make Global Adjustments

After your initial edit and renaming the files, make global adjustments to exposure, color, and contrast. Look at the images on a color-calibrated monitor and examine the computer histogram to determine what changes are needed and the extent of those adjustments. Programs such as Adobe Lightroom, Apple Aperture, and Adobe Camera Raw let you make extensive sophisticated adjustments to raw files. Making as many of the required adjustments and changes to raw files as you can before converting them to TIFF, JPEG, or PSD files will result in better final image files.

Software for Digital Photography

Computers and software are part and parcel of digital photography. Early in the evolution of the digital world, one of the biggest stumbling blocks was a lack of comprehensive programs with features designed for digital photography. There were no programs available that took the photographer from beginning to end of the digital workflow. Some programs were very good for the initial editing of the images, others were better at making global adjustments or optimizing the image, and still others were designed for digital asset management (DAM). Photographers were forced to use a combination of programs, in sequence, to go from downloading images onto the computer to final use of images.

Much of the problem was that software programmers and companies didn't know what was needed. Adobe Photoshop, an excellent program, was designed for illustrators, and it wasn't until the later Photoshop CS version that features specifically designed for digital photography were included. Fortunately, both Adobe and Apple recognized the problem and developed programs from the ground up with the needs of digital photographers in mind—Adobe Photoshop Lightroom and Apple Aperture. Many professional photographers acted as advisors during the development of these programs. The result is modular software packages that take the photographer from the beginning to the end of the digital workflow. Neither program is perfect, but they are major advances for the serious digital photographer.

Not everyone needs all the features of programs such as Lightroom or Aperture, however. For many, programs such as Photoshop Elements, Apple iPhoto, or Microsoft Picture Editor will be adequate. The very advanced will still need Photoshop, with all its advanced layer features. The bottom line is that computer software has reached a stage where everyone, no matter how advanced or rudimentary their requirements are, can find programs to suit them.

I usually stay away from out-of-focus and busy foregrounds. In this image, however, the arcs of the ornamental grass and the out-of-focus blades formed a base for the dahlia and bud. I positioned the camera to show the bud, the blossom, and the curve of the blossom's stem without merging into the background. I bracketed the exposure to compensate for the darkness of the blossom.

Canon 1Ds Mark II with 180mm f3.5 L macro lens, 1.3 seconds at f16 −1 stop exposure

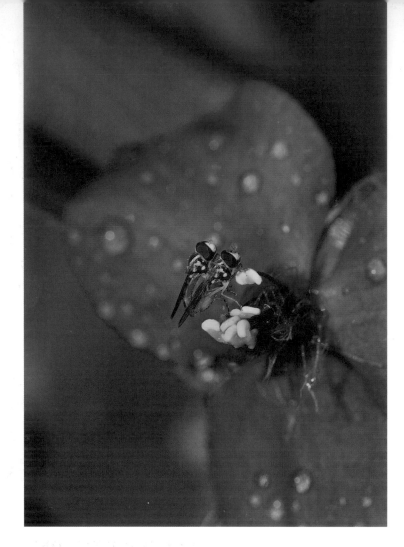

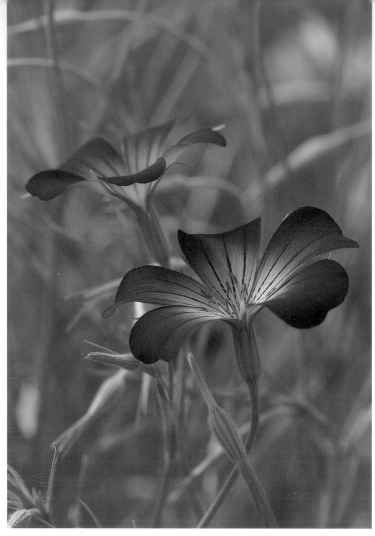

The Tradescantia *blossom these flies are perched on measures only 1-1/2 inches wide. I determined that I could get most of the flies' bodies sharp at f11. Stopping down to a smaller aperture might mean too much detail in the background as well as a shutter speed too slow to stop any movement from the subjects.*

Canon 1Ds with 180mm f3.5 L macro lens, 1/60 second at f11 –1/3 stop exposure

Back Up Raw

After the initial edit and the global adjustments, it's important to back up the raw files. They can be backed up as straight raw files or converted to DNG files. DNG is an open-standard archival format developed by Adobe for all camera raw files. The advantage of converting raw files to DNG is that this assures the ability to read the files into the future. Should a camera manufacturer decide to stop supporting its raw files, future computers and software will still be able to read the DNG file.

Whether you choose raw or DNG, making two copies of these image files on separate CDs, DVDs, or external hard drives is important. Should data become corrupted at some later point in the digital process or a hard drive fail, your backup copies will save the day. As software improves, it's also possible to go back to older raw files and reprocess them. Keep your duplicate CDs, DVDs, or external hard drives in separate locations for extra safety.

This image of corn cockle was taken in a greenhouse with the doors open. It wasn't exactly a gale-force wind, but all the plants were certainly moving. An artistic approach with shallow depth of field and high shutter speed was in order. An added benefit would be a softening of the light-colored objects in the background. I put the camera at a slight angle to compose the blossoms on a diagonal.

Canon 1Ds with 180mm f3.5 L macro lens, 1/160 second at f8

Software Upgrades

When you upgrade to the latest version of any software program, make sure it's compatible with your computer operating system. Sometimes a newer version is optimized for the latest operating system and has trouble with older versions. Also make sure your computer has the memory to handle the new version, since sometimes new versions require more memory to run efficiently. Then be sure to back up your files before loading the new version in case you run into problems uploading and launching. And remember that it may not always pay to be the first on your block with the latest and greatest. Even with prerelease testing, new software versions often have glitches.

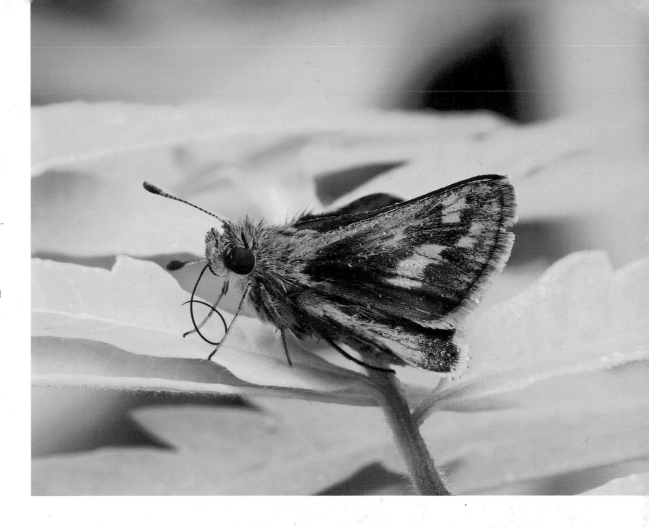

Optimize

Once all the raw files have been backed up, go ahead and convert the raw files into TIFFs or the file format of your choice. At this point, all the files are ready for final touches. Examine each file on the monitor for any dust or dirt. Look at each image critically at 100-percent magnification on a calibrated monitor. Correct any imperfections that can be corrected with your computer software. This is also a good time to decide if any selective sharpening is needed by examining the image at 50-percent magnification. Be careful—a heavy hand on sharpening can degrade the image.

The last step before storage is to set the file to 8-bit mode in order to save space. The 16-bit mode is good when you are working on the files, but 16-bit files take up large amounts of storage space. If you have been working with JPEGs, you are already in 8-bit mode. If you have been working with 16-bit TIFF or other format files, convert the files to 8-bit mode in your image-editing program.

If you have ever watched skipper butterflies, you know they rarely stand perfectly still. This image would not have been possible were it not for the early morning dew keeping the subject in place. The butterfly's pose with a forewing up and a hind wing down made it impossible to get everything sharp. Even at f22 with the camera in the best position, some of one wing would be soft. I focused on the eyes and chose a low camera angle to keep some of the out-of-focus hind wing from showing.

Canon 1DS Mark II with 180mm f3.5 L macro lens, 1/3 second at f16 +1/3 stop exposure

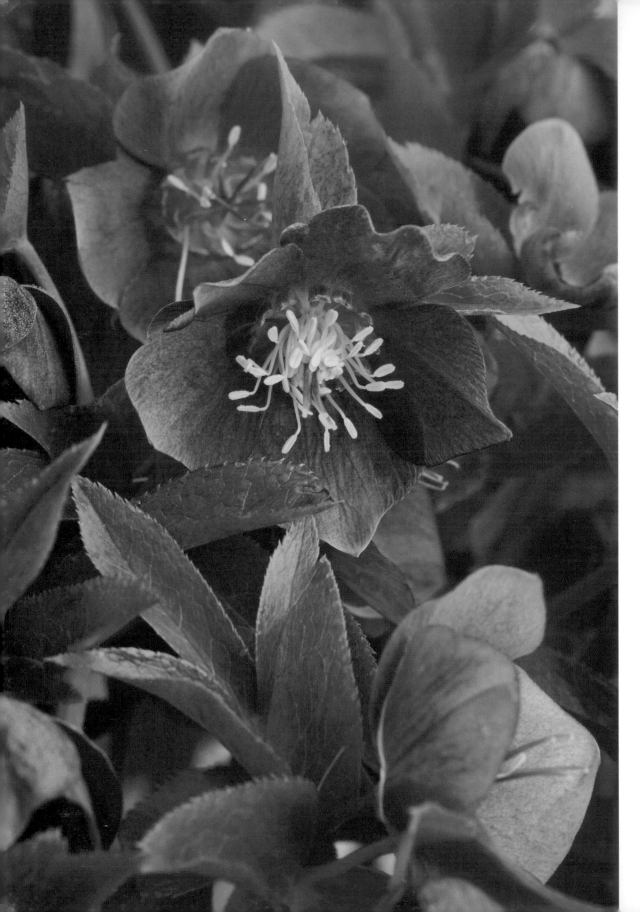

One of the early signs of spring is the arrival of hellebores. Their pendant blossoms, however, are a photographic challenge. I typically look for one blossom that can be isolated from the others. This very healthy clump in our garden made that approach impossible. Rather than pass up the shot, I decided to capture an image of the cluster. The early morning sidelighting brushed across the whole area. I framed the image to include just one full blossom and sections of many others. A shallow depth of field was needed to keep the foreground and background from getting too busy.

Canon 1Ds Mark II with 180mm f3.5 L macro lens, 1/6 second at f11 –1/3 stop exposure

Store

After capturing the images and going through all the steps to get the files ready for use, you need a system to store the finished or master files. Storage of slides and negatives was pretty straightforward. You had file cabinets, plastic sleeves, or perhaps cardboard boxes filled with yellow or green slide boxes. Storing digital files is more complicated.

Master files can be stored on CDs, DVDs, internal hard drives, external hard drives, tape, optical drives, or something still to be developed. CDs and DVDs are readily available and convenient to use. Their drawback is that as the number of files grows, so does the number of CDs or DVDs. The more discs you have to sort through, the more time it takes to find an image file. If you're looking for just one image, you may have to view the images on any number of discs. Even if you have a cross-filing system, where every image has a location designated, it still takes time. If you're searching for a number of images, the process is even more cumbersome. There's also the strong possibility that computers in the future may not accept CDs, and images stored on CDs or DVDs will have to be transferred to a new medium.

The more common solution is to store digital images on external hard drives. Still, hard drives are not without their problems. For one thing, hard drives fail. To prepare for this possibility, two hard drives should be used—one for primary storage and another for backup. Try not to use your computer's internal hard drive for storage; if you do, you may run into capacity problems. The better approach is to use two external drives. If your image library is very large, multiple hard-drive systems such as JBOD or RAID systems or the Drobo storage robot from Data Robotics, Inc., are an option. The drawback of large systems is the cost, but good, efficient storage is still less costly than losing hundreds or thousands of valuable images.

The key is to plan for the future. Try to estimate how much storage you will need three years into the future. It's far easier to design a large enough system in the beginning than to go back and rebuild six months down the road.

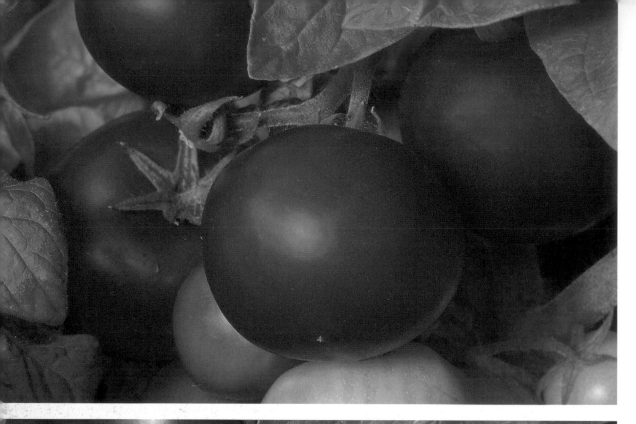

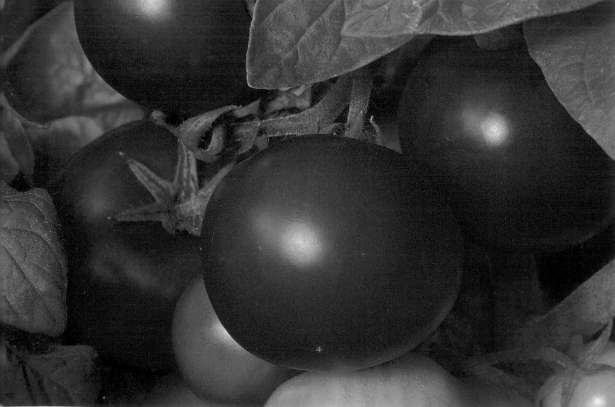

Although polarizers are very effective at eliminating glare in images, they don't work completely all the time. Images with round objects, such as these tomatoes, may still have glare evident. In these cases, you can correct the image on the computer if you don't like the glare (some people do like the glare)

These two tomato images demonstrate what's possible with the layer feature in Photoshop. Think of this feature as emulating separate sheets of clear plastic layered on top of the original file that allow the adjustment of certain aspects of an image. When the image is completed to the satisfaction of the photographer, the different layers can be kept separate or can be merged into one layer for storage.

To create the image without the glare, I made a separate layer and cloned color from the nonglare areas into the glare areas. I did all the touch-up work on the separate layer so the original layer wasn't affected. By adjusting the opacity setting of the separate layer, I was able to reduce the amount of glare to the point I thought appropriate. When the image looked right, I merged the separate layer and the original layer.

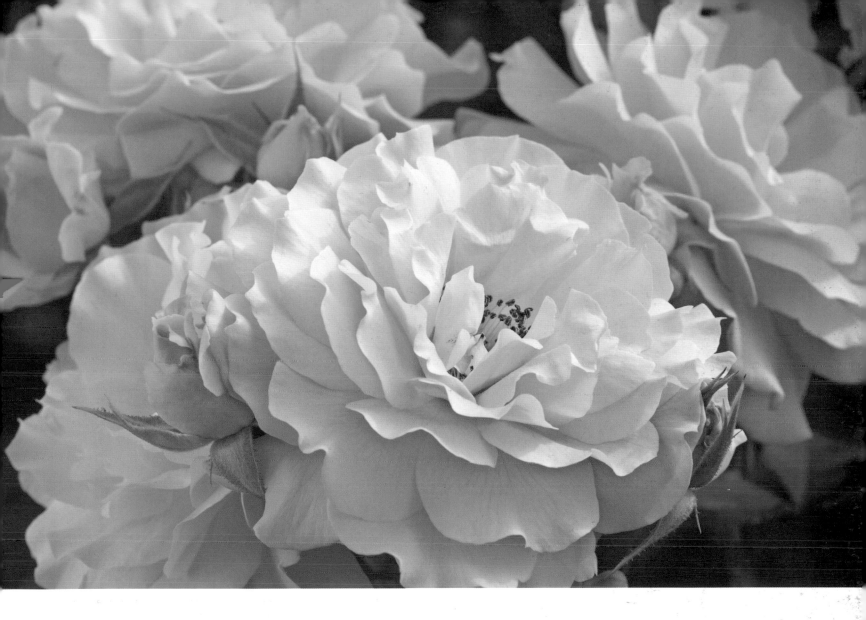

The soft directional lighting really shows off these roses at their best. Even though the main rose is centered, the image isn't static. The light and shadows creating the texture and the variations in the apricot color keep this from being a flat image.

Canon 1Ds Mark II with 180mm f3.5 L macro lens, 1/40 second at f16 +1/3 stop exposure

NEXT PAGE *The sun coming through the ribs of this irisine was captivating and a photographic challenge. The color was so strong that I was concerned it would over-power the image. I chose to use a medium aperture as well as include a darker area to offset the strong color. I bracketed the exposure.*

Canon 1Ds Mark II with 70–200mm f2.8 L zoom lens, 1/8 second at f11 –1/3 stop exposure

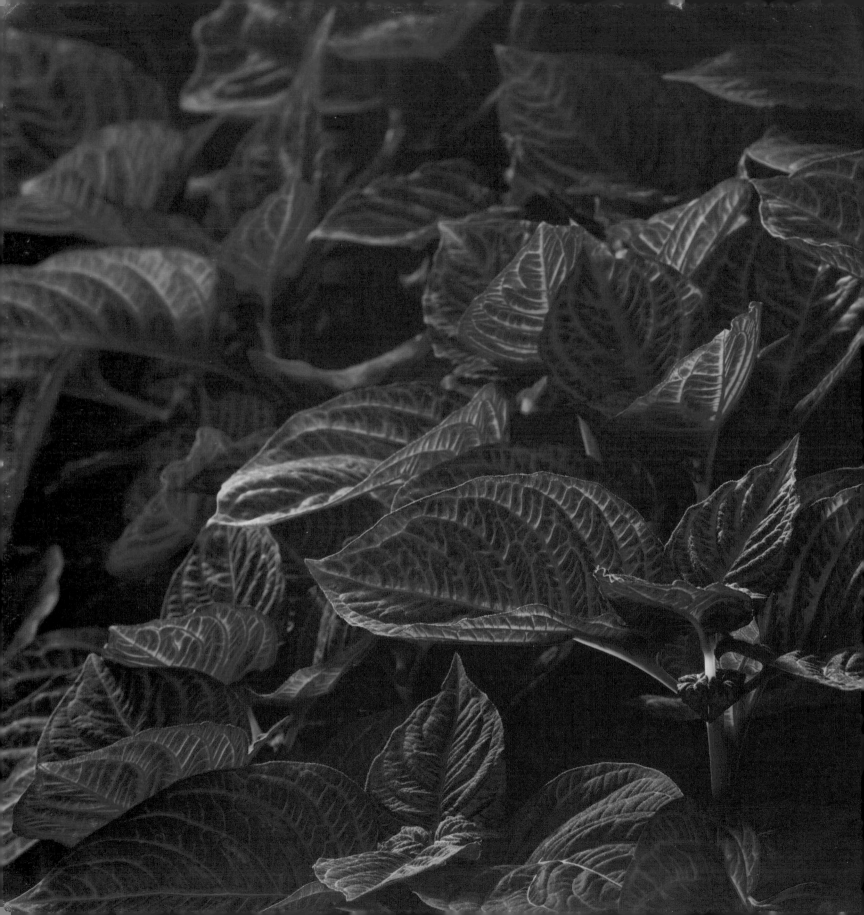

My Gear

Cameras:
- Canon 1Ds
- Canon 1Ds Mark II

Lenses and lens accessories:
- Canon 20-35mm f2.8 L zoom
- Canon 24mm f2.8 L tilt-shift
- Canon 24-70mm f2.8 L zoom
- Canon 70-200mm f2.8 IS L zoom
- Canon 100mm f2.8 macro
- Canon 180mm f3.5 L macro
- Canon 300mm f4 L telephoto
- Canon 1.4+ extender
- Canon 25mm extension tube
- Canon Speedlite 550EX flash, two units
- Canon 500D diopter
- B + W circular polarizers, 72mm and 77mm

Tripods:
- Gitzo model 1348 carbon fiber tripod with Kirk ballhead
- Gitzo 12-foot tripod

Photoflex and Westcott reflectors and diffusers in different sizes

Macbeth Color Checker

Tenba rolling case

Computer equipment:
- Two Power Mac G5s networked to a G4 server
- One external hard drive for each of the G5s to back up the internal hard drives
- Two external 500-gigabyte hard drives for raw storage
- WiebeTech RT5, 2.5 terabytes storage connected to the server
- Tape backup connected to the server
- Apple PowerBook 15-inch

Printers:
- Epson 2200
- Epson 7800
- HP laser printer

Resources

Recommended Reading

Macro photography

Shaw, John. 1987. *Closeups in Nature*. New York: Amphoto.

Loaëc, Ronan. 2003. *Macrophotography*. Trans. L. Ammon. New York: Abrams.

Thompson, Robert. 2005. *Close-up and Macro, A Photographer's Guide*. Cincinnati, OH: F + W Publications.

Digital photography

Caponigro, John Paul. 2003. *Adobe Photoshop Master Class, 2nd edition: The Essential Guide to Revisioning Photography*. Berkeley, CA: Adobe Press.

Eismann, Katrin, Sean Duggan, and Tim Grey. 2004. *Real World Digital Photography,* 2nd edition. Berkeley, CA: Peachpit Press.

Evening, Martin. 2004. *Adobe Photoshop CS for Photographers*. Burlington, MA: Focal Press.

——. 2007. *The Adobe Photoshop Lightroom Book: The Complete Guide for Photographers*. Berkeley, CA: Peachpit Press.

Johnson, Stephen. 2006. *Stephen Johnson on Digital Photography*. Sebastopol, CA: O'Reilly Media.

Krogh, Peter. 2006. *The DAM Book*. Sebastopol, CA: O'Reilly Media.

Garden photography

Adams, Ian. 2005. *The Art of Garden Photography*. Portland, OR: Timber Press.

Cooper, Tony. 2004. *Garden Photography*. East Essex, England: Photographers Institute Press/PIP.

Nichols, Clive. 1998. *Photographing Plants and Gardens*. Newton Abbot, England: D&C.

——. 2007. *The Art of Flower and Garden Photography*. London, England: Argentum.

Patterson, Freeman. 2003. *The Garden*. Toronto, Canada: Key Porter Books Limited.

Rokach, Alan, and Anne Millman. 1995. *Field Guide to Photographing Flowers*. New York: Amphoto.

Associations

American Public Gardens Association (APGA)
formerly American Association of Botanical Gardens and Arboreta (AABGA)
100 West Tenth Street, Suite 614
Wilmington, DE 19801
302-655-7100
www.publicgardens.org

American Society of Media Professionals (ASMP)
15 North Second Street
Philadelphia, PA 19106
215-451-2767
www.asmp.org

American Society of Picture Professionals (ASPP)
117 South Saint Asaph Street
Alexandria, VA 22314
703-299-0219
www.aspp.com

Garden Conservancy
P.O. Box 219
Cold Spring, NY 10516
845-265-2029
www.gardenconservancy.org

Garden Writers Association (GWA)
10210 Leatherleaf Court
Manassas, VA 20111-4245
703-257-1032
www.gwa.org

National Association of Photoshop Professionals (NAPP)
333 Douglas Road East
Oldsmar, FL 34677
www.photoshopuser.com

North American Nature Photography Association (NANPA)
10200 West 44th Avenue, Suite 304
Wheat Ridge, CO 80033
303-422-8527
www.nanpa.com

Photography Workshops

D-65
Digital workflow lectures and workshops with Seth Resnick.
www.D-65.com

Ian Adams Photography
Landscape and outdoor photography workshops.
www.ianadamsphotography.com

John Paul Caponigro
Color theory, photo tours, digital printing lectures and workshops. One
 of the best on digital printing.
www.johnpaulcaponigro.com

Maine Photographic Workshops
Workshops available for all skill levels.
www.theworkshops.com

Santa Fe Photography Workshops
National and international workshop locations for all skill levels.
www.sfworkshop.com

Stephen Johnson
Digital photography workshops. Stephen is one of the early digital
 pioneers.
www.sjphoto.com

Web Sites

Alan Detrick
The author's Web site.
www.alandetrick.com
www.digitalrailroad.net/alandetrick

Lightroom Extra
News, tips, updates, and information on Adobe Photoshop Lightroom.
www.lightroomextra.com

Lightroom News
Software information, tips, and news about Lightroom by the producers
 of the photoshopnews Web site.
www.lightroom-news.com

Luminous Landscape
Equipment reviews and outdoor photography articles.
www.luminous-landscape.com

Outback Photo
Equipment reviews and photography articles.
www.outbackphoto.com

Photoshop News
Latest news and information about Photoshop software.
www.photoshopnews.com

Pixel Genius
Plug-ins (sharpening) for Photoshop software.
www.pixelgenius.com

Scott Kelby
Web site of one of the most prolific authors on Photoshop, Lightroom,
 and anything digital, offering a wealth of information.
www.scottkelby.com

Universal Photographic Digital Imaging Guidelines
Current information and suggestions for establishing a universal
 standard for digital photography.
www.updig.com

The early spring color of the new epimedium leaves always catches my interest. I chose to isolate one leaf and keep only that leaf sharp.

Canon 1Ds Mark II with 180mm f3.5 L macro lens, 1/5 second at f16

Glossary

analog photography Film photography.

aperture Opening in the lens that allows light to reach the digital sensor. The relative size of the opening is indicated by an f-stop number, with larger numbers denoting smaller openings.

aperture priority Semi-automatic camera setting where the photographer selects the aperture setting and the camera determines the shutter speed. See also *shutter priority*.

autoexposure (automatic exposure) A camera setting such as "program" mode where the camera selects both aperture setting and shutter speed.

autofocus Capability of the camera to automatically focus the lens.

awb (auto white balance) Setting that makes the camera automatically perceive a white area in the subject and adjust the color temperature accordingly.

bit Basic digital unit of information. One bit can store two values, such as black and white or on and off.

bracketing Shooting the same image a number of times at different exposures to ensure that one of the shots will be properly exposed. Some cameras have an auto bracketing function that will take multiple exposures with one press of the shutter-release button.

brightness Value of a pixel in a digital file, stated on a scale from 0 (black) to 255 (white); luminance.

byte Digital unit of measurement. One byte equals eight bits.

card reader Device attached to a computer that reads the data from compact flash cards.

center-weighted metering Metering pattern that emphasizes the values in the center of the metered area.

CMYK Color mode used by commercial printers, with cyan, magenta, yellow, and black channels. See also *color mode, RGB*.

color mode Structure in a digital image file that determines the number of color channels used. The major color modes are RGB, CMYK, Grayscale, and Lab.

compact flash card Small portable storage device for digital information, the film of the digital world.

compression Method by which the total amount of data in a digital file is compressed so that the total file size is reduced. There are two types of compression, one that eliminates some data (lossy compression) and one that saves all data (lossless compression).

contrast Range of brightness or luminance in an image from the darkest area to the lightest.

cropping Reducing image size by discarding a portion of the original image. Cropping is done to eliminate unwanted details, improve composition, or fit a specified dimension.

depth of field (DOF) Distance from the front to the back of the zone (the field) around a focus point in which a captured image is acceptably sharp.

diffuser Light modifier used to soften harsh lighting on a subject.

digital sensor Microchip that takes the place of film in a digital camera. When the sensor is exposed to light, it records the intensities of the light as variable electrical charges. Digital sensors come in two varieties: CCD (charge-coupled device) and CMOS (complementary metal oxide semiconductor).

dots per inch (dpi) Measure of resolution for anything printed on paper.

dynamic range Range of f-stop values within which detail is captured in an image.

evaluative metering Canon's term for the automatic averaging of multiple meter readings.

exposure Total amount of light reaching the digital sensor, determined by the combination of the size of the opening in the lens (f-stop) and how long it stays open (shutter speed).

exposure compensation Adjustment of the camera exposure settings to let in more light (overexpose) or less light (underexpose) than normal.

extender Lens accessory (also called multiplier or teleconverter) placed between the lens and the camera to multiply or enlarge an image.

extension tube Hollow tube attached between the lens and the camera body to decrease the minimum focusing distance of the lens.

fill flash Flash used to add supplemental light to an image.

f-stop Number expressing the relative size of the opening in the camera's lens (the aperture), with larger numbers denoting smaller openings. For example, f22 is a smaller aperture than f8.

hi res Digital file resolution of 300 ppi, suitable for print publication.

histogram Graphical representation of the light values, brightness, or luminance in a digital image.

incident light measurement Measurement of the amount of light falling on a subject, made by using a handheld light meter.

interpolation Computer process for increasing (up-res) or decreasing (down-res) the total size of a digital file by adding or subtracting pixels.

ISO rating Number established by the International Standards Organization to denote the sensitivity of the digital sensor. The higher the number, the more sensitive the sensor is to light.

JPEG (Joint Photographic Experts Group) Standard format for image files used on the Web. JPEG is a lossy format, meaning information is lost each time the file is saved. The file extension is *.jpg* or *.jpeg*. See also *TIFF*.

LCD (liquid crystal display) Small window on the back of the digital camera that allows you to preview or review the image and any related information.

lo res Digital file resolution of 72 ppi, suitable for viewing and Web publication.

luminance Brightness of an image.

macro lens Flat field lens specifically designed to focus close to the subject.

magnification (or reproduction) ratio An expression of the relationship of the actual size of the subject to its image size on the digital sensor. For example, a subject that is actually four inches long that appears one inch long on the sensor would have a magnification ratio of 1:4.

matrix metering Nikon nomenclature for automatic averaging of several light meter readings.

metadata All the information that pertains to or describes a digital image.

mirror lockup Feature that prevents movement of the mirror in the camera when you use slower shutter speeds, between 1/30 and 1 second, so that camera shake won't blur the image.

multiplier See *extender*.

overexposure Loss of detail in the highlight areas of an image.

PDF (portable document format) File format used for text and image layouts. The file extension is *.pdf*.

pixel (picture element) Smallest piece of information in a digital file.

pixels per inch (ppi) A measure of the resolution of an image for monitors, cameras, and projectors.

raw File format for raw, unprocessed image data.

reflector Light modifier used to direct additional light onto a scene or subject.

reproduction ratio See *magnification ratio*.

resolution Total number of pixels per image a digital camera can capture (for example, a 6-megapixel camera), density of pixels in an image (as in 300 ppi or pixels per inch), or density of pixels that a monitor, printer, or projector can effectively handle.

RGB Color mode used by monitors and projectors, with red, green, and blue channels. See also *color mode, CMYK*.

saturation Intensity of colors in a digital image file.

shutter priority Semi-automatic camera setting where the photographer selects the shutter speed and the camera determines the aperture setting. See also *aperture priority*.

spot metering Light metering where the area measured is a very small circular area.

stopping down Changing the aperture to a smaller opening.

teleconverter See *extender*.

TIFF (tagged image file format) Standard format for image files used for print publication. The file extension is *.tif* or *.tiff*. See also *JPEG*.

underexposure Loss of detail in the shadow area of an image.

white balance Camera setting that allows accurate recording of the color temperature of an image.

working distance Distance from the front of the lens to the subject.

zoom lens Lens with a variable range of focal lengths.

Index

Adobe 1998, 146, 148, 153
Adobe Camera Raw, 160
Adobe Photoshop, 20, 51, 80, 161, 166
Adobe Photoshop Elements, 51, 161
Adobe Photoshop Lightroom, 51, 80, 127, 160, 161
ageratum effect, 110
anti-shake. *See* image stabilizer
aperture, 59, 64, 67, 90, 94, 99, 135
aperture priority, 64, 125
Apple Aperture, 51, 80, 160, 161
Apple iPhoto, 161
Archiving. *See* file storage
Autoexposure, 59, 64
autofocus, 28, 37, 72
autosharpening, 29
auto white balance, 148

background, 83, 84-87, 110
backup files, 162, 165
balance, 110, 148
bracketing, 53, 61, 106, 128-129. *See also* exposure compensation
brightness, 57, 60
butterflies, 34, 72, 73, 74

cable release, 27, 29, 38
camera. *See* DSLR
camera movement, 20, 27, 29, 38, 40, 87
camera shake. *See* camera movement
Canon, 30, 31-32, 35, 37
capture, 156
CD. *See* file storage
close-up, 14
CMYK, 146, 148
color, 110-112, 146-148
color checker, 110
color management, 148-151
color match, 146-148
color mode, 146-148
color space, 146-148

compact flash cards, 38, 158, 160
composition, 90, 109-110
cropping, 19

depth of field, 20, 66-70, 74-75, 90, 93, 94, 95, 96, 97, 99, 115, 136, 137
depth-of-field preview, 29, 69, 70, 86
diffusers, 46, 47, 48, 80, 133
digital noise. *See* noise
digital projector, 145
digital sensor, 14
diopters, 30-32
DNG, 162
dots per inch (dpi), 143
DSLR (digital single lens reflex), 27-29, 64
DVD. *See* file storage

equipment, 25-53
evaluative metering. *See* metering
exposure, 57-65, 128-129
exposure compensation, 16, 59, 61, 90, 128-129
extender, 30, 33-34, 35, 127
extension tubes, 15, 32-33, 127

fauna, 120-127
file formats, 151, 153
file mode, 151, 163
file size, 151
file storage, 165
filters, 38, 49, 50, 106, 166. *See also* polarizer
flash, 48-49
flora, 103-119
flowers, 106-117
focal length, 35-38
focus, 28, 31, 66, 69, 70-73, 74-75, 93, 96, 99
foliage, 117-119
format, 53, 85
f-stop, 59, 64, 67, 90, 94, 99, 135

gardens, 103
gray cards, 110
Grayscale, 146, 148
greenhouse, 90, 119-120

handholding, 20, 40, 99, 125
highlights, 61
hi res. *See* resolution
histograms, 60, 61, 127-129
horizontal format, 72-73, 85

image scale, 14
image stabilizer, 38
insects, 34, 89, 120-127, 137, 142, 144
interpolation, 19
ISO, 20, 22, 73

JPEG, 151, 152, 153, 156, 159, 163

Lab, 146, 148
Lastolite diffusers and reflectors, 47
LCD (liquid chrystal display), 20, 60
lenses, 29, 35-38
 macro, 16, 30, 35-38, 127
 telephoto, 34, 127
 zoom, 38
lens shades, 38, 40
life size, 14
light, 23, 53, 77-81, 83, 112, 117, 130, 131, 132
lighting, 23, 77-81, 83, 89, 112, 117, 130, 131, 132
light modifiers. *See* diffusers and reflectors
Lightroom. *See* Adobe Lightroom
lo res. *See* resolution
luminance. *See* brightness

macro, 13, 14
macro lens. *See* lenses
magnification, 14, 19
magnification ratio, 14

matrix metering. *See* metering
megapixels, 144
metadata, 160
metering, 57, 61
 average, 61
 center-weighted, 61
 evaluative, 61
 matrix, 61
 partial, 61
 spot, 61
Microsoft Picture Editor, 161
mirror lock-up, 29, 127
monitor calibration, 151
monitors, 148, 151
movement, 20, 29, 87-89
multiplier. *See* extender

Nikon, 30, 32, 35, 37
noise, 22

PDF, 152
Photek Lite Disc diffusers and reflectors, 44, 47, 48
Photoshop. *See* Adobe Photoshop
pixels, 19, 143-146
pixels per inch (ppi), 143
polarizer, 38, 50, 106, 166
ProPhoto, 146, 148, 153
PSD, 152, 153

raw format, 29, 80, 152, 159, 162
reflectors, 44-46, 80, 121, 132, 133
reproduction ratio, 14
resolution, 145-146
RGB, 146-151
rule of thirds, 83

sensor. *See* digital sensor
shade, 81
shadow, 23, 80, 130, 131, 133
sharpening. *See* autosharpening
shutter priority, 64, 125
shutter speed, 64, 125
Sigma, 30, 35, 37

software, 50-51, 160-161, 163
spectral highlights, 135
sRGB, 146, 153
storage. *See* file storage

teleconverter. *See* extender
TIFF, 152, 153, 156, 159, 162
tripod, 40-43, 125
tripod head, 42-43

underexposure, 63
UPDIG, 157

vertical format, 73, 85
viewfinder, 20, 70

Westcott diffusers and reflectors, 44, 47, 48
white balance. *See* auto white balance
working distance, 35-37

PHOTO BY LINDA DETRICK

About the Author

Noted garden, nature, and landscape photographer Alan L. Detrick
resides with his wife and business partner, Linda, in Glen Rock, New
Jersey. His award-winning work has appeared worldwide in major
publications including *Audubon, Garden Design, Horticulture, Modern
Maturity, Natural History, Reader's Digest, The New York Times, Sports
Illustrated,* and *Sunset.*

An experienced instructor, Alan has lectured and led photography
workshops for professional organizations and public gardens including
the American Horticultural Society, the Garden Club of America, the
Garden Writers Association, The New York Botanical Garden, Chanti-
cleer Garden, Brookside Gardens, and Longwood Gardens.

In addition to owning a stock photography agency, Alan and Linda
also provide photographic services for landscape architects and garden
designers. In 2005 they were honored as Fellows of the Garden Writers
Association. Their Web site address is www.alandetrick.com.